IRELAND IN FOCUS

Irish Studies
James MacKillop, *Series Editor*

Other titles in Irish Studies

IRELAND IN FOCUS

Film, Photography, and Popular Culture

Edited by **Eóin Flannery**
and **Michael Griffin**

With a Foreword by Colin Graham

SYRACUSE UNIVERSITY PRESS

For a listing of books published and distributed by Syracuse University Press,
visit our Web site at SyracuseUniversityPress.syr.edu.

ISBN-13: 978-0-8156-3203-0 (cloth) ISBN-10: 0-8156-3203-7 (cloth)

Library of Congress Cataloging-in-Publication Data

Ireland in focus : film, photography, and popular culture / edited by Eóin Flannery and
Michael J. Griffin ; with a foreword by Colin Graham. — 1st ed.

p. cm. — (Irish studies)

Includes bibliographical references and index.

ISBN-13: 978-0-8156-3203-0 (cloth : alk. paper)

ISBN-10: 0-8156-3203-7 (cloth : alk. paper)

1. Popular culture—Ireland—History—20th century. 2. Ireland—In motion pictures.
3. Photography—Ireland. 4. Ireland—In art. I. Flannery, Eóin. II. Griffin, Michael J.

DA959.I68 2009

306.09417—dc22

2008050304

Contents

Illustrations

Foreword

COLIN GRAHAM

In his book *At the Edge of the World,* a collection of photographs and impressions of the "marginal" places he has visited over the years, Jean Mohr reminisces about a 1965 trip to the Aran Islands, and specifically to Inisheer. For Mohr, Aran is primarily the place of Robert Flaherty's *Man of Aran,* "for a long time one of the most treasured features of film-club programmes." Flaherty's staged realism is clearly important to Mohr's particular aesthetic, which, like Flaherty's, is an intensely committed descendant of an anthropologically unflinching gaze. In true photo-journalistic fashion, Mohr recalls Inisheer by reverting to his own journal, and its recording of a journey around Aran by horse and cart:

> Nothing spectacular meets the eye: walls twice as high as those on the Irish coast, women turning away and hiding their faces at the sight of a camera, O'Flaherty's [sic] house in the distance. My guide remarked: "Flaherty didn't really come from Ireland you know. He adopted the name so that he could get on with his work in peace." (Mohr 1999, 75–76)

At stake here is the gap opened up by the inevitable inauthenticity of an image of any kind, and here specifically by that awkward form of knowledge which is made by the apparatus of photography. The camera as a device offers us seemingly precise metaphors, and tempts us with their critical and cultural valencies; focus, framing, aperture, scene, foreground—all terms that seem to offer the viewer some kind of purchase, even "perspective," on the cultural scene or historical moment they "capture." But the reassurance of

these metaphoric parallelisms, and the very idea of the image as something that will preserve evidence, is always made strange through the mechanics of an eye behind glass, recording the real with a distanced, edited mimeticism. Flaherty getting on with his work in peace is only possible because of a comic anonymity Mohr can wryly aspire to himself. Sometimes mistaken for a desire for impersonality, the distance between the creative lens, or the artist's eye, and its object is more than a cultural distance, and is not even a metaphor for it. That distance will always reminds us, secondhand, of our difference from what's in the image, and even the thrill of local recognition is heightened by the peculiarity of the photograph, and of the lens's work, or of the painter's brushstroke. Mohr's trip to Ireland, recollected in tranquillity, is a record of nothingness, of faces turned away, and of a creative camera which faked its authenticity so well its slippery grasp on truth is inadvertently replicated in the slip on Flaherty's name.

Film, photography, painting, and their variations in the visual arts are still a curiously invisible presence in the way Ireland, its history, and its meanings are understood, despite the fact there was a relatively early twentieth-century Irish passion for cinema, an even earlier trend for documentary photography, and a constant intertwining of visual and verbal arts during the same period in the Literary Revival. The politics and aesthetics of these visual forms have their own semantics—film's global language circulates in and out of cultural boundaries with an apparent freedom, yet as a commodity, film travels with and along the same lines as global capital. Early Irish films (for example, those made by the Film Company of Ireland) may owe part of their acting style and personnel to the Abbey stage, but they are nevertheless filmic narratives that make sense of cinema as a form in the same way as cinema did, at the same time, on the other side of the Atlantic. If a national cinema is an economic fantasy, then a national way of looking at cinema is merely a revealing intellectual aspiration. Painting, sculpture, and architecture, for all that they can provide moments of national pride, even national record, partake in a grammar of Western art before they become meaningful.

When the photographic, cinematic, and visual arts are analyzed to understand a culture, then they will only ever see a culture estranged from itself. In critical and sometimes artistic pursuit of the tantalizingly non-linguistic, talismanic image of pure knowledge, the inherently magical

qualities of the reproduced image heighten the promise of the mimetic to a form of hyperreality, and lead to a gnawing self-consciousness. The photographic and the cinematic stand in the same relationship to the nation as the intellectual who articulates nationality and speaks of and for a sense of belonging—given that a linguistic presence or a visual shape can never be, nor truly replicate, the nation, which must be beyond and greater than the sum of any words written about it, or any archive of images collected to exemplify it. The cultural vignette, the landscape, the portrait, and the filmic story all suffer from an often glorious failure of synecdoche, in which the whole is never known through the part. In this sense, the painting, photographic, or cinematic image embodies the structures of the modernist nationalism that dominated the epoch in which these technologies were instituted as epistemological and cosmological devices. The focused image, whatever its sharpness, is always spatially and temporally displaced. The full nation must be imagined through the part we see. The "Irish" image is always a reminder there is more outside the frame. There is no certainty in either the veracity or the semantics of the camera's version of Ireland, nor in the painter's artistry.

We look to the visual arts to repeat Ireland's reality magically, as if they could perform the supplementation of the actual and give it back in confirming overabundance. If we distrust "art," we might turn to the "popular," to images "from below" to see a truer representation of Ireland, one in which the formal intricacies of accumulated high cultural consciousness do not interfere with the "reality" of culture as it is lived. As Flannery's essay in this collection shows, even loyalist and republican murals in Northern Ireland, which we might think of as the epitome of visual culture from the streets, consist of layers of sincerity and irony, visual-political rhetoric, contingency, and self-consciousness, which makes them every bit as replete, partial, and complex, in terms of their cultural meanings, as a John Lavery painting or a R. J. Welch photograph.

Equally, the series of Celtic Revivals in the visual arts in the late nineteenth and early twentieth centuries appear, with hindsight, as signs of Irishness in search of completeness, hoping to strike an almost mystical harmony with past, present, and future, but always aware they may fall short of true Irishness or overstate their case. Other than through the separation of

function, it is difficult now to see a cultural distinction between, for example, the impulses that lead to the temporary erection of a Blarney Castle at the 1893 World's Columbian Exposition in Chicago and E. W. Godwin's Dromore Castle of 1868–70, which modeled itself on the Rock of Cashel. In each, there is a sincere attempt to mimic and pay respect to a tradition, a visual (and material) cultural heritage. And in each case, the replication causes a faltering in the steps of the revered.

When we think about Ireland and its visual representations, we are quickly shown through every example a fractured epistemology, a continually renewing cracked looking-glass. It is in the play of the image and its self-aware form, in the interaction of the mirrored reality and the crack that always interrupts its completeness, that criticism of the visual forms of Irishness finds the grain that begins a restless and productive knowledge. The essays in *Ireland in Focus* show in rich and provocative ways how seeing and reading visual representations of Ireland gives us refreshed understandings of the ways Ireland circulates as an idea in its own culture and beyond.

Introduction
Ireland in Focus

MICHAEL GRIFFIN

In his preface to an edition of *Sweeney's Flight* with photographs by Rachel Giese, Heaney writes of an "unease about the problematic relation between image and text. I always shied from the combination of speechless photograph and wordlogged verse: I think I felt that in these cases (to be extreme about it) the photograph was absolute and the text a pretext" (Heaney 1992, vii). Ireland has had plenty of text, and plenty to say about those written words that are pretext to a substantial tradition of literary criticism. Heaney's reservations about overriding, through combination, the suggestiveness of poetry with the less arbitrary representations of image are, however, as unwarranted as he himself suspected. The image, the photograph, and the realistic painting do not exist in degrees of verisimilitude; all can be subjected to interpretation: the photograph as much as the abstract painting as much as the poem, and the interpretation and analysis of each can be just as attuned to the various issues of intrinsic composition and extrinsic factors such as intention, reception, means, and contexts of production. John Berger's *Ways of Seeing*, published in 1972, has demonstrated that the image, even the photograph, is no more absolute, no less contingent in its representative power than is the word.

To W. B. Yeats, there is Jack B. Yeats, and for acres of novel and newsprint, there are photographic essays and films that document or fictionalize, humanize or dehumanize the protagonists, great and small, of Irish history. Books are emerging now that treat the visual arts in their separate compartments: filmic, televisual, photographic, sketched, and painted. Adele M.

Dalsimer edited an excellent and groundbreaking collection of Ireland's pictorial tradition in 1993; more recently, Fintan Cullen has synthesized and summarized the body of work on the painterly arts in Ireland in *The Cambridge Companion to Irish Culture.* Niamh O'Sullivan has commented suggestively on the politics of painting in nineteenth-century Ireland. Recent, stunningly presented artistic and photographic essays in the *Field Day Review* have also added to a burgeoning sense of the importance of the visual in the interdiscipline of Irish studies.

In film, the body of critical work has, since the late 1980s, been increasing exponentially. Some of the most influential studies include Kevin Rockett, Luke Gibbons, and John Hill's *Cinema and Ireland* (1988), which in many respects set the standard against which subsequent guides have been judged. Martin McLoone's *Irish Film: The Emergence of a Contemporary Cinema* (2000) surveyed Irish cinema in its relations with nationalism and notions of Irishness; Lance Pettitt's *Screening Ireland: Film and Television Representation* (2000) and Elizabeth Butler Cullingford's *Ireland's Others: Gender and Ethnicity in Irish Literature and Popular Culture* (2001) similarly survey problematic consolidations of Irish identity on screen. Harvey O'Brien's *The Real Ireland: The Evolution of Ireland in Documentary Film* (2004), situates constructions of the "real" in the political contexts of production and reception, while *Keeping it Real: Irish Film and Television,* which O'Brien edited with Ruth Barton (2004), demonstrates further the degree of activity currently taking place in Irish film and television studies.

No collections or works have yet conceived of Irish visual arts as an internally interdisciplinary field, with the possible exception of Luke Gibbons' *Transformations in Irish Culture* (1996), which studied the loaded signifiers at work in Irish culture from postcard photograph to political film three-quarters hence this book, which in a sense takes its prompt from Gibbons. Just as Giese supplements Heaney's poetry, so do these essays supplement our understanding of Ireland's traditions in visual culture by applying a multiplicity of critical methodologies to a multiplicity of visual forms. The purpose of this collection, therefore, is to think of Irish visual culture in a more holistic sense, to study the genres of visual culture three-quarters film, murals, photographs, and images in popular culture three-quarters alongside one another.

In film, Emilie Pine writes about Tom Cooper's *The Dawn* (1936), a fascinating film that found an Irish audience discovering its taste for cinema in the newly independent Free State, and the product of an increasingly capable domestic film industry, no longer as utterly dependent upon outside expertise and finance. *The Dawn* represented a real conflict. It provided the first indigenous representation of the War of Independence, performed by and for the people who participated in that very conflict. In light of the recent successes and controversies surrounding Ken Loach's *The Wind That Shakes the Barley* (2006), Pine's revisiting of *The Dawn* is timely.

B. Mairéad Pratschke's essay also deals with the moving image, but a moving image from the particular and peculiar sub-genre of the newsreel; in this case she deals with Gael-Linn's Irish-language documentary and newsreel series, *Amharc Éireann,* produced by Colm Ó Laoghaire. The author situates this visual material in the context of profound social change in the mid-century. The series, which began in July 1956 as monthly single-item short documentary films, was transformed in 1959 into a weekly newsreel, and became a staple of the Irish cinema-going experience until July 1964. This was a period that witnessed the beginnings of Ireland's transition from a protectionist economy into a period of much heralded economic modernity. The transition generated a degree of self-analysis regarding culture and language; nonetheless, the newsreels presented a strong positive image of Irishness and the Irish language, even while the economic doctrines meant to protect aspects of this identity were undone.

Also in the realm of film, Cahal McLaughlin writes on the representation on screen of the prison. Whether the scene of protest or as a forcing house of a stronger political identity among activists, the prison has always been a central image and metaphor of the colonial relationship itself, deploying a carceral culture on both sides of partition in Ireland to sequester elements subversive of that very partition. McLaughlin provides a historical survey of Irish prisons on screen, including those represented in Rita Donagh's *Long Meadow* (1983), Richard Hamilton's *A Cellular Maze* (1983), Rita Duffy's *Veil* (2000), Jim Sheridan's *In the Name of the Father* (1993) and *The Boxer* (1997), Terry George's *Some Mother's Son* (1996), Neil Jordan's *The Crying Game* (1992), and Michael Winterbottom's *Love Lies Bleeding* (1993). The films have the effect of humanizing the political figures whose lives they

fictionalize, and speculatively suggest the real human ties obscured by journalism and political abstraction.

Michael Patrick Gillespie opens a broader and essential discussion of what might in the first instance constitute an Irish film. His essay surveys the material conditions in which the cinematic flourish of the 1990s took place. Recent prosperity has made more Irish cinema possible at precisely the same moment economic success and globalization has made its subject matter and character more self-satisfied and less discernibly Irish, a double bind of sorts, which Gillespie studies with a deliberate sensitivity, deftly proposing subversion in the superficially saccharine. The study undoes some culturally protectionist pieties and provides a comparative framework within which mainstream films about Ireland can be better appreciated.

In the realm of the photographic, Sorcha O'Brien's essay connects with the emphasis in Gillespie's article on the problem of modernity in Irish visual culture. O'Brien studies visual representations of the Shannon Scheme at Ardnacrusha, including Sean Keating's landscapes, but more especially photographic representations. The latter, ostensibly more truthful or less ideological, reveal a great deal, perhaps inadvertently, through the camera's vantage points, focus settings, and chosen subject. Ultimately, the camera is as ideological as the painter's brush. Theoretically sophisticated in her analysis, O'Brien also compares Irish and German representations of Ardnacrusha, pointing to differences in emphasis as well as in technical and mechanical detail. Images of Ardnacrusha embody dialectics of modernity and tradition, of local and global, of technology and agriculture. The power station was an early attempt on the part of fledgling Free State to fashion a go-ahead, future-oriented image of itself. O'Brien writes about the notable absences, chief amongst them the centrality of German engineering in this constructed Irish self-image.

Christine Cusick's study of Rachel Giese's Donegal pictures is as earthily materialist as its subject, which is to say its starting point is as textural as the visual material it surveys. Like Giese, Cusick is working at the meeting points of cultural and natural history, and her essay shows a marked appreciation for Giese's sensitivity to her subject. The camera is no mere alienating medium here, but a tool for learning and earning cultural intelligence, and for appreciating the ways in which the landscape has been portrayed and distorted by colonialist and nationalist imperatives.

Rachel Tracie studies the visual culture of Northern Ireland in the general sense of its infusing the life-world of Northern Irish cities, returning again briefly to the theme of murals, statues, and flags. Her particular innovation is to study the visual as it is modified and performed on stage in the plays of Christina Reid. In Reid's plays, the image of, and the images in the family photograph album take center stage, invoking something beyond itself, and suggesting cultural meanings, domestic and social, beyond the frame of the stage, and beyond the scripted dialogue.

Connecting with essays on filming the Irish conflict, Eóin Flannery's essay studies political murals as visual expressions of community in the North of Ireland. Flannery's essay takes murals as a template onto which is projected the anti-imperial aspirations of the nationalist community. Flannery is unequivocal and engaged in his study, as he seeks to historicize the present by situating the "lived visual economy" of the North in terms of its late colonial experience. The parameters of the argument are not set by traditional empirical modes; here too, contemporary history is understood from below, through the art of the people and the community as it understands itself, and as it feels it has been understood, or deliberately misunderstood, by outside commentators. There is in this art the visual conjugation of the future perfect tense characteristic of republican aspirational language; this art is not utopian in a pejorative sense, but in the sense of its instilling communal self-esteem.

Barbara O'Connor revisits the image of Ireland as woman, and studies its variations and modifications as an enduring motif in nationalist imagery. Surveying a century and a half of visual representations of Irish womanhood, O'Connor argues representations have been dependent upon, and have consolidated, the interests of political elites. Idealized as impossibly chaste in some images, and as feisty and spirited in others, the Irish colleen's past and future has derived increasingly from a globalized economy of nationalized imageric ciphers.

Eugene O'Brien studies the modalities according to which Guinness—as brand and as physical substance decanted into branded pint glasses—has attained the status of visual synecdoche for Irishness itself. The marketing of Irishness for tourist-office purposes has been reflected, O'Brien argues, and sometimes even anticipated, by the modes in which Guinness has itself

been commodified. O'Brien attributes to Guinness an iconic status in which the beloved pint is equated with the nation. The ways the Guinness is packaged and advertised have changed with Ireland's economy and psyche. The company's symbol, the harp that stood for the nation, has now become incidental and embedded in a more ironic advertising discourse, the parameters of which presume a greater national taste for the global cultural logic of postmodern capitalism. Ireland is the most globalized country in the world; through Diageo, so too now is its favorite tipple.

From analyses of the branding of consumer favorites to readings of murals and film portrayals of political prisoners, this collection of essays stands as an original attempt to think about Ireland's relationship to visual culture as a whole. In this endeavor, it seeks to bring together those modes of visual representation manipulated through more advanced technologies of photography and film and the less technical modes of visual representation. Relatedly, it brings together the communally and the commercially produced. Its editors hope that it might open still further the dialogue between studies in visual culture and Irish studies.

Contributors

Christine Cusick is assistant professor of English at Seton Hill University. Her publications and scholarly interests explore the intersections between histories of colonialism and the natural world, specifically as they are voiced in contemporary Irish writing. She is currently editing a collection entitled: *Murmurs That Come out of the Earth: Ecocritical Readings of Irish Texts.*

Eóin Flannery is senior lecturer in English literature at Oxford Brookes University. He has published widely in the area of Irish studies, on contemporary Irish literature; visual culture; and postcolonial studies. His books include: *Versions of Ireland: Empire, Modernity and Resistance in Irish Culture* (2006) and *Enemies of Empire* (2007). He is currently completing a book on Ireland and postcolonial theory entitled *Ireland and Postcolonial Studies: Theory, Discourse, Utopia* (2009), and editing two books: *This Side of Brightness: Essays on Colum McCann* (2009), and *Modern Irish Gothic: From Bram Stoker to Patrick McCabe* (2010).

Michael Patrick Gillespie is the Louise Edna Geoden Professor of English at Marquette University. His latest book, *The Myth of an Irish Cinema,* will be published by Syracuse University Press.

Colin Graham is lecturer in english at NUI Maynooth. His publications include *Ideologies of Epic: Nation, Empire and Victorian Epic Poetry* (1998), with Richard Kirkland, *Ireland and Cultural Theory* (1999), *Deconstructing Ireland* (2001), with Glenn Hooper, *Irish and Postcolonial Writing* (2002), and with Leon Litvack, *Ireland and Europe in the Nineteenth Century* (2006). He is currently co-editor of *The Irish Review.*

Michael Griffin is lecturer in English in the Department of Languages and Cultural Studies at the University of Limerick, where he is codirector of the English and History Program. He has previously worked in Irish studies programs at Southern Illinois University, Carbondale, and the University of Notre Dame. He has published widely in eighteenth-century Irish and utopian studies, in journals such as the *Field Day Review, Utopian Studies, Eighteenth-Century Ireland: Iris an Dá Chultúr,* and *The Review of English Studies.*

Cahal McLaughlin is senior lecturer at the School of Media, Film, and Journalism at the University of Ulster. He is a filmmaker and writer, as well as chair of the Editorial Board of *The Journal of Media Practice.*

Eugene O'Brien is senior lecturer, head of the English Department and director of the *Mary Immaculate College Irish Studies Centre* at Mary Immaculate College, Limerick. He has published five books to date on critical theory and Irish studies, and has coedited two collections on Franco-Irish studies. He is editor of the Contemporary Irish Writers and Filmmakers series (Liffey Press) and of Edwin Mellen Press's Studies in Irish Literature and Irish Studies series and of *The Irish Book Review.*

Sorcha O'Brien is a doctoral student at the University of Brighton and holds a doctoral scholarship from the Arts and Humanities Research Council for her research on the representation of electrical technology of the Shannon Scheme. She teaches the history of industrial design at the National College of Art and Design, Dublin.

Barbara O'Connor is senior lecturer in the School of Communications at Dublin City University. She has an academic background in sociology and social anthropology, and her research interests include popular cultural forms and practices such as tourism, dance, and media. She has published widely in each of these areas and her most recent publication is a coedited collection, *Mapping Irish Media: Critical Explorations* (2007).

Emilie Pine is lecturer in drama at University College Dublin. She has published several essays on Irish theater and film studies, and she is cur-

rently working on a book manuscript on memory in contemporary Irish culture.

B. Mairéad Pratschke was born in Galway, and raised in Ireland and Canada. She holds a M.A. in European studies from the Katholike Universiteit Leuven in Belgium, and a Ph.D. in history from McMaster University in Canada. She is currently revising her book manuscript on the *Amharc Éireann* series for publication.

Rachel Tracie is assistant professor of theater at Azusa Pacific University in California and holds a Ph.D. in theater studies from Royal Holloway, University of London. Her research interests are in Canadian theater, and in particular, the monologue play; and also in the field of Northern Irish theater, with a special interest in the plays of Christina Reid.

Part One
Film

1

The Whole Picture
The Dawn (1936)—Tom Cooper

EMILIE PINE

In the first few decades of independence, Ireland went "cinema-mad" (Longford 1937, 70–71). In the 1930s, the leading film genre was the domestic comedy, with American and British films dominating the box office. Cinema was enormously popular throughout the country with thirty-six cinemas in the greater Dublin area, nineteen in Cork, Limerick, and Waterford, and 190 totaling over one hundred thousand seats in the Free State altogether (Beere 1935–36, 85). J. T. Beere, in an analysis of cinema going in this decade, estimated that between 1934 and 1935 there were approximately eleven million admissions to Irish cinemas. However, as Liam O'Leary, film critic for *Ireland Today* and the *Irish Press,* frequently lamented, cinema output was relatively homogenous and low in quality with many international and foreign language films never receiving releases in Ireland. Positive developments included the formation of the Irish Film Society in 1936, which struggled against high import duties on 35mm film, but nevertheless filled a space in the market for more intellectual foreign films, as well as supporting indigenous film, for example, reviving Denis Johnston's film of *Guests of the Nation* (1935) in 1938.

Inspired by the developments in film style and technology, and aided by a period of political stability, the 1930s saw the growth of an indigenous Irish film industry with films exploring issues ranging from urban development to life on the Blasket Islands, as well as two films that dramatized events from the War of Independence. Johnston's *Guests of the Nation,* an adaptation of Frank O'Connor's 1931 short story, was a disillusioned look back at the war and the compromises it necessitated. Shot on 16mm, however, it never

received a commercial release. In contrast, *The Dawn* was released one year later to large audiences and played for at least three weeks in Dublin. Also in contrast to *Guests of the Nation, The Dawn* represents the War of Independence as a glorious moment in Irish history that should be remembered for the strong bonds it forged within Irish communities. Although *The Dawn* has received passing critical attention, it has not received the recognition it deserves for its subtle construction of landscape and for the role landscape plays in the film's construction of the Irish past.

Although *The Dawn* is a fiction film, it does have a connection to actual history, not only to the War of Independence, but also to the first Irish Republican Army (IRA) ambush of Black and Tan soldiers, at Kilmichael Cross in Cork carried out by Commandant Tom Barry in November 1920.[1] Indeed, as Kevin Rockett notes "the War of Independence had a particular poignancy for some of the actors in that they participated in events similar to those depicted in the film" (Rockett 1988, 63). Tom Cooper, a garage and cinema owner, made the film with a group of friends, in particular Donal O'Cahill, who helped write the scenario, and who also plays the part of Billy Malone.[2] With a minimal budget, they either bought materials in England or improvised them and used Cooper's cinema to view each day's film rushes. Remarkably, considering these limited resources, Cooper managed to produce Ireland's first indigenous feature-length sound film and *The Dawn,* thus, stands as a tribute to what amateur filmmaking can achieve.

The literal connection between the film and Irish history was seen, upon its release, as a counter to the portrayal of the Irish in such British films as *Ourselves Alone,* directed by Brian Hurst and released in the same year as *The Dawn.* The *Irish Press* declared *Ourselves Alone* to be "unhistoric history" and a "lie" (*The Irish Press,* 14 Jul. 1936, 5).[3] Just a few months later, however, the

1. This ambush concerned two Black and Tan trucks and no prisoners survived. In fact, in a recent documentary on the Kilmichael Cross ambush, Radio Telefís Eireann (RTÉ) used footage from *The Dawn* in place of a dramatic reconstruction. The film seems to serve as a historically accurate image for the War of Independence.

2. Donal O'Cahill went on to cowrite the 1938 film *The Islandman* directed by Patrick Keenan Heale.

3. See John Hill (2000, 317–33), for more discussion of this controversial film.

Irish Press wrote of *The Dawn*, "The film is natural. It represents life. There is no incident that could not have happened in the Kerry of 1920. The film is true" (*Irish Press,* 25 Aug. 1936, 5). Within the review of the film, this paragraph has been emphasized, illustrating the importance of the "trueness" of *The Dawn*. Another reviewer, in the *Dublin Evening Mail,* called the film "an important 'documentary' picture" (*Dublin Evening Mail,* 25 Aug. 1936, 9). Even local newspapers reflected this admiration of the accuracy of the film. The *Cork Examiner* praised its "naturalness" and stated, "it is real—real in its moments of hate and its moments of quiet" (*Cork Examiner,* 1 Sept. 1936, 2), and the *Limerick Chronicle* declared Cooper's acting is "natural" because he "filled in real life the part he is now acting [Dan O'Donovan] in the picture" (*Limerick Chronicle,* 2 Sept. 1936, 4). Although the film is talked about as "true" and a "'documentary' picture," it remains a fiction film and thus, is not "real" in the sense of being accurate or actual, but "real" as in authentic, confirming for reviewers, and the audiences that flocked to see it, their sense of the events of the War of Independence.

The Dawn combines a believable imitation of the War of Independence with the story of the Malone family, who have been haunted by the rumor and local belief their family ancestor was an informer. The film thus foregrounds the need for communities to tell "the whole truth" and to overcome the secrets and treachery of the past so they may function fully and healthily in the present. In a prologue set in 1866, their ancestor, Brian Malone, is shown rowing on a lake with his friend Maria Cooper, while a local informer betrays the Fenians to the Royal Irish Constabulary (RIC). This informer then protects himself by spreading the rumor Brian Malone was responsible for the capture of the Fenian men. Over fifty years later, in 1919, Malone's grandson, also named Brian, is ousted from the IRA when rumors about the betrayal resurface. In defiance, he joins the RIC and loses his nationalist fiancée because of his perceived faithlessness to the cause. Having moved away, he hears by chance of a planned ambush of his old IRA flying column by the Black and Tans. Out of loyalty to his friends, Brian returns to his home to recruit his father and younger brother to help stop the Tans but meets with opposition from his other brother, Billy, who tries to prevent them from going to stop the ambush.

Billy is portrayed throughout the film as an Anglophile and a possible informant himself; his actions in preventing Brian from going to the IRA's

aid are therefore in character with his previous foppishness and antinationalism. Despite Billy's efforts, however, Brian, with his father and younger brother, sets off to try to stop the Black and Tans, not realizing the ambush is, in fact, a setup by the IRA who plan to ambush the Tans themselves. Despite Brian's interference, the counter-ambush eventually succeeds because Billy Malone is secretly a double agent for the IRA and manages to tip off Dan O'Donovan, the IRA leader, to the Malones' presence. In the nick of time, the IRA rescues the Malones and together they attack the Tans. But Billy Malone's actions lead to his death because he is shot after alerting O'Donovan to his family's danger. The film ends with a call for the fight to go on from Mr. Malone and the solemn burial of his son.

The IRA and Modernity

The Dawn foregrounds its loyalties and priorities during Dan O'Donovan's schooling of the volunteers in the rules of the IRA. He declares that "Fealty to the Republic must come first in all circumstances and at all times both night and day." In *The Dawn* the most important message that emerges is the idea of the nation as above all other ideas and "circumstances," including love. Although there is a love story between Brian Malone and Eileen O'Donovan, it is by no means the dominant plot and Cooper thus avoids the Hollywood motif of a central love story. When Brian Malone is forced to leave the IRA and joins the RIC, his fiancée, Eileen O'Donovan, completely rejects and erases him from her life. Indeed, even before their split, Eileen puts the nationalist cause first, refusing to marry Brian until Ireland is free, saying she couldn't "desert" her brother and father while they are fighting for freedom.

The IRA's adherence to a strict code of behavior is communicated in the first of the scenes depicting an IRA meeting, during which Brian Malone is voted out of the organization. Each member has a vote and the decision must be made democratically. O'Donovan stresses he does not wish to influence anyone's vote and they must decide the vote rationally "without prejudice and personal feeling." The emphasis on democracy and rationalism depicts the IRA as modern, orderly, and respectable, and this illustrates a desire for the IRA to be considered as a comparable authority to the British and not their

chaotic, dangerous "other." Modernity is central to the film as it represents the IRA as a modern force. O'Donovan's column is depicted manipulating modernity, in particular the mass media and the telephone. The successes of the IRA ambushes are conveyed by newspaper headlines pasted up onto notice boards, illustrating the IRA's control of both surprise attacks and the mass media to influence public opinion and emotion. This provokes the British authorities to supplement the forces stationed around Kerry with a company of Black and Tans, thus playing into the hands of the IRA, who then mount their biggest ambush yet. The telephone is of vital importance in the film's denouement but its most noticeable effect in the film is as a tool with which to taunt the British.

When the Black and Tans arrive in the town, they are instantly portrayed as less humane and more violent than the RIC. The Black and Tan officer in command is particularly sadistic, ordering the shooting of two young men who refuse to inform and then setting it up to appear as a failed escape. In a later scene, the officer has to terminate a phone call from the barracks because the IRA have cut the telephone lines again. He walks away from the telephone in disgust and annoyance at having lost the power of communication. By cutting the phone lines, the IRA seems to represent the antithesis of modern forms of communication. This seeming antipathy to the telephone is immediately undercut, however, when the telephone in the barracks begins ringing just as the Black and Tan officer walks away. When he answers the phone the scene cuts to a hillside shot of the IRA linking their field telephone into the main phone wires. The Tan officer demands "Is this a joke?" of the IRA man on the other end of the line, to which he replies "No, this is the first act of a tragedy we're preparing for you." By goading the Tans with what is supposedly their own tool of communication, the IRA adeptly show their control of technology. The conjunction of technology with the landscape is important because it challenges the view of the Irish as premodern and the untamed landscape as maintaining that premodernity. As Luke Gibbons writes, there was the view that "political violence and "agrarian outrages" were not a product of colonial misrule, or any social conditions, but emanated instead from the inexorable influence of landscape and climate on the Irish character" (Gibbons 1988, 211). *The Dawn* seeks to challenge the notion that the wild Irish landscape determined the character of the Irish. Rather

than being barbarians from the wilderness, the IRA's liminality enables them to inhabit the hills and bogs while simultaneously mastering the technology of the colonizer.

Indeed, through this technological mastery, *The Dawn* shows the IRA to be capable not only of self-government, but also of surpassing the British authorities in terms of ability and authority. This view of the IRA echoes the perspective of Ireland in the 1930s, a country which had moved relatively recently from being outside political power to being in power, and from representing and taking part in acts of civil disobedience to being in government and enforcing the law. *The Dawn* also reflects the early emphasis in *Guests of the Nation* on the movement of the IRA from the hillsides to the road. As Tom Barry writes in his autobiographical work, *Guerrilla Days in Ireland,* the Kilmichael Cross ambush helped the IRA be recognized "by the enemy as an army in the field, instead of [as] . . . a gang of rebel murderers" (Barry 1949, Preface). It is this desire for recognition that runs through *The Dawn*. O'Donovan's column needs to be seen as a modern, organized force, which could become capable of self-government.

Landscape

The emphasis throughout *The Dawn* on modernity and on besting the British at their own game represents a dangerous strategy. When Billy is shot, he is running across the horizon, over the hills, to convey the message to the IRA of Brian's plan. Billy is spotted by two RIC men from the road who stop and shoot at him, and it is thus Billy's visibility that proves fatal.[4] He changes from being a secret agent, constantly in disguise, to running across the horizon, fully revealing himself, and his death implies the emergence of the IRA from the safety of the landscape is a risky move. Billy's fate represents the sacrifices the IRA had to make not only to win the war but also to be perceived as modern combatants. Although the wilderness of the hills may prove a strategic location for retreat, it is only safe once you are hidden in it. As Billy

4. Although the RIC is made up of Irish men, in *The Dawn* they are quite clearly complicit with British rule, and it is this Brian realizes when he decides to leave the RIC and go to the aid of his old flying column.

runs across the horizon, he sheds both his disguise and the protection of the landscape, and is thus prey to the RIC men on the road. *The Dawn,* while signaling the modernization of the IRA, also suggests their strength, at least initially, comes from being hidden within the landscape.

It becomes clear, however, that it is not the landscape of the wilderness the Malones and the O'Donovans are interested in. Rather, both families are invested in the landscape as a sign of wealth and power. Not only are the Malones and the O'Donovans property owners, but they also display an attitude to land and landscape (which the film endorses) that portrays them as unaware of divisions other than that between colonizer and colonized. When an RIC raid is carried out at the O'Donovans' house, one IRA man pretends to be working there as a gardener, drawing attention to the immaculate lawns and flowerbeds surrounding the house. The RIC men do not challenge the idea he might be the gardener because it is unremarkable the O'Donovans would have had one. The O'Donovans' garden also plays a key role in an earlier scene, between Eileen and Brian. As they walk into her garden, he compliments her on her ornamental rockery, saying "I wish I had one like it." Eileen replies "You have no rockery," to which Brian says, "I'll build one when you decide to become Mrs. Malone." This exchange is important because Eileen then goes on to say she won't marry him until Ireland is free.

The film thus links the idea of Ireland's liberation and Eileen and Brian's marriage with the creation of a garden. The idea of the garden signifies for Brian and Eileen both marriage and the overthrow of colonialism. Rather than concentrating on the redistribution of land to the rural poor, what they prioritize is the molding of the landscape into something ornamental for their pleasure. This is reminiscent of the colonial vision of Ireland as a wild landscape to be tamed, with walls to keep out the Irish peasantry.[5] Thus, rather than wanting fundamentally to change social inequalities, the Malones and the O'Donovans resent colonialism, not for its inherent injustice, but because it excludes them from the power and social status the colonizers enjoy.

5. See Hall and Hall (1841–43) (1996) and Gibbons' (1996) account of their travels in Ireland in which they frequently admire the sublime beauty of the wild Irish landscape from the safety of the walled estate.

The image of the Irish landscape as a garden to be enjoyed is established in the prologue, set in 1866, which concerns the misidentification of the ancestral Brian Malone as an informer. The audience is aware of his innocence because Brian Malone and Maria Cooper are shown rowing around the Killarney lakes while the treachery was being committed. Malone's innocence is thus inextricably linked to his gazing at the picturesque landscape. The film elides the presumably financial reason behind the informer's actions (he is shabbily dressed) and chooses instead to side with the landowner. Like his ancestor, Brian Malone's idea of the nation emphasizes the romanticization of the landscape and connects that romantic vision to being in a position of political power. This view of landscape runs throughout the film and even the representation of the hills, which contain the violence that erupts between the IRA and the Black and Tans, is not entirely "wild." As one contemporary reviewer noted in *The Leader,* "at times it perhaps gives too pleasant a picture of the guerrilla war in Ireland. Off to the hillside we are brought with the Volunteers. They loll in beautiful wooded glades or on rocky crags overlooking a picturesque winding road" (*The Leader,* 6 June 1936, 443). The use of the word "picturesque" suggests *The Dawn*'s hillsides are far from being either a realistic or subversive landscape, but instead are framed within a more amenable and pleasant aesthetic.

The reviewer in the *Dublin Evening Mail* praised the film for the absence of the "'mists that do be on the bog' of the 'stage' Irishman." However the realism of the film does not stretch to including any kind of labor or hardship in the portrayal of landscape (*Dublin Evening Mail,* 22 Aug. 1936, 9). Instead, the beautifully rendered landscape is used as a counter to the military struggle, with one reviewer noting that even at the moment of Billy's death, the Killarney "scenery affords a most enchanting background" (*Kerry News,* 9 Sept. 1936, 1). Consequently, although the hills serve as a strategic location for retreat and assault, they are primarily viewed by the characters in the film as a place for leisure, as highlighted in Brian and Eileen's vision of independent Ireland as a landscaped garden.

Yet, this vision of landscape is not held by all of the characters in *The Dawn.* While two IRA volunteers are on duty, they overhear Molly, the woman they are both courting, denying any allegiance to either of them. Significantly, they are able to overhear her conversation because they are

hiding in a dark hollow in the hillside, an image far from the mastery of the landscape their leaders enjoy. These men belong to the class that will not materially benefit from Irish independence. Their joint romantic failure and humiliation, although a moment of light comic relief in the film, also illustrates that, for them, landscape is linked to a lack of mastery and impotence. *The Dawn* thus imitates the traditional class hierarchies and social conservatism of comedy and, by doing so, the film bolsters the already implied sense that the newly controlling nationalist families will replicate the middle class status quo of their British counterparts.[6] As already wealthy families and leaders in the IRA, the Malones and O'Donovans are more interested in consolidating their power than redistributing land. Rockett writes:

> *The Dawn,* in fact, suppresses any social tensions which might appear between the Irish themselves. The film's main nationalist catalysts, the Malones and the O'Donovans, clearly belong to a different social stratum than the rest. . . . Indeed, the men under IRA leader Dan O'Donovan's . . . command are most likely property-less workers. The film does not pursue this issue. (Rockett 1988, 64)

Both the Cumann na nGaedheal and the Fianna Fáil governments had, since 1922, abandoned the radical republicanism and the ideals of socialism that had formed their cornerstones during the War of Independence. As R. F. Foster notes: "exalted leaders first fought out a brutal duel over a form of words, and then constructed a new state around preoccupations that resolutely ignored even the vague social and economic desiderata once outlined for Pearse's Visionary Republic" (Foster 1988, 515). This view of the Irish revolution as a socially conservative one is supported by David Fitzpatrick, who argues "[r]epublicanism itself had been tamed by the men of substance almost from the start" (Fitzpatrick 1998, 220). Accordingly, although *The Dawn* may advocate freedom, it does not hold any hope of social change or emancipation from poverty.

6. Indeed, Billy's anglophilia suggests the link between the Malones, and the IRA in general, and the British.

The social agenda of the film can be seen in its emphasis on self-government and power as the goal of the war. In a scene in the Malones' house, the youngest brother asks what Sinn Féin means. In reply Brian says it means "everything . . . our own parliament, our own army . . . we just want to be left on our own to work out our own civilization and our own future in our own way." In this speech, interrupted several times by Billy's taunts, Brian establishes that it is not the land he is fighting for, but the ability to establish a parliament, to be self-reliant, and to be considered civilized. This reveals very clearly both Brian's perception of nationalism and his class position. Rather than accepting the stereotype of the Irish as premodern and outside civilization, Brian seems instead to endorse a vision of beating the British to usurp their forms of government and ideals by adopting such mores themselves.

As audiences in the 1930s were aware, the form of government adopted by the Irish Free State in the 1920s bore a strong resemblance to the previous British government hierarchies. As Billy's interjection that Sinn Féin wanted to establish their "own colonies . . . their own empire" illustrates, there is an underside to the ambition of gaining political power. The egalitarian impulses behind the democratic meetings of the IRA, therefore, need to be reexamined. In fact, when Brian Malone is voted out of the IRA, Dan O'Donovan brings the decision to a higher council within the IRA. The vote is confirmed, not because of the votes of the local IRA men, but because O'Donovan and the IRA council have other reasons for wishing Brian out of the IRA. With Brian in the IRA, it casts suspicion on Billy, their secret agent, and so, instead of respecting the democratic process, which he appears to so nobly uphold, O'Donovan uses procedure to disguise the fact he and the other leaders are the ones with real power.

The Dawn does not attempt in any way to destabilize the existing Irish social structure. Instead, it advocates the establishment of a new ruling elite in Ireland, through its envisioning of the Malones as honest, past and present, and the O'Donovans as noble and worthy. Indeed the prologue serves not only to inform the viewer of the ancestral Malone's innocence but also to establish the Malones historically as a land-owning family. This gives added weight to their claim to power in an independent Ireland. *The Dawn* thus endorses the extent to which, since the end of the civil war, the ruling British elite had been replaced by a new Catholic middle class.

The "Whole Truth"

The past haunts the Malone family. Brian Malone is ostensibly voted out of the IRA because of his familial association with an informant; as the film's first inter-title announces "[t]here is one sin which Irishmen will never forgive—Treachery to the Motherland. The stain lingers on through the generations." Despite the innocence of Brian's ancestor, the stain on his family circumscribes what he can do with his life and it devalues the Malones' status in the community. The "happy ending" of the film is not only the successful ambush of the Black and Tan trucks, but also the erasure of the stain of treachery from the Malones. When Brian Malone deserts the RIC and goes to the aid of the IRA with the help of his father and brother, the three Malone men establish their republican credentials by risking their lives for the sake of the IRA. After the ambush, the IRA retreat to their hiding place, a ruin in the hills where, when she hears of his role in the ambush, Eileen forgives Brian for joining the RIC. The couple embrace and as they pull apart again, Brian's father's head appears in the space between them. John Malone's smile represents approval of their relationship and signals the film's move from the burdens of the past to the promise of the future, while also indicating by his separation of Brian and Eileen that Ireland is not yet free.

The harmony of this scene is jeopardized, however, when the Malones learn of Billy's death. Two IRA men come into the hiding place to inform the others they have found Billy Malone dead in the hills. John Malone accuses the two men of having shot his son until Dan O'Donovan takes him aside and asks him if he wants to know "the whole truth." O'Donovan then proceeds to tell the astonished Malone men about Billy's role in the IRA, how he was the best secret agent the IRA had ever had, and how he died trying to save his family, the IRA, and the fight for independence. The Malones accept Billy's death for the greater good and John Malone declares, "I'm glad he died for Ireland." It would appear that the burden of the past was lifted and everything resolved. However, Billy Malone's death and martyrdom raise serious problems for the film's apparently civilized image of the IRA.

Billy's death illustrates not only the danger of "the whole truth" emerging from its disguise, but also the resurgence of Pearse's idealization of blood sacrifice. Superficially the film implies that it is the IRA's mastery of technology

that enables them to save the ambush. Dan O'Donovan is shown using a field telephone and then dispatching a volunteer to rescue the Malone men from sabotaging the ambush. Yet, it is Billy's physical sacrifice for his family and the sake of the ambush that the film ultimately heroizes. Indeed, *The Dawn* signals its allegiance to the idea of martyrdom early on, in a scene in the O'Donovans' house. In the kitchen, instead of the usual religious portraits, hangs a framed poster of the rebels of 1916 who were executed by the British. This picture is shattered by the Black and Tan officer when he fails to find anything incriminating in the house, but it is the very idea of sacrifice which defeats the Tan officer as Billy dies to ensure the success of the ambush.

Billy's death and, in particular, his funeral are not straightforward images. On the one hand, his death suggests that, although combining the identities and tactics of both a modern army and a guerrilla force, inextricably linked to the landscape, is a powerful position for the Irish Volunteers, there are times when these identities and tactics need to be thrown off. Billy's discarding of his disguise implies that emerging from the landscape is a dangerous action for the Irish. Billy's grave also serves as a permanent scar on the hillside, reminding those who see it of the violence the Irish landscape played host to and even inspired. John Malone's call for the struggle to continue thus reflects the dormant but ever-present threat of war over land of which the civil war was only too close a reminder. On the other hand, however, the way Billy's funeral is represented suggests the film is also trying unproblematically to bury the past. Billy can be seen as a symbol of the sacrifices the Irish nation made to win its freedom and that it can now, from the distance of the Free State, relegate to the realm of memory. The film pays lip service to a cause assumed to have ended in 1921, and this sense of the War of Independence as a distant memory is reinforced by the archaic Celtic cross marking Billy's grave.[7] In particular, this image lends a nostalgic tone to the end of the film, placing bloodshed and violence firmly in the realm of a heroic, yet also mythic, past. The nostalgia of *The Dawn* and its picturesque

7. There are also no women at the burial, illustrating the exclusion of part of the community from the ritual. Only one reviewer, Maud Gonne-MacBride, commented on the absence of women in the film: "Marion O'Connell in the part of Mrs. Malone, makes the most of a small part . . . and one would have liked to have seen more of her" (MacBride 1936, 1).

representation of landscape are tailored for a 1930s audience, enabling them to acknowledge the past in as unproblematic a way as possible and thus, to move into a peaceable future.

The Dawn's attitude toward Billy's death is symptomatic of the ambivalence of politics in the 1930s. While Fianna Fáil were distancing themselves from the IRA and, indeed, outlawed the organization in 1936, public perceptions toward the War of Independence must have been shifting also. The ambiguity of the film's ending, in particular John Malone's call for the fight to go on combined with the nostalgic atmosphere of Billy's funeral, plays to both the hard-line Republican and the revisionist Free Stater as illustrated by its rapturous reception by both *An Phoblacht,* the IRA's newspaper, and the *Irish Press,* the pro–Fianna Fáil newspaper. The majority of newspaper reviews, however, did not even pick up on, let alone support, John Malone's final call for the struggle to go on, indicating the dominant mood of a desire for peace in the Free State. As Foster points out, "Irredentism, Anglophobia and a determinedly Catholic ethos had paid great political dividends in twenty-six-county terms. The corollary was a blind eye turned to the North" (Foster 1988, 554).

Conclusion

Reflecting on *The Dawn,* Richard Kearney suggests it "interpreted political violence according to the yardstick of a dominant national ideology . . . [its purpose] was to propagate a romantic vision of Ireland which would add to the prestige of the Irish abroad" (Kearney 1988, 174). Kearney's comments are an astute recognition of the strategy of glossing over the uglier realities of the War of Independence, inherent in *The Dawn's* portrayal of the Killarney landscape as a romantic backdrop to the war, exemplified by the mythic image of the Celtic cross. At the time of *The Dawn's* release, tourist films were being made of just such landscapes. The director of one of these, interviewed by *Kerry News,* "expressed himself as delighted with Irish scenery" (*Kerry News,* 1 June 1936, 1). The same could be said for the public response to the scenery of *The Dawn.*[8] Yet, because Billy's death occurs within

8. For example, "The setting is in the lovely scenery of Killarney" (McBride 1936, 1).

the landscape, it disrupts the prior romanticization of the landscape as a rural idyll, insisting instead on its association with a past of violence and death. As Gibbons writes, "landscape, can never be reduced to mere scenery but always bears some traces of meaning" (Gibbons 1988, 208). In this instance, Billy's grave and John Malone's fighting call undermine the film's attempt to gloss over the violence of the past. Contemporary reviewers did not respond to this but willfully saw the film as an attractive and satisfying representation of "one of the most gallant episodes in our history" (*Munster Express,* 28 Aug. 1936, 8). The attitude regarding the signs of Ireland's colonial and violent past thus tended toward denial of the realities of violence so that the country might move on to a space where everyday life, including the romance between Billy and Eileen, is possible. Yet, the civil war is a phantom presence throughout the film, one not vanquished by Cooper's attempts at an easy resolution and at closure upon a period of such violent unrest.

2

The *Amharc Éireann* Early Documentary Film Series

Milled Peat, Music, and *Mná Spéire*

B. MAIRÉAD PRATSCHKE

THE YEAR: 1956.

THE LOCATION: An Grianán, County Louth.

THE OCCASION: a summer course offered for rural women by the Irish Countrywomen's Association.

THE SCENE: a group of women of various ages gather around a cow in the courtyard of a large old house.

THE PURPOSE: the crew of Gael-Linn's new Irish-language *Amharc Éireann* film series is making an issue on the Irish Countrywomen, which will be seen by cinema audiences all over the country.

The late 1950s marked the beginning in popular consciousness of Ireland's internal and external transformation from an economically underdeveloped and politically isolated nation on Europe's western fringe, into a modern member of the international community. The so-called "Lemass years" of 1959–66 began the dramatic political and economic changes that culminated in Ireland's membership in the European Economic Community in 1973. Gael-Linn's Irish-language documentary and newsreel series, *Amharc Éireann,* normally translated as "Look at Ireland," was produced from 1956 to 1964 by Colm Ó Laoghaire and provides a unique visual record of the prelude to and beginnings of this crucial period in contemporary Irish history. The series, which began in July 1956 as monthly, single-item, short documentary films, was transformed in 1959 into a weekly newsreel and became a

staple of the Irish cinema-going experience until July 1964 (Mac Górain n.d., 67–70). This valuable archival material was used by Louis Marcus in 1996 to produce the historical documentary series *The Years of Change* and continues to be the most heavily used of all film material by contemporary Irish documentary makers. The series is important, however, for more than the visual record and commentary it provides on the changes taking place during this period. As the first and longest running Irish-language documentary and news film series, *Amharc Éireann* was more than simply Irish news. The series represented an attempt on the part of a few committed Irish-language enthusiasts to succeed in doing what the government failed to do, namely to present Ireland to the Irish in a way that would instill a sense of pride in the country and to promote the language in a way the public would accept.

Until the mid-1950s, the Irish cinema-going public was exposed overwhelmingly to foreign productions. Even films about Ireland or those filmed in the country were produced by foreign companies, usually British or American. The newsreels that preceded the main features were those distributed by the British J. Arthur Rank Organization, which enjoyed a monopoly in Irish cinemas. There had never been an Irish-language documentary or newsfilm series of any kind made or shown in Irish cinemas. The only native Irish newsreel series was a pre-independence venture entitled *Irish Events,* which ran from 1917 to 1919 but stopped production in 1920 because of the escalating violence in Dublin, as well as the objections voiced by the British authorities after the screening of some nationalist-themed films (Rockett, Hill, and Gibbons 1987, 33–38). During "the Emergency," the jingoistic tone of wartime British newsreels was particularly ill suited to an Irish audience, and throughout the 1940s, the opinion was increasingly voiced that the country needed an Irish alternative to such foreign imports.

Gael-Linn began in 1953 as a fund-raising project initiated by a handful of people whose intention was to shame the government into paying more attention to the fate of the Irish language.[1] In March 1953, Dónall Ó Móráin recommended an organization be formed under the patronage of Comhdháil Náisiúnta na Gaeilge (CNG), the Gaelic National Congress, an umbrella

1. See "History of Gael-Linn" on Gael-Linn Web site: www.gael-linn.ie for the general history of the organization.

body for all Irish language organizations, to raise the funds for Irish film production. The name Gael-Linn is a play on words, meaning both "Irish-pool," an allusion to the football pools, or private members lottery, created to raise the funds, and "Our Irish," a reference to Gael-Linn's general mandate, the promotion of Irish language and culture. Ernest Blythe, then chairman of the CNG, lent Gael-Linn one hundred pounds, and in 1956 Ó Móráin contacted Colm Ó Laoghaire to discuss the prospects for a series of monthly, short Irish-language documentary films. Ó Móráin knew Ó Laoghaire from university as a long-time member of the Irish Film Society and, as a nephew of the 1916 Rising's Joseph Mary Plunkett, a member of a well-known literary and nationalist family interested in the Irish-language cause (Pratschke 2005). Gael-Linn also approached the Rank Organization's Irish distribution manager, Bobby McKew, who agreed to distribute the films, and so the *Amharc Éireann* series was launched (Mac Góráin n.d., 69).

The *Amharc Éireann* series is split into two phases: for the first three years, from 1956 to 1959, monthly, single-item, short documentary films were made on a variety of Irish topics under the title "Eyes of Ireland." The series' purpose was twofold: first, to replace the representation of foreign, particularly British, documentary and news items with those of domestic interest, and second, to do so through the medium of Irish. In both of these senses, the series was a major breakthrough. These monthly issues were attached to the end of the *Universal Newsreel,* which was screened in all cinemas owned by Rank. In all, thirty-eight issues of the magazine series were shot, although two of these were never released. By 1959, however, television's impact on the British cinema industry was such that Rank decided to withdraw the British newsreels from all its cinemas. Because television had not yet come to Ireland, this left a gap in the viewing program and presented a significant opportunity to Gael-Linn. The series was then transformed into a weekly newsreel entitled *Gaelic News,* which lasted until 1964, when its function as a source of national information was replaced by television. This essay focuses on the first, short documentary phase of the *Amharc Éireann* series, the "Eyes of Ireland" collection, produced from 1956 to 1959.[2]

2. Although the series as a whole is entitled and normally referred to as *Amharc Éireann,* the original short documentary scripts were entitled "Eyes of Ireland" and the newsreels

The short "vest-pocket documentaries," as Ó Laoghaire described them (Ó Laoghaire 1957, 9–11), were quite distinct in both content and style from the newsreel series that followed. The three to four minute films were explanatory in nature, didactic in tone, and intended to introduce Ireland and various aspects of its culture to its own population hitherto divided by geography or ignorance. They unwittingly convey the sense of lingering insecurity of the mid-1950s, and aim to inspire confidence in Ireland's capacity to produce valuable goods, to promote its own development, to compete internationally, to sustain its population, and to reassure the Irish of their collective self-worth at a time when depression had taken its toll on the national psyche. That this message was being communicated three years before the implementation of Lemass's First Economic Programme is significant in that Ó Laoghaire and Gael-Linn were spreading a new message to a population not yet particularly optimistic about Ireland's future economic growth. The idea was, quite simply, to put Irish on the screen, to present hearing it in the cinema as a normal occurrence (Ó Laoghaire 1957, 9–11), which, with the domination of American and British feature films and newsreels, was clearly not the case. Although the series did not purport to teach Irish in the off-putting sense the state's compulsory educational system did, its mere existence was presumably expected to spark sufficient interest in and attention to the language at a time when the population did not hold Irish in very high esteem. By presenting a positive view of Ireland, the long-held association of the language with rural backwardness and poverty would be effectively undermined, while the validity of the Irish language as a means of communication outside the Gaeltacht areas would be reinforced by its association with a popular form of modern media.

In 1956, Irish was associated in the public mind with compulsory schooling rather than popular entertainment. Ó Laoghaire began with short documentary films rather than with newsreels to "ensure their success with the public by giving them a technical polish" (Ó Laoghaire 1957, 9–11). The assumption was quite reasonably made that the Irish cinema audience,

were *Gaelic News*. The "Eyes of Ireland" collection here refers to the thirty-six short documentary films made from 1956 to 1959.

accustomed as it was to British newsreels and Hollywood-produced feature films, was discerning enough to demand a certain level of professionalism if its imagination was to be captured. Ó Laoghaire was keenly aware of the need "to counteract audience prejudice against films in Irish" (Ó Laoghaire 1957, 9–11) by providing subject matter beyond the realm of the expected in terms of Irish-language material. It was vital the topics be of sufficient interest to avoid them being perceived as boring, and Ó Laoghaire had a clear idea of the type of documentaries he wanted to avoid to hold the audience's attention. He was interested in the development of an identifiably Irish documentary style, and was at pains to dissociate the content and style of his films from John Grierson and his followers. Ó Laoghaire rejected the influence of the British documentary movement as a model for both ideological and stylistic reasons. The British documentary was perceived as stylistically "very logical, statistical and often, rather boring" and thus wholly unsuited to the Irish people, who "express ourselves, as a nation, more emotionally and impulsively than the English" (Ó Laoghaire 1957, 9–11). Ó Laoghaire thus accepted and used the stereotype of the Irish national character as emotional and impulsive, as opposed to the more rational and predictable English, to justify the need for a distinctly national documentary style. By reappropriating the essentially colonial characterization of the Irish for this purpose, Ó Laoghaire presented the supposed difference between the Irish and the English character as a positive attribute, wherein the English documentary style is "boring" in comparison to the more lively and "impulsive" Irish.

Ó Laoghaire's real objection to the ideology of British documentary producers was not simply their tendency toward logic and statistical inquiry, which was merely indicative of a more serious ideological difference. Ó Laoghaire took exception to their "Liberal and Humanist outlook" and, more specifically, the philosophical basis from which such a dispassionate view of documentary developed, arguing "[a]ny code of ethics or morals implicit in British documentaries, however scrupulous and sincere its application, generally stems from the belief in man as the supreme rational being. A curious standpoint for a professedly Christian nation, but there it is" (Ó Laoghaire 1957, 9–11). This was the crucial difference for Ó Laoghaire between the Irish and British approach to documentary. The Irish moral-philosophical basis for documentary making was fundamentally different, based as Ó Laoghaire

saw it on Catholic Christianity. Distinguishing the two positions, he noted, "[o]n this evidence, it is valid to contend that British documentary, considered as a movement, tends to propagate the humanist viewpoint; a viewpoint which is not ours, and with which we have a fundamental difference" (Ó Laoghaire 1957, 9–11). Ó Laoghaire hoped that the Irish documentary style would emulate the continental rather than the British style. As a fan of continental, particularly German, cinema (Pratschke 2005), he was much more impressed by the potential for fertilization from that direction rather than from across the Irish Sea.

The "Eyes of Ireland" collection comprises thirty-six short magazine-style documentary films made between 1956 and 1959.[3] Ó Laoghaire produced, directed, researched, scripted and edited the entire single-item magazine series, with the exception of two, which were produced by George Morrison.[4] Vincent Corcoran photographed thirty-three of the thirty-six issues;[5] the commentary was read by Padraig Ó Raghaillaigh, who was occasionally replaced by Breandán Ó hEithir or sometimes by Donnacha Ó Miochán. The music for the series was composed by Gerald Victory and differed according to each film's subject matter. Sometimes stock music was reused for various films, while others had special pieces specially composed for them. Each film opens with the *Amharc Éireann* theme music, a folksy and lighthearted mixture, yet martial and triumphant in tone. The title of the series is emblazoned on the screen in large, block white, capital letters, with the subtitle "arna lerú ag Gael-Linn/produced by Gael-Linn." The issue title follows against a background silhouette of a cameraman holding his camera, cleverly constructed to look like a shamrock. Each issue ends with another silhouette,

3. Information about *Amharc Éireann* magazine and newsreel series taken from discussion with Colm Ó Laoighaire, Sept. 28, 1993. Thirty-eight short documentary films were made in all, but two were not released because they were deemed out-of-date or too stage Irish.

4. Réadlann Ráth Fearnáin (Rathfarnum Observatory) and Gáirdíní na Lus (Botanic Gardens), 1958. Morrison is best known for the two historical compilation films he made for Gael-Linn, *Mise Éire* (I Am Ireland) (1959) and *Saoirse?* (Freedom?) (1961).

5. George Morrison's cameraman, Robin Bestick-Williams, shot three issues: *Caiseal na Rí* (Rock of Cashel), *Madraí ar Saoire* (Dogs on Holiday) and *Snámh Sábhálta* (Safety Swimming).

this one a map of Ireland, with the word "críoch/end" superimposed on it. These images instantly communicate the overriding purpose of the films: the presentation of Ireland to the national cinema-going public. The presentation style is obviously modeled on the British newsreels, which traditionally preceded the main features in Irish cinemas, but in this case, the large bold lettering announces the command to the audience: "Amharc Éireann/Look at Ireland."

A number of the films in the "Eyes of Ireland" short documentary collection deal with aspects of the country's industrial development. In 1956, Ireland was still feeling the effects of the balance of payments crisis of 1955, the second one that decade, and by 1958, the economic situation became so dire the government was finally forced to act (Girvin 1989, 196–201). Seen in this context, these films are surprisingly optimistic regarding the state of, and prospects for, Ireland's industrial development. The second interparty government had taken a number of measures such as the Finance Act of 1956, which bolstered the prospects for economic development, and it was the promise and results of measures like these Ó Laoghaire wanted to publicize. Focusing specifically on Irish indigenous industries utilizing domestic resources, the films provide a visual antidote to the pessimism and depression resulting from the perception of national impotence in the face of record-breaking emigration and high unemployment. Sea fishing, copper mining, turf cutting, and glass making were all Irish indigenous industries, but until the 1950s, none of these activities in their traditional forms were sufficient to make a significant contribution to Irish economy. As small-scale, seasonal, or short-term enterprises, their significance on a national scale was limited to the symbolic.

In the "Eyes of Ireland" films, the public saw for the first time how these industries could, with the necessary development, contribute in a significant sense to the national economy. The beginnings of the rebirth of Irish mining are seen in *Mining in Avoca*[6] on the work of the miners employed at a reopened nineteenth-century copper mine in Avoca, County Wicklow. A major feature in the film is the Canadian dump truck, which is used to carry rocks out of the mine. It is obviously the Canadian financial input that has

6. *Mianaigh Thrá Dhá Abhainn (Mining in Avoca)* #3: August 1956.

facilitated this operation, without which the work would not be possible. Canadian investment is the catalyst for Irish national development. Rich natural resources are combined with international finances and equipment, which allows for the continued exploitation of a resource previously assumed to be exhausted. The role of the Irish state is not mentioned in the film, although it was the Finance Act of 1956, which included tax concessions for new mining enterprises that brought the Canadian company, St. Patrick's Copper Mines Ltd., a subsidiary of the Canadian Mogul organization, to the area from 1958 until 1964 (Kearns 1976, 253). The 1956 Finance Act built upon the 1940 Minerals Development Act, which first facilitated increased mining activity by foreign companies. The first exploration at Avoca recorded in this film was thus both a product of measures built on since the 1940s, and a foreshadowing of the good things to come in the shape of the Irish mining boom in the 1960s.

A similar message emerges from *Winning of the Peat*,[7] a film on Bord na Móna's milled peat-making operation in Lullymore. In this film, as in *Mining in Avoca*, it is thanks to foreign technology and machinery the Irish are able to make the most of their indigenous resources. Essentially, the film is a display of machinery's power to transform an underutilized part of the Irish landscape into a usable source of energy for the whole country. Shot after shot shows machines going back and forth over the bog, raking and cutting the turf to make the milled peat that will find its way to the Electricity Supply Board's power-generating station. Again the technology is imported, this time from Germany or the Soviet Union (Kearns 1978, 182).[8] Although the general history of large-scale peat production can be traced to pre-Emergency years, as in the case of mining, the specific mechanical innovation displayed in this film was very recent. Bord na Móna's 1950 Second Peat Development Program represented a major shift in policy, directed toward the Soviet style of milled peat operation rather than the traditional sod peat (Kearns 1978, 183). The Soviet inspiration for the milled peat operation is detectable in the similarity between the images of the machines raking the bog and images of the rapid industrial development that took place in the

7. *Bua na Móna (Winning of the Peat)* #13: June 1957.
8. Turf cutters were ordered from Germany in 1936 (Kearns 1978, 182).

USSR during the period of Stalin's five-year-plans. Of course, Ireland was about to embark on its own period of accelerated transition from underdeveloped rurality to modern industrialism; the Communist-style homage to godless machinery is striking, however, coming as it did from the avowedly Christian Ó Laoghaire (Ó Laoghaire 1957, 9–11) and produced for a notoriously red-phobic nation.

In stark contrast to the scenes of machines working the land is *Shannon Airport*,[9] a film on Ireland's most famous example of capitalist enterprise and innovation during this period. Built in what was once a quiet rural area in County Clare, the airport is presented as an example of successful Irish innovation, which put the country on the map in the area of international travel. The airport is a showroom for Irish goods, where the international visitors are a captive audience. Entering the duty-free shop, we learn not only is Shannon the major stopover point for international flights, it is also an innovator in the industry as the first duty-free airport in the world. The surrounding location, far from being the rural backwater it once was, is now a successful hub of international travel and a path-breaker in the industry worldwide. The building of Shannon airport in County Clare was a product of the history of British-Irish relations and the development of the international aviation industry. The British needed a stopover point in Ireland for transatlantic flights, and the Americans later agreed to the "Shannon stopover" requiring all U.S. flights to land in Shannon (O'Grady 1996, 36–39). When jet aircraft technology removed the need for the stopover in the early 1950s, the Irish government designated the airport a duty-free zone, and in 1957 prepared Aer Lingus to open a transatlantic route of its own in 1958. Although the stopover clause was officially dropped, Shannon remained Ireland's international airport because American planes were forbidden from landing in Dublin (O'Grady 1996, 42–44). The Shannon Free Zone Development Corporation, established in the large area surrounding the airport, and designated and promoted as a duty-free industrial estate, was created to save the airport and to ensure its continued future (O'Grady 1996, 46). Shannon became a symbol of Ireland's success in the early 1960s, representing all that could be accomplished in the country.

9. *Aerphort na Sionainne (Shannon Airport)* #2: July 1956.

Praise for innovation in the "Eyes of Ireland" collection was not limited to large-scale industrial ventures. *Waterford Glass*[10] celebrates traditional craftsmanship, tracing the steps involved in making this distinctly Irish product. Once again, the master craftsmen are not Irish; the men featured blowing glass were recruited from Bohemia when the original company was revived in 1947. This was designed to establish a German-style *meister* system of master craftsmen, and an apprenticeship system. The majority of the employees are Irish, however, as the shots of them using Waterford crystal to drink their tea attest, and the commentator proudly declares the success of the resurrected company stands as proof that Ireland still has the best craftspeople in the world. *Funeral of the Barrel?*[11] presents the other side of the coin in an example of a traditional craft-based industry doomed to extinction because of the introduction of modern technology in the form of metal barrels. The film illustrates the skills employed by the coopers and displays the traditional tools still used to repair the used wooden porter barrels. It is a lament for the old-fashioned craftsmanship that was dying out in Ireland and everywhere, thanks to the introduction of new materials and methods, and represents Ó Laoghaire's attempt to raise awareness of some of the losses that accompanied the gains more frequently advertised as a result of modernization and development. In each of these films, attention is drawn to the new and innovative ways of conducting traditional Irish industries, indicating their enormous prospects for the country's future economic success. Much of this work began in the 1930s and 1940s, and was built upon in the 1950s. Thus, the independent state that appeared to be utterly failing its population in the mid- to late 1950s was partially redeemed, and could actually be applauded for some of its more innovative measures. Its openness to international influence is also noteworthy because this is commonly assumed to be a characteristic that Ireland only acquired from 1959 onward, once given the nod from the more internationally minded Lemass.

Some of the "Eyes of Ireland" films suggest certain aspects of Irish national culture were more favored candidates for protection and promotion than others. Heritage tourism is presented as another means of regenerating

10. *Gloine Phortláirge (Waterford Glass)* #20: January 1958.
11. *Tórramh an Bhairille? (Funeral of the Barrel?)* #38: April 1959.

the local and national economy, in which the Irish landscape, through specific historical sites, geographical features, and cultural events, is the locus of national identity and the repository of national culture. *Holiday on the Shannon*[12] follows the new river boat tour along the River Shannon from Athlone to Killaloe, past a number of islands and monasteries of national historical interest, including Clonmacnoise, the famous monastery founded by St. Ciarán. The film combines some of the highlights of Irish monastic history with modern tourism—in effect a large dose of recreation and scenery with a little bit of history thrown in for good measure. The focus of the film is not the national historic significance of the monasteries; rather it notes their presence to supplement the authenticity of the journey and to create a more satisfactory touristic experience. It also focuses on the mode of transportation itself and the experience of being on the River Shannon. The journey is in this sense a reenactment of the historic route taken by the Vikings through the country, a means of reliving history in the present. In January 1954, the Inland Waterways Association of Ireland (IWAI) was formed to protect the Shannon Navigation, and the two boats featured in the film, the St. Ciarán and the St. Breandán, played an important part in keeping the Shannon open to navigation at a time when it was threatened by short-sighted policy makers. Coras Iompar Éireann bought the St. Ciarán and the St. Breandán, and ran day tours from Dublin starting in June 1955, giving many people their first trip on the river (Goggin 2002, 3). As a result of this venture, the water highway of the Shannon stood out once more as it did before the days of modern roads and railways, and the river itself was opened up for boating business. Therefore, the film is a demonstration of Irish heritage tourism in its early stages of development, and it reflects Ó Laoghaire's keen awareness of the topical aspects of Irish national heritage and culture in need of protection.

In a similar vein, *Visit to Killarney*[13] follows the tour taken by a group of American tourists to an area long popular with visitors for its rugged beauty. The tour functions as a moving postcard of Killarney, highlighting the scenery and the location's evocation of the national past. The stress in this film is on the lyrical beauty of the area, dramatized through allusions

12. *Saoire ar Sionainn (Holiday on the Shannon)* #16: September 1957.
13. *Cuairt ar Chill Áirne (Visit to Killarney)* #33: February 1959.

to well-known poems and operas that decorate the commentary. All of the stock pictures of Killarney are used including, horses and jaunting carts, views of the Gap of Dunloe, Lough Leane, and the surrounding mountains. The tourists' itinerary is also a set piece involving tours on horseback up the Gap, beginning at Kate Kearney's cottage, the eternal starting point, perched at the entrance way. The visitors are passive receptors of these images of rural Ireland, set to music and choreographed from start to finish, and including all of the appropriate sights. And yet, they *seem* active participants in the reality of the experience. Like the film on the Shannon, the modes of transportation used in the tour are important because they serve to authenticate the tourist experience by enabling them to be, for a short time, real Irish people from the past, traveling through the area in the customary fashion. Killarney is seen on foot, on horseback, and from a rowing boat, rather than a giant tour bus, and it is by reliving the experience of the ordinary people who traveled on horseback through the Gap of Dunloe and rowed their boats across Lough Leane that the tourists' experience is made authentic. Ireland's colonial history is represented in the shape of Ross Castle, famous as the last stronghold to fall to Cromwell's forces. No mention is made of these events; the castle merely adds interest to the locale by calling attention to the rich and turbulent history of the area (Gibbons 1996, 23–44) in the same way shots of Clonmacnoise refer to Ireland's earlier history of invasion by the Vikings and others. The tourists thus sample a piece of "timeless" Ireland and enjoy all of the loveliness of Killarney without engaging with any of the hardship or struggle that actually gave the locations their current tourist value, an elision that is, of course, is a key component of heritage tourism.

Music Festival,[14] in contrast, is a fly-on-the-wall glimpse into living Irish culture. The film is of a Fleadh Cheoil, one of the popular national music festivals convened by the Comhaltas Ceoltóirí Éireann, the Association of Irish Musicians, all over the country. The Comhaltas was formed in 1951 to promote Irish traditional music, and within five years, had grown into a national festival attended by thousands of traditional musicians and dancers from all over Ireland and overseas.[15] This festival is the live, communal

14. *Fleadh Cheoil (Music Festival)* #14: July 1957.
15. Comhaltas Ceoltóirí Éireann Web site: www.comhaltas.com.

experience of Irish traditional music, in which the whole community participated and others from all over the country attended. The atmosphere is lively and informal. Normal social mores and barriers are ignored; nuns are seen doing Irish dancing, and there are uilleann pipers playing in the courthouse. If Ó Laoghaire set out to prove Irish traditional music was not dead, he certainly succeeded here. The entire film is crammed with crowds, young and old people dancing, clapping, marching, listening, playing, drinking, smiling, and enjoying the festival. The film is highly entertaining and depicts Irish culture as vibrant and energetic, leaving its own sort of monument to the musical tradition.

In *Souvenirs,*[16] tradition, tourism, and trade form an uneasy alliance in a cottage-industry approach to the production of souvenirs from Ireland. In keeping with its title, it serves as a visual postscript to the theme of heritage tourism, warning viewers of the potential dangers inherent in this path of development, while simultaneously proclaiming the authenticity that redeems the souvenir industry from attack. The film features various types of "traditional" souvenirs made from natural fibres, including Killarney landscapes made from pieces of tweed and wooden figurines of Irish monks. These souvenirs are made by Irish women in their homes to replace the mass-produced thatched cottages and leprechaun figurines made overseas. The use of natural fibres, Irish cloth, tweed, clay, and wood, and of familiar Irish designs, historical figures, and scenery, all tie the souvenirs to the land from which they came and the people who made them.

The tension is apparent here between the demands of modernization and the opening up of Ireland and its resources on the one hand, and the attempt to remain true to the "real" Ireland and its traditions on the other. That tension is resolved by the use of Irish materials rather than mass-produced plastic to sell its symbolic representations. Ironically, it is the supposed authenticity of the product that makes it marketable to tourists desperate to reclaim a piece of "old Ireland." The use of landscape and heritage to encourage tourism is presented in each of these films, where visitors and viewers are presented with a certain image or experience of Irish culture and history. The turbulent history of the country is turned around and transformed into a source of

16. *Féiríní Cuimhne (Irish Souvenirs)* #29: October 1958.

wealth in the modern world, where, the more dramatic the story, the more tourists are drawn. On the other hand, *Music Festival* is a refreshingly frank and contemporary look at an aspect of traditional Irish culture that has not been forced to sell itself to survive, although it will suffer from its own form of growing pains in the years to come.[17]

The tendency for Irish women to be rendered invisible as a result of church and state policy was such that their appearance in their own right in a number of "Eyes of Ireland" films is noteworthy. The nature of that depiction, however, is another matter. This group of films features the training of Aer Lingus air hostesses, modeling courses in Dublin, the Irish Countrywomen's Association's (ICA) summer courses, and a hospitality training course attended by a Gaeltacht woman. Each of the films presents a very different sort of work opportunity for women and corresponds to the type of woman that is portrayed as taking them. Aer Lingus air hostesses and the Dublin soon-to-be models constitute a new class of urban glamour girls who stand in stark contrast to the wholesome rural women who attend the ICA's summer course and the hospitality industry's training courses attended by Gaeltacht women. *Women of the Skies*[18] concerns the training course for the new Aer Lingus flight attendants. The women were minor celebrities in Ireland in the 1950s, considered very elegant and cosmopolitan by their peers. Ó Laoghaire was apparently not as easily impressed. The title of the film in Irish, *Mná Spéire,* is a double entendre literally translated as "women of the skies," normally used to refer to the women who represented Ireland in national mythology. By using this phrase to refer to the group of flight attendant trainees, these women were being presented somewhat tongue in cheek as the stuff of modern urban legends, chosen to embody Ireland in flesh and blood in the international skies. The "girls" are praised for their good looks and elegance in their Aer Lingus uniforms, as if they were models rather than workers wearing the compulsory company attire. The film follows the women through the various stages of their training course, which consists of demanding tasks including holding a tea tray single-handedly

17. The *Amharc Éireann* newsreels (1959–64) allude to the tensions between the players of "trad" versus "traditional" Irish music in the early 1960s.

18. *Mná Spéire (Women of the Skies)* #12: May 1957.

while the plane is in midflight. As they take their final test, the commentator finally makes it explicit what the women's role is perceived to entail: "There is no question on how to pick up a rich passenger!" His statement indicates the belief that this is their real agenda. Their employment merely constitutes a cover for the true goal of women: the luring of a rich man.

It is worthwhile to compare briefly this film with the other made about Aer Lingus's pilot training programme, *Call of the Skies*.[19] The difference in approach between *Call of the Skies* and *Women of the Skies* is clear. There is no discussion at all of the men's appearance or the angle at which they must wear their hats. Although the women are on show, the men sit at their desks working with instruments and are taken seriously as pupils. The idea of a woman working for the money or even for its own sake is never addressed. While the film superficially applauds the new air hostesses and wishes them well in their new career, the tone borders on sarcastic, indicating slight disapproval of all that their new career signifies about Ireland and the path it is taking.

Women of the Skies attempts to dissipate the tension inherent in discussing this potentially problematic employment opportunity for women in Ireland by using humour and by refusing to take the job seriously. The easiest way to deal with the conflict presented by the idea of this new class of young, independent, and attractive women was simply to ignore its social implications. Yet on the other hand, the simple fact of the film's existence in the collection is indicative of the increased representation of women as workers in their own right in the late 1950s. Tracing the employment of another constituency of urban women, *Mannequin Training*[20] relates the details of a modeling training course. Although the models and the flight attendants follow much the same training—learning to dress properly, walk elegantly, and present themselves well to their audience—there is no mockery of the modeling course or the "technical" training these women undergo. The comment on their appearance is also more appropriate to this context: "[w]hen the result is a pretty girl like this, you know the work has been worth while!" Modeling appears to be much more acceptable work for women, in which the peddling of their wares simply fits the job description. It also fits within the

19. *Glaoch na Spéire (Call of the Skies)* #11: April 1957.
20. *Oiliúint Bainicín (Mannequin Training)* #7: December 1956.

traditional boundaries of women's work and identity in Ireland in the late 1950s. Although unusual and glamorous work, it posed no threat to men to cast women in a traditional role as pretty clotheshorses. The flight attendants, although also glamorous and applauded for their appearance, wore uniforms meant to impart an air of authority, however superficial; and this presumption of authority left them open to criticism.

Leaving Dublin, *Country Women*[21] narrates the Irish Countrywomen's Association's (ICA) organization of summer courses for rural women. The ICA was founded in 1910 as the United Irishwomen to improve the lives of rural women, and was closely affiliated with the Irish co-operative movement initiated by Horace Plunkett, another famous Plunkett and relative of Ó Laoghaire's. Likewise, the ICA was aligned with other rural organizations such as Muintir na Tíre, the Rural Community, in the campaign for rural electrification in the 1950s (Shiel 1984). The ICA has been accused of being antifeminist, but its official biographer maintains that, in fact, the ICA was quietly revolutionary in the slow but steady progress it made in the most important, if mundane, aspects of daily life for rural women, reflected in its anti-ideological motto, "deeds not words" (Heverin 2000, 188–95).

The representation of these rural women is diametrically opposed to that of the two previous films on urban girls. The ICA women are practical and hard working; they take their jobs as rural housewives seriously, and are attending the ICA's summer course to improve their skills in this area. The topics covered in the courses offer an insight into the extent of responsibilities and the daily routine of rural women in Ireland in the late 1950s, including cooking, basket-weaving, milking, cheese-making, and of course, the art of picking out a good cow! The ICA courses, however, offer more than mere instruction; they are also a reason for rural women to gather together in a community, to share experiences and knowledge, and simply to enjoy a week's break from the monotony and isolation of rural existence. This contact and activity with other like-minded women could do as much or more for a demoralized population as any government program. It is this quiet growth in the women's confidence because of education and communal solidarity that comes across in this film. In fact, the progress the ICA made

21. *Bantracht na Tuaithe (Country Women)* #4: September 1956.

in the decades before it was officially recognized by the government laid the foundations for much of the modernizing work in the Irish countryside. As such, the ICA was indeed a harbinger of progress in small and unthreatening steps to the dark and backward homesteads that, though romanticized by de Valera in his famous "dream" broadcast of St. Patrick's Day 1943, have been more aptly described by J. J. Lee as one of the main reasons for female emigration from the country (Lee 1989, 333).

An option for rural women seeking work beyond the farm is recorded in *Hotel Courses*,[22] which follows a Gaeltacht woman as she attends a course with English-speaking students on the basics of domestic work in a hotel. At the end, she is pictured entering a hotel entrance with an English name, where the commentator assures us that thanks to her training, there is a job waiting for her. The fact she can obtain a job so quickly after finishing the course is an indication of the growth in the tourism and hospitality sector in some parts of Ireland; unfortunately, the economic advantages of that growth were not shared by all. The opening shot of the beautiful but empty Donegal landscape speaks volumes about the lack of opportunities for advancement in the Gaeltacht. Modern society appears to exist only beyond these areas, which are deemed useful only insofar as they attract tourists. The message is the only way to get a good job for which one requires formal training is to leave the Gaeltacht and join the ranks of English-speaking members of the growing service sector.

Women's work in Ireland in the mid- to late 1950s usually meant unpaid work in the home or on the farm. Single women could work, but once married, they were expected to retire and those who did not were actively discriminated against in state policy (Beale 1986, 7–9). These "Eyes of Ireland" films present a view of some of the urban, rural, and Gaeltacht women's work opportunities, which in turn serves as commentary on the values Ireland was embracing or discarding during this period. Ó Laoghaire never overtly casts judgement on whether it is the urban or the rural "girls," as women are unfailingly described in the commentary, that constitute the "real" Irish but it is quite plain where his sympathies lie. The urban-based models and air hostesses are depicted as glamour girls on the surface but lacking the qualities

22. *Cúrsaí Óstán (Hotel Courses)* #9: February 1957.

the rural women possess. Although admired, they are denied the respect that comes with "real" work such as that undertaken by members of the ICA, and it is implied their values are somehow less than those promoted by the state and church. Although the films do not display the sort of naïveté de Valera displayed when he referred to Ireland as the land of comely maidens (Lee 1989, 334), Ó Laoghaire is clearly sceptical of the new breed of woman appearing in urban centers, and particularly Dublin, in the late 1950s. The ICA's rural women, on the other hand, are the embodiment of Horace Plunkett's ideal of hardworking equals in a cooperative rural Irish society, while the Gaeltacht women are the other side of the rural coin, forced to leave the land that sustains the language to find work.

Once television replaced newsreels in Britain, the Rank Organization withdrew its news films from Irish cinemas, bringing the "Eyes of Ireland" short documentary phase of the *Amharc Éireann* series to a close. The next phase coincided with the reign of Seán Lemass as Taoiseach between 1959 and 1966, and the period of rapid modernization Ireland underwent in preparation for its entry into the European Economic Community in 1973. The *Gaelic News* films created from 1959 to 1964 tell some of that story using a format that, although outdated elsewhere in Western Europe and North America, was oddly appropriate for Ireland as a relatively late starter in the European wave of postwar development. Before then, however, the beginnings of those changes were detected, recorded, and reflected upon by Colm Ó Laoghaire in the "Eyes of Ireland" early documentary phase of the *Amharc Éireann* series. By using both the Irish language and a form of modern media associated with popular entertainment to draw attention to the wealth of natural and human resources available for exploitation, Ó Laoghaire and Gael-Linn attempted to eliminate the link between the Irish language and rural poverty in the public consciousness. The collection recorded the prelude to Ireland's dramatic period of development and was visionary in its attempt to revive the Irish language by presenting a positive vision of Ireland and its native language to the Irish population before the Lemass years of prosperity.

3

Cold, Hungry, and Scared
Prison Films about the "Troubles"

CAHAL McLAUGHLIN

Sites of Conflict

Prison has always played a central role in the political conflict between Ireland and Britain. This site of punishment and resistance has been both a mirror of, and an influence on, political developments outside. The use of prisons by the British Government, and later by the Irish Free State, to contain opposition to their rule met with mixed success. Although individuals were captured and incarcerated, their influence was never successfully undermined. Imprisonment became a battleground with rich propaganda potential for all sides, although frequently the measure became counterproductive for the state. The most recent example of this form of imprisonment and its conflicts occurred during the low intensity war, often referred to as the "Troubles," from 1968 until the 1994 cease-fires, with the main armed protagonists being the British, Republican, and Loyalist military groups. Internment was introduced in 1971, with inmates housed in Nissan huts in prisoner-of-war conditions on the site of a Royal Air Force airfield called Long Kesh. Secretary of State William Whitelaw granted political status in 1972 in response to a hunger strike. This acknowledgment by the state that there was a distinction between political prisoners and what are known as "ordinary decent criminals" (ODC) was a propaganda victory for the insurgents. The government was soon to regret this decision, and attempted to effect its reversal.

Political status not only allowed the prisoners to portray themselves as prisoners of war, but also to organize along military lines, with chains

of command, military parades, and political education. Escape attempts became frequent, with 57 separate successes between 1972 and 1976. When the internment camp was badly damaged in a fire set by republican inmates in 1974, the ensuing Gardiner Report recommended the camp's replacement with a cellular structure as soon as possible. The intention was to restore state control by separating, individualizing, and imposing a work and discipline regime on all prisoners, whatever their convictions. The Maze Prison was built on a site adjacent to Long Kesh, and in 1976 it began receiving prisoners convicted of "scheduled" offences. The first republican prisoners refused to accept the new regime, by refusing to wear prison uniforms and refusing to do prison work. It became infamous as one of Europe's largest and most volatile prisons, housing hundreds of political prisoners. The Maze was a place of constant conflict between inmates, prison officers, and the government (Ryder 2000, ix). Loyalists and republicans embarked on blanket protests, no-wash protests, and later, hunger strikes. Prisoners alleged brutality by the prison authorities, and prison officers were attacked both inside and outside the prison. Resulting fatalities included ten hunger strikers, many prison officers, and an assistant governor. The Maze Prison was closed in 2000, when prisoners were released under the terms of the Good Friday Agreement.

Armagh Prison was the Maze's equivalent for women. An old Victorian Prison, which also held ODCs, Armagh was based near the city's center, unlike the isolated location of the Maze. Although the number of political prisoners never exceeded thirty at any one time, this site also became the focus for tense and regular battles over segregation and political status between the authorities and the political prisoners. Strip-searching, sometimes by male officers on female prisoners, lead to international protests by feminist organizations. Inside the prison, government policies lead to no-wash protests, hunger strikes, and violence against both prisoners and prison officers (Ryder 2000, 196). The state operated other prisons in Northern Ireland: Crumlin Road Prison in Belfast was primarily a remand center, while Magilligan in County Derry provided incarceration for short-term prisoners, sometimes political. Although conflict erupted periodically in these prisons, for instance loyalist and republican rioting in Crumlin Road Prison in 1991, the transitory nature of their populations prevented more long-term campaigns. Maghaberry Prison was eventually to replace the Maze and Armagh,

and currently holds a small number of prisoners from military groups that have not called cease-fires. In 2003, those prisoners won segregation after a campaign of protests, but as far as international audiences were concerned, the Maze and Armagh Prisons had the strongest hold on the imagination.

Prison on Film

Representations of these prisons and their conflicts have received much attention from artists, including Rita Donagh's *Long Meadow* (1983), Richard Hamilton's *A Cellular Maze* (1983), and Rita Duffy's *Veil* (2000), but filmic and televisual representations have tended to place them as bookends or back stories to the main narrative. Until recently, the longest screen time given to prison was in Jim Sheridan's *In the Name of the Father* (1993), based on the injustice of the wrongful conviction of the Guildford Four. The main drama between father and son occurs inside prison cells, although the police interrogation and the courtroom scenes vie for prominence. Because the anonymous prison is in England, the Irish political prisoners are outnumbered by ODCs. There are two father figures. The symbolic father of the Irish Republican Army leader is ruthless and dedicated. The blood father has a religious and pacifist outlook, and the central character, Gerry, is torn between the two. As his father's health fades, Gerry is drawn to his philosophy and turns his back on the IRA. The film is not as much about the political conflict and its participants, as about those who are caught up in its maelstrom. As Martin McLoone noted, "[t]hese prison scenes work well enough for the oedipal tensions in the relationship and for establishing the moral universe in which they are played out. However, the resulting emphasis on character limits the political potential of the film and renders it unsatisfyingly poised between oedipal melodrama and political thriller" (McLoone 2000, 71–72).

From father-son to mother-son relationship, Terry George's *Some Mother's Son* (1996) uses a prison hunger strike as the climax of the struggle of Kathleen to balance her political disquiet at the British government's policies and her desire to save her prisoner son from dying. Important scenes occur inside the prison hospital wing and an adjoining waiting room, but the bulk of the narrative occurs outside as the story focuses on the contrasting ideologies and fortunes of two mothers and their republican sons. Because the world of the

prison is such a common experience for those living in republican areas of Northern Ireland, either as inmates or visitors, it is not surprising many films about these communities touch on the prison experience. Other examples include Sheridan's *The Boxer* (1997), whose action begins after Danny, an ex-prisoner attempting to put his activist past behind him, leaves prison and returns to the Belfast streets. At the other end of the prison time line, Neil Jordan's *The Crying Game* (1992) concludes with a scene in a prison visiting room somewhere in England. Fergus has been convicted of a murder he did not commit and is receiving a visit from his "lover" Dil, the actual killer. Michael Winterbottom's *Love Lies Bleeding* (1993) uses a parole weekend to tell the story of a prisoner looking for the killer of his lover as a narrative device to explore, somewhat prophetically, the organizational tensions of declaring a cease-fire. Again, although the prison setting is crucial to the plot, and indeed the film's bloody climax occurs inside a prison, most of the story and action takes place on the streets and in the clubs of Belfast.

I have suggested elsewhere that most of the films that deal overtly with the politics of the Troubles were produced as a result of the stabilizing influence of the republican and loyalist 1994 cease-fires (McLaughlin 2004, 238). It is almost certain neither of the two films I wish to discuss in detail here would have been funded or distributed if those cease-fires had not taken place. They both base their stories almost entirely inside prison walls and give a voice to those who were yesterday's "terrorists." Foregrounding the Maze Prison and the hunger strikes of 1981 is Les Blair's *H3* (2001), written by two former prisoners, Lawrence McKeown and Brian Campbell. Maeve Murphy's *Silent Grace* (2003) tells the story of the republican women in Armagh Prison and their campaign for political status. Not surprisingly these films have more in common with other narratives involving political conflict, for example Yilmaz Guney's *The Wall* (1983), in which Turkish prisoners form a community of resistance, than with the more mainstream prison film, where the individual, albeit with aid from his fellow inmates, is pitted against the system, as, most obviously, in *The Shawshank Redemption* (1994). But *H3* and *Silent Grace* necessarily retain some of this binary of authority versus the captured, although prison history and these films both suggest prisoners' organization can sometimes undermine assumptions about how power operates and where it lies.

H3

Les Blair is a successful British filmmaker who won a British Film and Television Award for *News Hounds* (1990). *H3* opens with text briefly outlining a background to the prison conflict and concludes, "they would not wash, wear prison uniform or do prison work." The next text page states, "H Block Prison, January 1981." The official title of the prison is Her Majesty's Prison The Maze, but much controversy surrounds the name because it was changed from Long Kesh. The authorities appeared to want to erase the indignity of operating an internment camp for detainees, with its attendant bad publicity, while republicans, especially, persisted in calling it Long Kesh. The filmmakers solve the problem by calling it neither, instead referring to the "H" design of each block, divided into four wings and one central connecting administrative bar. The film opens with Seamus, an H-Block 3 leader, waking up on the mattress of his furniture-less cell to see a bug pass in front of him. The conditions are appalling. The naked prisoners wear blankets over their shoulders in their windowless cells to keep warm and wrap towels around their waists when moved about the block. The narrative uses a recently sentenced youth, Declan, to introduce us to the survival strategies of the prisoners. In contrast to their long hair and beards, Declan is clean shaven and short haired. As he arrives, some of the prisoners are forcibly strip-searched by prison officers. Four officers force a prisoner to squat over a mirror and the beam of a torch is shone up his anus in search of contraband. Declan is put into Seamus's cell and the ensuing "older brother" relationship allows Seamus to explain the back-story to him and us, and neatly gives us a visual and abbreviated version of the protesting prisoners four-year journey from young volunteers to men aging before their time. The next difficult initiation into the way of protest life is to smear his excreta over the cell walls to "reduce the smell" and "irritate the screws," according to Seamus. When the lights go out and the prison officers retire from the wing, the prisoners begin their night's entertainment with story telling. Somewhat ironically, Madra (Tony Devlin) calls out a remembered episode from the adventures of the New York Police Department. Declan makes his contribution with a rendition of "My Perfect Cousin," then a popular song from the Derry-based punk band, The Undertones. It evokes the carefree life young men of similar ages are experiencing

3.1. Brendan Mackey as Seamus in *H3*. Courtesy of James Flynn.

outside, although the inmates mock Declan's efforts to sing unaccompanied because the words pale without the punk rock accompaniment.

The no-wash protest appears to have reached a stalemate and Ciaran, a friend of Seamus's, expresses doubt about how much longer he can withstand the strain. The prisoners meet in the prison chapel, the only place where they can associate, to discuss the way forward. The inevitable escalation to a hunger strike is postponed as they agree to try once more to negotiate with the authorities. They appear to be given enough concessions to end their protest and return to a "normal" prison life that includes shaving and access to the canteen. However, the protest soon flares up again when the concessions are not forthcoming. The prisoners smash up the new furniture in their cells and the heavily armed riot squad are sent in to subdue them. Ciaran, who we see in flashback was shot and captured along with Seamus in an operation that went wrong, buckles under the pressure. He gives up his protest and is removed to a conforming wing, despite shouted pleadings from Seamus. Bobby Sands, the prisoners' leader, takes the decision at the next chapel meeting to go on hunger strike. He names Seamus as his replacement, because "I need someone who has the strength to let me die." The prisoners prepare themselves for volunteering for hunger striking. In one scene, Madra

takes a visit from his wife, Marie. There is an awkward silence between them, punctuated with snippets of news from outside about the upcoming elections. Marie smokes nervously. Madra tells her he has put his name forward. She holds back her feelings, as her lip trembles, and in a show of painful solidarity, tells him "I knew you would." The death of Frank Maguire, a sitting Nationalist Westminster member of Parliament and supporter of the prisoners, allows Sands to stand in the elections. The prisoners immerse themselves in a letter writing campaign and hold onto the hope the British "can't let an MP die." Sands wins by an overwhelming majority, leading to an outburst of joy in the cells and taunting of prison officers. A prisoner shouts, "Is that political enough for you?" But there is no compromise by the authorities, and Bobby Sands dies in the hospital wing after sixty-six days on hunger strike. The prisoners recover from their despondency and reassert their solidarity. Even Ciaran is moved to rejoin the protest and Seamus is left with the unenviable decision of which names to select next for the hunger strike, now unquestionably to the death. He spends a sleepless night, and in the morning takes out a sheet of paper and pencil. He writes his own name first.

Silent Grace

The female republican prisoners in Armagh Prison were also involved in the first hunger strike of 1980, although not joining in the second and fateful strike of 1981. There were relatively few women political prisoners and, although receiving less attention than their male counterparts, they became the focus of campaigning by feminists internationally, with small but noisy demonstrations outside the gates each International Women's Day (Cantacuzino 2004). *Silent Grace* is Maeve Murphy's debut feature and she is credited as writer, director, and producer. The film opens with the text, "Armagh Women's Prison, Northern Ireland, 1980." The underlying, gently rumbling sound track rises and intercuts with the voice and visual of the officer commanding of the republican prisoners, Eileen (Orla Brady), giving parade ground orders in the prison yard. The voice of Margaret Thatcher competes with Eileen's commands. Her often used broadcast interview exclaims, "[t]here can be no question of political status for someone who is serving a sentence for crime. Crime is a crime is a crime." Next the prisoners hold a

minute's silence for a dead comrade and are watched from a high window by the prying prison governor, Cunningham (Conor Mullen).

The film cuts to the title sequence as a car speeds past the camera in a night time urban setting. Three young occupants are sniffing glue and arguing among themselves when they are interrupted by a British army patrol. The youths speed off and are shot at by the soldiers. The youngest in the back is killed by a bullet through his head. The driver disappears and Aine (Cathleen Bradley) is arrested. She is sentenced to one year in prison and, dressed in a leather jacket, arrives at Armagh Prison to the soundtrack of the Clash's "I Fought the Law and the Law Won." Her rebellious nature has already been established by her mocking attitude to the magistrate, her swagger, her frequent cursing and her tendency to roll her eyes. The governor places Aine in the political wing, against Eileen's wishes. The ensuing tension between Aine and the republican prisoners offers the opportunity for the film to explore the "outsider versus insider" aspect of the escalating protest over political status and even some broader issues of the conflict outside. Aine's initial wish to be with the political prisoners turns out to be mere bravado and soon her antipathy shows. In response to Eileen's "[t]hey say we are criminals," Aine responds, "Well, yous are. You run rackets and rob banks. Sure half the Lower Falls are paying out to yous." This tension erupts when Aine finds out on a visit from her mother that the driver of the car, her boyfriend Kevin, has been killed by the republican movement. She wrecks her furniture and is restrained by her cellmate, Geraldine (Dawn Bradfield). As she breaks down Eileen comforts her over an improvized tube "telephone" system the prisoners have created. This relationship develops when Aine is moved into Eileen's cell. They discuss rock music and boyfriends. She is even encouraged to join the no-wash protest and, despite almost vomiting, manages to smear some of her own excrement on the cell wall. The tension momentarily returns, however, when news arrives that a prison officer has been shot dead outside the prison gates. In the prison yard, Aine storms off, but Eileen follows her and forces a debate about the conflict that is unusual in any "Troubles" film.

EILEEN: That is emotion. I'm asking you to use your critical faculties.
AINE: What?

EILEEN: We're fighting a war; you can't afford to be sentimental. I'm asking you whether this was an effective form of military action.

AINE: I don't think I like 'effective military action' from you or anyone.

EILEEN: That's emotion again. Give me some clear thought on this.

AINE: (*raises her eyes to the sky, pauses*) In the short term, it gives us the upper hand. In the long term, it'll cause even more of a hardened attitude to us from the prison authorities. That, from the point of view of our long term aim of political status, it means it is less likely to negotiate with us on that.

EILEEN: Very good. Very well argued.

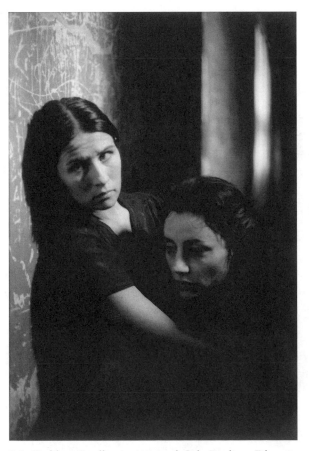

3.2. Cathleen Bradley as Aine and Orla Brady as Eileen in *Silent Grace*. Courtesy of Maeve Murphy.

Back in the cell, this exchange is followed almost immediately by another that could not be more contrasting when Aine talks sex. Later, on the excuse of looking for "illegal paramilitary uniforms," the riot squad are sent into the prisoner's cells and destroy their contents, including personal items. The women are locked in their cells for days and, to deal with overflowing pots, smear their excrement on the walls. The no-wash protest has begun. When a hunger strike is announced in Long Kesh, the women are angry they have been excluded. Margaret and Geraldine argue over the "new strategy." In response to Margaret's "We are to take a supportive role," Geraldine shouts "We'll be back making tea and knitting jumpers next." Through the media-tion of a priest, Father McGarry (Robert Newman), Eileen demands the IRA Army Council send a representative. Peter (Patrick Bergin) arrives. He is a quietly spoken and imposing figure. He tests Eileen on her association with the "joy rider," and after praising her leadership gives her the go ahead to lead a hunger strike. The prison governor, in an increasingly personal campaign to break her, comes to her cell where she is hunger striking: "[w]here's your family, where are your friends? Doesn't anybody care about you? Do you even care about yourself?" This reflects the director's belief that the Armagh women were forgotten both at the time and subsequently (Cantacuzino 2004). Later Aine reports, "Ma says there was a picture of you in the paper yesterday. And marches in New York and London for the Armagh women." But Eileen replies "Ha, Liar. They's marches for the men." As the wind on the sound track increases in volume, Eileen deteriorates, becoming angry with Father McGarry for questioning her protest. "You can fuck off. You are either with us or against us. There's no middle ground," she shouts. After fainting, she is taken to the hospital wing. A darkly lit close up of Eileen's face, to the sound track of a single violin, is intercut with scenes of her court-ship with her ex-boyfriend Conor (Colm O'Maonlai) and the governor mak-ing urgent phone calls to his superiors about the dangerous consequences of Eileen dying.

A scene toward the end of the film offers us a triple perspective on Eileen's failing health, which reflects the three points of view that the director has been interweaving. Aine, the everywoman and humanitarian, runs from her cell, along the wing, up the steps and into the hospital wing (surprisingly meeting only one prison officer along the way) where a small group gather

around the dying Eileen. Aine bursts in, "It's over. The hunger strike is over. It's on the news. Conor has called it off." Margaret, the republican ideologue, dogmatically retorts, "This strike continues until we get word from the army council." "Are you insane? The hunger strike is over. Do you want her to die or something?" "Not until it is official," replies Margaret with steely determination. "It is official," intervenes the relieved state official, Cunningham, entering the room. Margaret explains, "I mean official from our army council." "It's official, because I'm releasing her under the Cat and Mouse Act." The governor comes up with a technical solution, based on a little known act from the time of the Suffragette movement in England, which brings the hunger strike to an end without further protests or losing face. Aine's resolution is to return to her normality. She tells a recovering Eileen, "I've signed the form. I'm outta here. I am a criminal. I should never have been in here. It was a mistake." This contrition not only has strong Catholic overtones of sinning and forgiveness, but allows the film to both espouse support for the struggle of the protesting prisoners and at the same time distance itself from that struggle.

Relationships

H3 and *Silent Grace* both deal with the historical period of the 1980 and 1981 hunger strikes, and events that came to shape the contemporary political landscape. The films, for the first time, offer cinematic representations of the shared sounds, sights and smells of a claustrophobic intimacy enacted on the bodies of the protesting prisoners. The films also share the story of the strength of human relationships, as evidenced by a political solidarity and the device of the older prisoner guiding the younger, which is partly designed to reveal the back-story and partly to carry the narrative. Their common privileging of the prisoner's point of view appears to offer more implicit empathy to their political struggle than has been available in the cinema up to this point. However, these films are not one dimensional, and although we are offered external oppositional forces, such as the governor and prison officers, there is as much space, if not more, allowed for internal debates and conflict, both in the sense of the collective and of the individual. However, there are some notable differences that might benefit from further scrutiny if we are to

consider the overall question of how post-cease-fire films are engaging with the past and how recent history is being reimagined.

The older/younger relationship in *H3* allows not only an opportunity to initiate the audience into the conditions of the prisoners' protest, but also to explore their past and present. The prisoners' average age was twenty, which means many were teenagers. When Declan arrives at the prison for the first time, he is clean shaven with short hair, looking like a schoolboy, in contrast to all the other prisoners who have long hair on their heads and faces. They all, of course, entered the prison looking not dissimilar to him. In *Silent Grace,* Aine, although she looks older than a schoolgirl, refers at one point to the head nun of her school. However, the strategy here is not just to have a younger prisoner but an ODC, which creates dramatic tension between her and the political prisoners. Although this scenario would appear to offer more scope for exploration, including more points of view and narrative sub-plots, it tends to strain our suspension of reality, not so much because such a mixing of political and nonpolitical did not occur and was actually one of the issues the prisoners protested, but because within the film's world Aine's punk persona seems to vacillate uneasily between opposition to the republican movement and support for it. Aine's contrition at the end undermines her development. The device of an outsider opens up possibilities for exploring the tensions between ideological commitment and youthful rebellion, between dogma and emotion, much as Oliver Schmitz's *Mapantsula* (1988) did for the representation of the struggle against Apartheid in South Africa. However, unlike the development in *Mapantsula* from township "spiv" to political identity, Aine has a conversion followed by a reconversion to self-confessed criminality, if not in action at least in identity. Because Declan entered the fray a committed republican, the development of his relationship with Seamus is predicated on the bonding of men who face the same overwhelming obstacles and whose survival depends on a collective solidarity. Aine, however, is initiated not only into the prison protest, but into republicanism. The previously discussed prison yard exchange reveals her ability to enter the military mindset, but it is her underlying humanity and sociability that motivates her to identify with the prisoners, join their protest and eventually to argue their case with her mother during a visit, much to her mother's consternation.

It is not surprising differences occur in the representations of male and female prisoner relationships, especially, but not only, if the writers and directors are of the same gender as those represented. The socially constructed male sense of commitment, loyalty and solidarity are evident in the men's dependence on each other, highlighted by the sense of betrayal when Ciaran ends his protest. The men are able to show dissent with each other in discussions of strategy, in the chapel scenes, and individuals are sometimes torn in opposing directions. Ciaran is driven to distraction by the mental and physical deprivations and beatings. Seamus is exasperated by the end of the short negotiated settlement and later spends a sleepless night considering who should replace Bobby Sands on hunger strike. There is tentativeness to these young men in contrast to their more usual representation as irrational murderers (Hill 1988, 149). The women, too, show dissension, and although this is primarily revealed through Aine's relationship with the others, in one exceptional scene Geraldine and Margaret argue forcibly over the role of women in supporting the male hunger strikers rather than engaging in their own, with Geraldine kicking the pot of urine and excreta across the floor. There is more physical embracing between the women, who hold each other for comfort, while the men hold each other in greeting or celebration. Reflecting the socially constructed tendency for women to express their emotions more easily than men, the female prisoners are shown to cry and scream in a way the men are not. When Aine breaks down over the death of her boyfriend, Eileen soothes her and later cries over the break up of her own relationship. In response to Aine's "Is he dead?" Eileen replies "Aye, he may as well be." In a rare display of emotional armor melting, Seamus is seen to shed a tear over the dying Bobby Sands, who strokes Seamus's face tenderly. The meeting occurs when Prison Officer Simpson (Dan Gordon) offers one last concession of a visit before he is sidelined by the more ruthless Macken (Gerry Doherty).

Although *H3* avoids addressing the issue of the sexual urges of the young men, who are locked up in small cells in enforced celibacy for years on end, *Silent Grace* engages with both emotional love and physical lust. From poignant separation and loss, the film jumps to overt sexual humor. Margaret and Eileen discuss the contrasting desirability of the lead actors in the popular U.S. television police series, *Starsky and Hutch,* and the Hollywood actors Robert Redford and Paul Newman. Aine is more forthright. When

she refuses to continue with Eileen's history lesson, she complains, "What about having a laugh? What about sex, with Conor?" Holding out her arms, miming a huge penis, she declares him "the man with the biggest cock in Long Kesh" and then simulates intercourse. She lies panting on the bed, climaxing to her own spoken, "Ireland unfree shall never be at peace." Eileen enjoys this exaggerated and tension-releasing performance.

What follows is a difficult encounter in the visiting room between Margaret and her own child, who is accompanied by Margaret's sister. The child does not recognize her. When she is asked who gave her the lovely cardigan she is wearing, the response is "My mummy." Margaret is speechless, torn inside, as her sister says off screen to the child, "That's your mummy, love. I'm your aunty." This short scene hints at the sacrifices paid by prisoners and points to a painful future of reconciliation for those separated. *H3* gives us three scenes in the visiting area, two with Madra and his wife, Marie (Abigail McGibbon). They involve silences broken by casual conversation as a defense against the overwhelming acknowledgment of their separate existence. Although an argument could be made that women are seen as subordinate in the representation of their role as supporting the men, something which Murphy addresses, there is also evidence of a quiet strength of shared commitment in this scene. The film's suggestion is that although men died, women were at the forefront of the protest campaign. Seamus's visit with his elderly parents, his first one taken during the protest to inform them of his decision, provides a parallel of generational support. Although emotions are expressed more easily for the women, the men are physically more exposed. The women wear their own clothes during their protest, but the men only wear blankets to keep warm and frequently are seen semi naked. This vulnerability is made acute when they are being moved around the prison by uniformed officers, and, on one occasion, when they are attacked by armed officers. Although they hug rarely, it is done skin on skin. Their bodies are at once soft and hard, vulnerable to attack and sites of resistance.

Priests and Prison Officers

Catholic priests act as intermediaries in both films. This reflects the influence of the Catholic Church on the nationalist communities and the privileged

position the authorities accord it, allowing its priests to officiate at mass in Long Kesh and to visit cells in Armagh. The Long Kesh priest is the provider of contraband cigarettes and messages, but McGarry begins to take on a more complex role. He is the subject of sexual musings by the women and becomes involved in attempts to end the hunger strike. It is his idea of, and research into, the Cat and Mouse Act that allows Cunningham to intervene. Although there is no record of such collaboration, there is much evidence priests were heavily involved in negotiating with families to sign their sons off hunger strike (Beresford 1987, 343). Because "H3" does not reach this historical juncture, its priest remains merely a conduit. Murphy plays with the record more freely, as we have seen with the Aine character, and her priest is both a narrative device and a player in the drama.

The two sets of prisoners have contrasting responses to the provocation of the prison officers. When the Long Kesh prison officers whistle "The Sash," the Orange Order's anthem, the prisoners refuse to be provoked and put up a defense of silent nonresponse. When an opportunity arises later, they vent their anger when they shout at the prison officers about Bobby Sands receiving more votes in his electoral campaign than Margaret Thatcher did in the general election. The women are subjected to a similar provocation when the prison officers make a bonfire of their old mattresses outside their cell windows and proceed to sing "The Sash" and burn the Irish tricolor flag. In response, Margaret begins the Country and Western song, "Sometimes It's Hard to Be a Woman." The other women join in, in a gesture of defiance by distraction. Both films show elements of empathy with the prison officers, although this is selective and rare. In *H3* there is the good/bad officer binary. Those on the coalface implement the Northern Ireland office's negotiations and maneuvers, with Macken standing for intransigence and Simpson for finding a way out of the impasse. Macken is provocative, violent and spiteful. Simpson wants a return to a "normal" prison and believes a settlement can be negotiated. In some ways, this implacability versus reform approach of the authorities' forecasts the persistent stalemate of the current peace process that sees the British and Irish governments, as well as the unionist political parties, split between negotiating with, and distancing, from Sinn Fein.

Murphy's strategy is to move this conflict to the governor's office and make it Cunningham's internal battle. She spices it up with sexual tension.

He is consistent in his attempt to break the prisoners, in particular Eileen. He pries into her personal relationship with Conor. He uses intimate observations in an attempt to undermine her and infers a sexual attraction when he claims Eileen was in his dreams. "Don't you want to know what happened?" is his call as she leaves his office, refusing to become involved. Curiously, during a conversation with Aine, who refers to the priest as good-looking but "repressed," Eileen says of the governor, "I used to fancy him once, way back at the beginning. He seemed alright then." The governor's internal battle occurs when Eileen approaches death. He begins to panic, doesn't want a riot and one assumes from the increasing intimacy of his interest in her, doesn't want her to die. In an exchange with McGarry, he defends his position but acknowledges Eileen's.

> CUNNINGHAM: It's my job to run this prison. If people want to start killing themselves.
> McGARRY: Those cells are a crime against humanity.
> CUNNINGHAM: Did I make them do it?
> McGARRY: You changed the rules.
> CUNNINGHAM: No, I didn't. The NIO changed the rules. They won't budge an inch.
> McGARRY: Neither will the women.
> CUNNINGHAM: Just trying to do my job.
> McGARRY: A remarkable woman, isn't she?
> CUNNINGHAM: Yes.

His release from this tension occurs in the penultimate scene of the film. When the protest is over, Cunningham dips a biscuit in his tea and eats it satisfyingly. To a prison officer's complaint that the prisoners are dancing, he responds, "Miss McAuley, we no longer have a hunger strike. We no longer have a dirty protest. If they want to dance, let them dance." *H3* offers neither its characters nor the audience such release. Simpson attempted his own negotiated settlement, but the governor, and implicitly the Northern Ireland office, rejects this and the prisoners are devastated. Seamus decides to meet the authorities' decision to revert to intransigence by restarting the hunger strike. The film ends before nine more men die and civil disturbances escalate on the streets outside. This ending not only is more ambivalent than the release

offered by *Silent Grace,* but is also indicative of a more skeptical view taken by the filmmakers. In this, their approach is more prophetic than Murphy's.

Sites, Sounds, and Stars

Although neither film was able to access the actual prisons for its locations, they nevertheless successfully re-create an institutional claustrophobia. The producers of *H3* reconstructed the prison interior in Ardmore Studios, relying on Maze Prison exteriors for authenticity. Blair attempted to make "every effort to be as authentic as possible" (*H3* Production Notes), and so actors were greeted on set with a huge banner that reads "Cold, Hungry and Scared." *Silent Grace* reimagined the old Victorian Armagh Prison inside Kilmainham Jail in Dublin and, although convincing in its sense of the grey coldness reported by ex-inmates, portrayed too bleak a visual picture, with paint peeling off walls, even in the governor's office. One assumes options for redecorating were limited because Kilmainham is of heritage value. The relentless dampness and crumbling surfaces of Kilmainham remind one more of a dungeon than of a twentieth century penal institution.

H3 is not only a tighter film in terms of its points of view, structure and narrative, but also in its minimalist mis-en-scène, reflecting the reality of sensory deprivation more closely. Extensive use of handheld camera maximizes movement, and implicitly drama, in a limited space. Visual storytelling competes with dialogue for development. In the grey and blue hues of the prison, young naked men leave their cell rarely for occasional visits (many refused the condition of wearing a prison uniform) and for chapel. *H3* uses melodic gently plucked acoustic guitar and slow blues melodies to set its atmosphere and to progress its narrative. The unaccompanied singing by Declan of the Undertones' pop song, "My Perfect Cousin" sits uneasily beside its remembered punk rhythm, but although he trails off after jibes by his comrades, there is a tenderness to his innocent joy in the singing that is juxtaposed with his brutal and isolated surroundings. *Silent Grace* primarily utilizes violin strings, singly and in chamber orchestration, to give color to the story. The rhythm here works well to speed up or slow down the narrative, but by occasionally continuing well into the following scene appears to hinder rather than ease the transition. The very London-sounding Clash's

"I Fought the Law and the Law Won" is used twice to drive forward the intermediary scenes of punctuation. Margaret's unaccompanied singing of the Country and Western classic "It's Hard to be a Woman" may suggest a heavy handed ironic analogy with the condition of women, but her rendition is subtle and evocative of a feminist irony.

Flashbacks are used sparingly. Seamus spends a sleepless night considering future strategy, reliving his and Ciaran's capture. The volunteers complete an operation, which is not explained to us, and are chased by British soldiers. Ciaran is shot and Seamus makes the difficult decision to leave his injured comrade behind in his escape attempt, although he is also caught soon afterwards. The sequence is post produced in slow motion to reinforce its memory or dream qualities. The purpose of the scene appears to be to convince Seamus there is no benefit in walking away from a situation. On waking, he resolves to put his name down first for the hunger strike. Murphy uses two flashback scenes and one of a fantasy dream. The first flashback takes us to the initial meeting of Eileen and Conor in a pub. He gentlemanly puts her coat on and as she leaves, she glances back and their eyes meet. The film cuts to two figures walking across an Atlantic coastline of sand dunes and a background of endless ocean. They embrace. Later, when Eileen is close to death, she reimagines the scene on the sand dunes. Shot in slow motion, this is memory or at least reimagined memory. She has lost Conor and now is close to losing her life. Aine's fantasy sequence shows the aesthetic risks Murphy is prepared to take. As Eileen tells Aine a reaffirming story of her entering a bar and picking out the best looking man, the film cuts to a literal representation complete with Stetson hat and bar fight. It is a risk that almost pays off, with a palpable sense of relief from the tension of everyday prison conflict. However, there is a literalism to the sequence that suggests a televisual aesthetic and it struggles to capture the surrealism of fantasy.

Murphy chose to use well-known actors in her film and relies heavily on dialogue to develop the story. Orla Brady plays the prisoners' leader, who can be interpreted as a representation of Mairéad Farrell, officer commanding the Armagh republican prisoners and later shot dead in Gibraltar by British soldiers. The likeness between Brady and Farrell, evident from an interview given by Farrell in Ann Crilly's documentary *Mother Ireland* (1988), is not only physical, for example in their similar facial characteristics; they also

seem to share a feminist intellectual rigor. The Irish Hollywood actor, Patrick Bergin, has a cameo role as the senior republican figure who is allowed in at a crucial moment to consult with the women on their imminent decision to go on hunger strike. His full, unshaven face is in stark contrast to his previous leaner appearance as predator in *Sleeping with the Enemy* (1991) and as hero in *Robin Hood* (1990). His character's quietly teasing, but supportive, play with Eileen is uncommon in a role that has been frequently played for the effect of manipulative godfather (Hill 1998, 166). Cathleen Bradley has starred in *About Adam* (2001), Conor Mullen has taken the leading roles in several Irish films over the last decade including *Ordinary Decent Criminal* (1999), and Dawn Bradfield has played in *About Adam* and *Rebel Hearts* (2001). By contrast few of the young actors in *H3* can compete with these credits. As the film's publicity states, "For most of these actors, it was the first time playing their own accents in a film" (*H3* Production Notes, 2001). The effect is to undermine the "star" syndrome, with its foregrounding and hierarchizing of performance, and to focus our attention on the portrayal of a sense of comradeship and egalitarianism among a group of very young men.

A common approach by the filmmakers is their attempt at giving a human voice to the political story. The events these films address have become internationally well-known and were part of the battle of discourses between the British government, who wished to "criminalize" the prisoners, and the prisoners and their allies who campaigned on a platform of political prisoners' "rights." Murphy explained, "I wanted to humanize these women and show that in a situation of total deprivation, human beings endeavor to retain their dignity" (Cantacuzino, 2004). McKeown stated, "Despite everything, it's the humor and camaraderie that kept us going and I really wanted to show this" (*H3* Production Notes, 2001). Both films received funding from the Northern Ireland Film Commission and the Irish Film Board. They received short releases inside and outside of Ireland, but they achieved critical acclaim, both on their own merits and as attempts at opening up stories that had remained in the shadows of more popular representations of the "Troubles." For similar reasons, they deserve wider exhibition and more critical comment and are evidence of the cultural spaces slowly, if hesitantly, appearing in the aftermath of the 1994 cease-fires and the 1998 Belfast Agreement.

4

True Grit

The Evolution of Feature-Length Irish Films in the 1990s

MICHAEL PATRICK GILLESPIE

It has become a critical commonplace to observe that favorable economic, political, and artistic conditions combined to make the 1990s a particularly prolific decade for Irish filmmaking. The economic growth of the Celtic Tiger created a strong climate for corporate investment and an increase in disposable income. The renewal of governmental support, with the revival of the Irish Film Board in 1993 and the accompanying tax incentives, provided a strong financial foundation for this development (Barton 2004, 104–12). The opening of the Irish Film Institute in 1992 and the increasing number of young men and women trained in all areas of the profession by Irish technical schools, colleges, and universities enhanced Ireland's cinematic infrastructure. Together, these elements fostered boom times for the Irish cinema. Between 1980 and 1998, cinema attendance in Ireland rose by nearly one third, from 9.5 million people per year to 12.5 million (Pettitt 2000, 285). Lance Pettitt lists thirty-six feature-length, commercial Irish dramas that appeared in the 1990s—a sharp jump from the preceding decades. And Ruth Barton, listing top grossing Irish films from 1993 to 2001, adds two dozen more titles to Pettitt's compilation (Pettitt 2000, 286; Barton 2004, 191–92).

The current decade has shown no abatement in production. However, the evolution of the Irish cinema goes well beyond increases in movie releases or audience attendance, and defining the term Irish film has proven to be

a complicated proposition for most critics. In their pioneering book, *Cinema and Ireland,* Kevin Rockett, Luke Gibbons, and John Hill acknowledge, without overtly saying so, that reference to the Irish cinema can encompass anything from a narrow focus on indigenous films to the broadest possible view that includes any Irish themed motion picture (Rockett et al. 1987, xiv). Both Brian McIlroy's *Irish Cinema* and Kevin Rockett's *The Irish Filmography* take similar positions (McIlroy 1988, viii; Rockett 1996, i). Anthony Kirby and James MacKillop's "Selected Filmography of Irish and Irish-Related Feature Films" lays out criteria that seem to offer a much more prescriptive set of criteria for defining an Irish film, but then concludes with a loophole that provides them a great deal of leeway in categorizing specific motion pictures. An Irish film must be "(a) one made in Ireland, with (b) an Irish director, (c) produced or backed by an Irish company, and (d) based on a text by an Irish writer, or a compelling minority of those four elements" (Kirby and MacKillop 1999, 182). Lance Pettitt's *Screening Ireland* presents the most detailed view of the problem, linking Irish film to a national cinema and then going on to acknowledge the difficulty of defining the idea of nation. Ultimately, because he recognizes the multinational component of most feature film productions, Pettitt takes a liberal approach to Irish film: "a national cinema may be identified by the narratives that occur in the films themselves" (Pettitt 2000, 29–30). Martin McLoone's *Irish Film* also endorses thematic delineations, emphasizing "a desire to explore the contradictions and complexities of Irish identity as it looks inwards and backwards at its own history and outwards and forwards to its European future" (McLoone 2000, 128). And most recently, Ruth Barton expands the scope to incorporate the way others see Ireland as part of the Irish cinematic tradition (Barton 2004, 4–5).

This emphasis on thematic delineation reflects awareness of the material realities of contemporary filmmaking. The worldwide influence of the U.S. film industry insistently challenges indigenous identity. In studios from Wexford to Bombay, directors adhere to the narrative structure and cinematic techniques laid out in classic Hollywood cinema. Indeed, the universality of the form has lead Thomas Elsaesser to note "Hollywood can hardly be conceived in the context of a 'national' cinema as totally other, since so much of any nation's film culture is implicitly 'Hollywood'" (Elsaesser 1987, 166). This dominance of a single formal structure—namely classic Hollywood

cinema—heightens reliance upon specific thematic concerns and cultural contexts for establishing national identity.

Using thematic criteria may allow one the latitude to encompass all possible manifestations of Irish film. At the same time, differences in narrative emphasis have evolved over the past two decades to highlight the notion that, even within fixed thematic categories, interpretive subjectivity can produce widely differing opinions among critics on the current state of Irish cinema. *Criminal Conversation* (1980) and *About Adam* (2000), for example, present detailed examinations of the sexual mores of modern day Dubliners, yet the grimness of the former and the flippancy of the latter underscore a growing cosmopolitanism that can rob a film of traits that make it Irish. This condition becomes exacerbated by finance stress that has internationalized the industry. Kevin Rockett points to "the national celebration which greeted the success of *My Left Foot* at the [1990] Academy Awards" as illustrative of a disturbing internationalizing trend. He sees in that motion picture narrative priorities reflecting

> the sea change in national ideology during the past three decades. [*My Left Foot*'s] universalist sensibility helps confirm the replacement of the earlier inward-looking cultural and political nationalism with an outward-looking liberal humanist ideology. This allows, as in so many aspects of Irish life in recent decades, for a displacement of what is particular to the Irish social formation on to a non-specific universalism. As a result, with British and American investment in Irish films replacing Irish money, we are likely to see more sanitized or neutral versions of Ireland produced for cinema and television. (Rockett 1991, 22)

Rockett published this criticism at the beginning of the 1990s, with widely respected films by Bob Quinn, Kieran Hickey, Pat Murphy, and Cathal Black still relatively recent releases, yet by singling out Jim Sheridan's highly commercial effort, *My Left Foot,* he announces his assessment of the direction in which the Irish cinema is headed with a tone of unmistakable pessimism.

Martin McLoone, on the other hand, writing near the end of the same decade in the *Cineaste* special issue on contemporary Irish films, holds a far

more exuberant view of the thematic evolution of Irish cinema despite the appearance of even more commercial films of the nature that Rockett laments:

> Contemporary Ireland, on the other hand, is now on the cusp of European modernity with the fastest growing economy in the European Union as well as the youngest population and together these have given rise to a cinema which offers a challenge, not only to the "*cinéma de papa*" but also to the laws of the father and the embraces of both Mother Ireland and Mother Church. Even the new orthodoxy in Ireland, built on modernization and secular liberalism, is subject to interrogation and challenge. In this way, contemporary Irish cinema is beginning to emerge as a cinema of national questioning, one that seeks to re-imagine the nation in excitingly different and profoundly challenging ways. (McLoone 1999, 28–34)

Certainly, one could cite films like *I Went Down* (1996) and *The Butcher Boy* (1998) to justify the optimism McLoone felt at the time. At the same time, a number of motion pictures from the 1990s—movies like *The Playboys* (1992), *Circle of Friends* (1995), and *The Miracle* (1991)—embody the traits Rockett criticized so vehemently. In fact, the recent economic prosperity has produced a diverse narrative range of films, provoking one to question whether representations of Irishness are equally diverse. The query turns not on the degree to which a particular motion picture meets a fixed conception of Irishness. Rather, one must ask what elements of Irishness does a particular motion picture choose to emphasize to define its identity; and, I think more important, despite its thematic disposition, does that movie's emphasis maintain its integrity as an Irish film?

An exchange from the film *The Fifth Province* (1997) illustrates how subjective such perceptions can be. In a scene presenting a satirical depiction of a scriptwriting seminar, the seminar leader, Diana de Brie, played by Lia Williams, sums up the industry's current conception of a viable script by telling her audience:

> When it comes to the story, I'll tell you what we don't want. We do not want any more stories about . . . Irish mothers, priests, sexual repression and the miseries of the rural life. We want stories that are upbeat, that

are urban, that have a pace and verve and are going somewhere. (cited in McLoone 2000, 169)

Despite the avowedly satirical aims of de Brie's monologue, her characterization nicely sums up many of the motion pictures of the past five years, with an insistent undertone of satisfaction punctuating these narratives. Certainly, one still finds grit and desolation in a film like *Last Days in Dublin* (2000) or *Disco Pigs* (2001), which evokes the seamy underside of the Celtic Tiger. At the same time, there are an even greater number of movies, like *When Brendan Met Trudy* (2000), *Wild about Harry* (2000), *The Most Fertile Man in Ireland* (2001), *Goldfish Memory* (2003), and *The Honeymooners* (2004), that could be set anywhere in the world. The question then becomes: what films continue to represent a uniquely Irish cinema? In an essay written in 1999 entitled "Myth, Mammon and Mediocrity: The Trouble with Recent Irish Cinema," Hugh Linehan seems to question the bona fides of this brand of film. With a harsh opening that dismisses a range of motion pictures that seem to him little more than stereotypes, he uses sweeping generalizations to brush aside the notion that an entire category of movies do anything more than ridicule the concept of Irishness:

> Despite rumors to the contrary, stage Irishness is alive and kicking. Films such as *The Matchmaker* (1997) and, most recently, *Waking Ned Devine,* play on the sort of awful whimsy that sets Irish teeth on edge. Most of these films have been written, directed, and produced by non-Irish filmmakers (and, in the case of *Waking Ned Devine,* weren't even filmed in this country). They present an arch, cutesy image of this country that has its roots in Victorian stereotypes and has been well charted by Irish film historian Kevin Rockett (Linehan 1999, 46).

Certainly, Linehan raises a problem of identity that needs to be addressed. At the same time, as examples in this essay have already affirmed, neither rigid classification nor elitist bias should influence the debate. The cinema is an evolving entity, and one can legitimately expect Irish films to participate in that evolution. Further, neither public acclaim nor commercial success in themselves should call the credentials of an Irish film into question. I think the example of *Waking Ned* provides a useful illustration of how, in spite of

a seemingly programmatic approach, a film can offer a subversive assertion of its Irishness.

It is a familiar tactic to find flaws in a motion picture like *Waking Ned* as an example of foreign filmmakers travestying Irish subjects—"the sort of awful whimsy that sets Irish teeth on edge," though it strikes me as simply another form of stereotyping. If an American film critic, for example, complained German born director Billy Wilder insulted Americans by the stereotypical representation of Sugar Kane [Marilyn Monroe] as a dumb blonde in *Some Like It Hot,* others would be justified in suggesting the critic missed the point of the film. This unsubstantiated judgment too easily establishes a reductive dichotomy between native good/foreign bad. In the same essay, Linehan does go on to make the telling observation that *I Went Down* succeeds by taking a familiar American genre, the gangster film, and translating it to an Irish context. However, he misses the point in not seeing a similar process at work in *Waking Ned.* Like *The Quiet Man,* though admittedly with less subtlety, *Waking Ned* plays upon audience expectations about stereotypical Irishness to set up a searing critique of pieties about rural life and bucolic innocence.

Admittedly, many Irish film critics share Linehan's view. In the opening of a relentlessly acerbic review posted on his Web site, Harvey O'Brien articulates the animus many feel toward *Waking Ned:* "[w]orthless comedy shot in the Isle of Man but set in Ireland which attempts to capture the feel of Ealing films from forty years ago, but fails miserably to achieve their tone, pace and humour" (O'Brien 2006). Neil Jackson, writing the Kirk Jones entry for *Contemporary British and Irish Film Directors,* offers a slightly less vitriolic perspective on *Waking Ned* by calling it "not as saccharine as it might have been" with "a strain of black humour that provides a welcome relief" (Jackson 2001, 170). In his book, *Irish Film,* Martin McLoone, while less splenetic than O'Brien, is far less forgiving than Jackson, "[t]he problem with a film like *Waking Ned* is that it lacks any degree of self-consciousness or internal subversion that might rescue it from the charge of 'paddywhackery'" (McLoone 2000, 59). Although all of these issues merit response, the most serious question is whether it can legitimately be considered an Irish film. The criticism quoted above suggests that simply meeting objective thematic criteria, although an important starting

point, is not sufficient. One must also be able to argue the motion picture treats its themes legitimately.

Waking Ned serves as a paradigm for a very important form of film, Irish and otherwise—slapstick comedy—and it illustrates what one can accomplish within the relatively narrow confines of commercial filmmaking in Ireland by playing upon conventional expectations to offer a scathing critique of sentimental suppositions about rural Ireland. It shows the subversive effect of slapstick comedy when applied to representations of fundamental aspects of Irish identity. Barton touches on a similar element in analyzing a scene from *Hear My Song*, a film I must admit I never saw as anything but a stereotypical representation until I read Barton's comments (Barton 1997, 51). Indeed, in the remainder of this essay, I hope to establish that the complexity of *Waking Ned* comes closer to the corrosive self-examinations of *The Quiet Man* than McLoone believes. Further, in its combination of Irish themes and broader international concerns, it assumes a paradigmatic role in outlining central concerns of contemporary Irish cinema.

Before going into the particular Irish features of *Waking Ned*, let me address some of the more persistent complaints about the film's authenticity as an Irish motion picture. There has been grumbling because filming of *Waking Ned* took place on the Isle of Man and because it has a Scot (Ian Bannen) in a starring role and an English director (Kirk Jones). This critique simply reinforces the standard of indigenous film without fully articulating an argument for it. I have seen no similar assertions that *Cold Mountain*—filmed in Romania with English (Jude Law) and Australian (Nicole Kidman) actors in the leading roles and a Britain born of Italian parents as its director (Anthony Minghella)—is anything but an American film. In fact, there is a long cinematic tradition of integrating actors and filmmakers of various national backgrounds into films that nonetheless retain their national flavor. More to the point, actors are so mobile that when Fionnula Flanagan (who plays Annie O'Shea in *Waking Ned*) takes the role of a woman of the American South in *Divine Secrets of the Ya-Ya Sisterhood*, it becomes meaningless to classify her performance in that film as that of an Irish actor. *Waking Ned* has also been criticized for its British and French financial backing, although multinational funding has become a way of life for feature-length productions. Indeed, in the often rancorous debate over the strengths and

flaws of *Michael Collins,* that a large American studio bankrolled its production never entered into consideration as an element relating to its merits as an Irish film (For a sample of some of the critiques of the film, see Newey 1996, Cullingford 1997a, and Gibbons 1997).

Viewers have also questioned whether the thematic choices in *Waking Ned* affirm its Irishness. Although there may not be complete unanimity regarding this concept, Martin McLoone has identified a number of themes he sees as essential to any film claiming an Irish connection. *Waking Ned* does not address every category McLoone lays out, and in fact, I doubt any film could. However, I have listed below the relevant categories that have an active role in its narrative:

An interrogation of the rural mythology that underpinned cultural nationalism and is encapsulated in the use of landscape. Director Kirk Jones and cinematographer Henry Braham deftly integrate lush scenery and rural types evoking standard expectations of rural Ireland while confronting the audience with repeated and insistent evidence of the venality and mendacity that underlies these images and critiques the impulse to valorize country life.

A consequent desire to reveal the social and political failures of independent Ireland and latterly to probe the failures and contradictions of the Irish "economic miracle." The film presents the issue of collecting the lottery winnings in slapstick comedic fashion, and offers the fanciful opinion of the child Maurice that the villagers would stay in Tullymore and only spend the money in the pub. At the heart of the narrative, however, a grimmer view emerges of a stagnant social life dominated by gossip and alcohol in a village with only one child in evidence and only a handful of people under the age of sixty. That is to say, that beneath its veneer of charm, Tullymore represents a portion of the country that has been marginalized and embittered by the Celtic Tiger.

An interrogation of religion in Ireland. Despite the pieties of Annie in praying for the soul of Ned Devine, a cynical sense of the way religion functions in the lives of the villagers permeates the film. This becomes particularly evident in the willingness of the visiting priest not only to look the other way as the village defrauds the lottery commission, he also allows Jackie O'Shea to travesty Ned Devine's eulogy funeral to fool the lottery man.

The question of women in Ireland (McLoone 2000, 128). Although the narrative gives relatively little direct attention to Irish women, it does offer

a muted and admittedly rosy picture of single motherhood. Although the subplot of the romance between Maggie and Pig Finn may seem predictable in its resolution, the conflict acknowledges complex social and economic considerations. Maggie takes a practical view of providing for herself and her fatherless son, initially dismissing Pig for hygienic reasons and considering Pat Mulligan for financial ones, and later reversing the order of preference when the lotto money alleviates financial and insalubrious impediments.

Overall, viewers may debate the effectiveness of the narrative in *Waking Ned* in taking up each of these thematic issues, but they nonetheless stand as central features of the plot development. As the criticisms of McLoone and others make clear, even after establishing its thematic credentials as an Irish film, the argument still needs to be made that *Waking Ned* legitimately engages those issues in a fashion that merits attention. One can certainly name any number of genuinely Irish motion pictures that deserve no consideration from serious critics. I want to make the argument that *Waking Ned* has a paradigmatic value for assessing contemporary Irish films.

It is important, however, to judge the film on its own terms, assessing its successes or failure according to what it tries to do rather than what one might wish it did. First, keep in mind that *Waking Ned* never pretends to be anything but a slapstick comedy. The opening exchange, with Annie's brisk smack to Jackie's cheek in response to his trickery, announces the physical dimension of the film's humor. In subsequent scenes—Jackie replacing Ned's upper plate, Michael O'Sullivan's naked motorbike ride and Jackie's similar journey in briefs, the removal of Ned's remains in a Post Office van, and Lizzy Quinn's spectacular fall from a cliff inside a telephone booth to name the most obvious examples—the film relies on the same broad physical humor the Marx Brothers made famous in their films of the 1930s and that remains a staple in films like *Animal House, Raising Arizona,* and *Analyze This.* Irish movies like *Eat the Peach, The Snapper, Puckroon,* and *An Everlasting Piece* follow this tradition as well. In every motion picture of this type, the plot is predictable and the action often plays upon sentiments, so faulting *Waking Ned* for following this form seems beside the point.

A more telling critique, and one echoed by McLoone, although not with the same ferocity that O'Brien displays, is that the dialogue is weak and the

characterization facile. In some cases this is intentional. Transparent romantic subplots—like the courtship of Maggie O'Toole by Pig Finn—are a common feature of the genre, and they represent a banal domestic alternative to the chaotic lives of the central figures. More to the point, in slapstick films, it is the slipperiness of meaning in the exchanges between characters and the promise of imaginative complexity beneath the surface of the action that carries the narrative. When Jackie and Michael go to the pub with Pig Finn, for example, their conversation is intentionally banal. What animates the action is the audience's awareness of the subtext of the discourse. What may initially appear superficial, even stereotypical, can in fact have a more profound effect once one becomes attentive to the cynicism and ambivalence that underlies the exchange. As in so many slapstick comedies, much of the film's humor turns upon the interaction of a comedic pair—in this case the sweet-natured straight man Michael O'Sullivan, played by David Kelly, and his conniving partner Jackie O'Shea, played by Ian Bannen. Michael is a guileless creature whose simple minded generosity makes him an easy foil. Jackie is the trickster, but very much the country fellow, as Annie pointedly reminds him several times during the movie. In consequence, it would be easy to see these roles degenerate into stereotypes. However, two key features in Jackie's nature prevent such an outcome.

From the start of the motion picture the ruthlessness of a natural predator informs Jackie O'Shea's behavior. In matters grand and small, Jackie moves determinedly to gain an advantage and to forestall the success of others. His life is informed by a zero-sum game philosophy that sees every interaction as a challenge to get the better of the situation. A number of events in the first portion of the film alert viewers to this aspect of his nature. The first, tricking Annie into bringing his apple tart into the parlor so he does not have to leave his chair, seems a small gesture and one that would be familiar to many long married couples. Nonetheless, it signals the presence, in matters great and small, of a single-minded, cunning determination and a relentless desire to best the other fellow that will drive the action. The tart itself means little and the slap Annie administers in response means less. What is important for Jackie is his ability to manipulate, to get another to do his will whether she wishes to or not. A series of equally small gestures that follow neatly reinforce this impression. Once he deduces that someone from Tullymore has

won the national lottery, a gesture that in itself testifies to Jackie's continual watchfulness for opportunities to exploit, he seizes on the idea of finding the winner and, as he tells Michael, "making sure we are their best friends when they cash the jackpot."

Enlisting Michael O'Sullivan to help him may not seem to fit the pattern of a self-absorbed conniver until the audience sees his near complete control of Michael. After a fruitless night of buying drinks for the village, Jackie takes another turn at finding the winner of the lottery with his chicken dinner scheme for the eighteen regular lottery players. As the camera makes clear, Jackie is adept at turning the conversation toward winnings and at making himself seem the most open handed of men. At the same time, mirthlessness informs his actions. He is not a man who enjoys the company of others, but rather one who, when in a group, always remains on the lookout for an advantage. The actual discovery of the ticket underlines Jackie's relentless self-absorption. After Annie points out that someone failed to attend the dinner, Jackie realizes Ned Divine was not present. He cannot contain himself, but sets out in the middle of a storm with a dinner for Ned. When he discovers the body of Ned in front of a flickering television with the lottery ticket clasped in his hand, Jackie does not hesitate for a moment. In a wonderful bit of cinematography, the camera moves to a close shot of Ned's hand with the ticket and then shows Jackie's hand, shark-like, snapping it up.

Certainly, none of these episodes reveals Jackie to be a debased and depraved individual on the level of Hannibal Lector or Jack the Ripper, but that is not the point of slapstick comedy. What the scenes do is alert us against a superficial reading of his character. Although Jackie is adept at self-deprecation and at seemingly straightforward selfishness, and this is where some critics detect stage Irishness, in fact, there is much more to his character. He has an animal cunning and a consistent need to triumph over others that lurks just beneath the surface. But even more arresting, there is an ambiguity inherent in his nature that makes it difficult even for the audience, seemingly aware of his goals and motivations, to understand completely what he intends. These traits do not so much blacken his nature as suggest there is a complexity to his behavior his supposed stage Irishness belies. Like any con game, the film takes great pains to set up the circumstances for tricking its victim. And, also like any con game, there are ample opportunities to see

through the scheme if observers can keep their wits about them. For the first half of the movie, *Waking Ned* shows us what Jackie plans to do to get the lottery money, but it also provides numerous instances to see Jackie as more than the village character willing to run great risks for the thrill of the game. In the end, recognizing the ambiguity inherent in Jackie's character keeps us from being taken in by the simplistic figure he presents to the public, and it invites us to see much broader opportunities for interpretation in the film.

This ambiguity about motivations in key situations informs the action. Jackie's desire for the money is always clear, but only gradually do we come to realize money may be of less significance than the pleasure he derives from manipulating others. One of the first suggestions that Jackie's roguish nature might not be as transparent as it seems comes in his recruitment of Michael as an accomplice. As they discuss their plans, Michael says something about his half of the winnings. Jackie immediately replies, "We agreed on half did we?" Although the conversation goes no further and Jackie's teasing nature makes it easy to dismiss his remark as banter, the suggestion remains of edginess beneath the amiability. After the lottery man announces his intention to return to Tullymore to verify Ned's identity, it becomes clear to Michael and Jackie they cannot keep the secret of the winning ticket from the rest of the village. Rather than give up the plan, however, Jackie decides to enlist everyone in the plot. He does so in a speech that mixes exhortation and confession, telling them he realizes he was wrong to keep the secret from them and that Ned wants them all to share the good fortune. The very simplicity of Jackie's remark clashes with the cunningness of his nature already displayed, and it begs the question whether his dream of Ned does not become a convenient excuse to make his behavior palatable to others.

The eulogy Jackie delivers in the church stands as one of the most sentimental moments of the film, but it also challenges our interpretation. On the one hand, it expresses quite poignantly the power and satisfaction of a lifelong and intimate friendship. It charms both the lottery man who witnesses it, and, if the transfixed expressions on the faces of the congregation serve as accurate reflections, the villagers who know the irony of Jackie speaking of the man, Michael O'Shea, sitting in the pews with them. At the same time, the very power of the scene turns on its ambiguity. After all, the eulogy, as Jackie delivers it, acts as a self-conscious, if extemporaneous,

performance undertaken to fool the lottery man. Although it may be charming to think that in telling the truth Jackie is succeeding in his deception, there is no reason to believe he is any more sincere in what he says here than he was when he told the villagers at the chicken dinner that if he ever came into money he would simply "take what I need, and then share the rest with my friends."

What seems to be the most generous and straightforward gesture comes near the end of the film when, during the final celebration in the pub, Maggie comes to him for advice. "Would you say Maurice needs a father more than seven million pounds?" She goes on to reveal, admittedly somewhat improbably given the differences in age (although in the slapstick genre such illogic is often part of the narrative), that Ned Devine is Maurice's father. Jackie gallantly urges Maggie to take all the money, but one might reasonably see that gesture as nothing more than a calculated risk. Maggie has already indicated an inclination to give up a complete claim, and by seeming to take her side, Jackie provides her with the opportunity to feel she has made the right decision on her own. A true con man would know that was the best way to play a mark. An underlying cynicism permeates the atmosphere of the village of Tullymore and puts Jackie's nature in context. Although, like Jackie, the inhabitants seem easily to fall into familiar types, a persistent sense of venality and greed makes each more complicated. Annie, Jackie's putative moral compass, is as quick to go off in search of the lottery winner as is he. Although the harridan, Lizzy Quinn, appears as the fiercest embodiment of grasping self-interest, all of the villagers show themselves quick to assess a situation in terms of its benefit for them. Time and again, as Jackie searches for the winner, people ask him "have you come into some money?" Indeed, given the opportunity to profit from participating in defrauding the lottery, the villagers line up at dawn in front of Jackie's door, and as the scheme progresses, the publican Dennis Fitzgerald is canny enough to anticipate difficulties in collecting the winnings. Even the visiting priest finds himself swept into the scheme with very little persuasion. In the end, Jackie O'Shea presents a cunning, ruthless, and determined rural character not too distant from those we see in motion pictures like *Travellers* or *The Field*. The fact that he is in a comedy seems superficially to soften his nature. In fact, the overt sentimentalism of the film is as cynical as any technique Jackie himself

would use: it shows how an unscrupulous manipulator can play upon emotions to gain his ends.

Like so many Irish films of the late 1990s and of the early part of this century, *Waking Ned* winks at the viewers. It flaunts a superficial sentimentality that as some critics have complained comes very close to stage Irishness. In fact, it insinuates a much darker view. By evoking and then undermining the stereotypes of Irish identity, *Waking Ned* implies a truly sophisticated audience will understand the send up and appreciate the irony. In the process, it critiques both the simpleminded view of the Irish nature those stereotypes play to and the humorless insecurities of critics who cannot see beneath superficial representations. Indeed, this duality may prove more familiar to the Irish sense of themselves than some critics would wish to admit. Although this may not stand out as the kind of production Irish cinema critics would wish to define the medium, it is more in keeping with the national filmmaking tradition than many would acknowledge.

Part Two
Photography

5

Images of Ardnacrusha
Photography, Electrical Technology, and Modernity in the Irish Free State

SORCHA O'BRIEN

> A free Ireland would not, and could not, have hunger in her fertile vales
> and squalor in her cities. Ireland has resources to feed five times her
> population: a free Ireland would make those resources available. A free
> Ireland would drain the bogs, would harness the rivers, would plant the
> wastes, would nationalize the railways and waterways, would improve
> agriculture, would protect fisheries, would foster industries, would pro-
> mote commerce, would diminish extravagant expenditure (as on need-
> less judges and policemen), would beautify the cities, would educate the
> workers (and also the non-workers, who stand in direr need of it), would,
> in short, govern herself as no external power—nay, not even a govern-
> ment of angels and archangels could govern her. (Pearse 1922, 180)

Introduction

After the founding of the Irish Free State and the ending of the Civil War, the
next order of business for the Free State government seemed to be the order-
ing and organization of the affairs of the country. The late 1920s seemed to
be a time when anything was possible and when Pearse's vision may, after
all the fighting, have become an achievable reality. The pressing need for the

I would like to thank Brendan Delaney, Gerry Hampson, and the staff of the ESB Archive
for their invaluable help in researching this article, as well as the staff of the National College
of Art and Design library, the National Irish Visual Arts Library, and the National Library.

new country to end dependency on its former ruler and to reorganize the running of the country in a recognizably Irish fashion meant a large amount of effort went into "nation-building," both literal and figurative. Apart from the building of schools and the design of coins and stamps for the new state, one such project was the harnessing of the Shannon by a hydroelectric power station near the small village of Ardnacrusha in County Clare, also known as the Shannon Scheme. Although there had been some small generator schemes providing electrical power to individual townlands from the 1880s (Manning and McDowell 1984, 1–16), the majority of the country was unelectrified and would remain so well into the twentieth century (Shiel 1984).

There had been considerable debate as to the best way of approaching the electrification of the country. Because the power from the Shannon Scheme was expected to greatly exceed the current requirements of the state, most of which were centered around Dublin, an alternate plan for the electrification of the Liffey was discussed in the Dáil and in the newspapers (Manning and McDowell 1984, 28–38). However, the Shannon Scheme was championed by the engineer T. A. McLaughlin, who had recently returned from working with Siemens-Schuckert on the electrification of the German province, Pomerania. One of a group of German engineering companies, Siemens-Schuckert submitted a plan for the electrification of the Shannon to the government that was accepted as the best long-term solution. Work commenced in 1925 and carried on for four years, using mostly German engineers and skilled labor, along with many Irish unskilled manual workers. It was a huge undertaking for the time, both in the size and complexity of the project, compounded by problems such as a complete lack of freight transport from Limerick docks to the construction site. A core of mostly German engineers supervised the labor of up to 3,000 Irish manual and semiskilled workers in the construction of head and tail race canals, as well as the power station building itself (Manning and McDowell 1984, 40–53; McCarthy 2004, 27).

Images of Ardnacrusha: Sean Keating and *Night's Candles Are Burnt Out*

Because of the importance of the Shannon Scheme in national eyes, an attempt was made to claim the power station and to integrate it into the

developing discourse of Irishness with Sean Keating's paintings of the scheme, both allegorical and bare landscapes. Keating's work has been analyzed in the light of the building of national myths, creating and representing the discourse of Irish nationalism by scholars such as Sighle Breathnach-Lynch and Andy Bielenberg (Bielenberg 2002, 43–47; Kennedy 1991, 18–46; Breathnach-Lynch 1998). His portraits focus on the heroic figure of the "freedom fighter," and many of the larger scenes are allegorical constructions of West of Ireland peasants in an outdoor rural environment (Breathnach-Lynch 2000). His paintings, along with those of Paul Henry and their contemporaries, are instrumental in promoting the rural western landscape and its people as definitive examples of Irishness (Scott 2005, 10–13; Breathnach-Lynch 1998). The creation and solidification of these archetypes of national culture were defined during the 1920s and 1930s. They emphasized the values of tradition and rurality, and provided the backdrop for the best known image

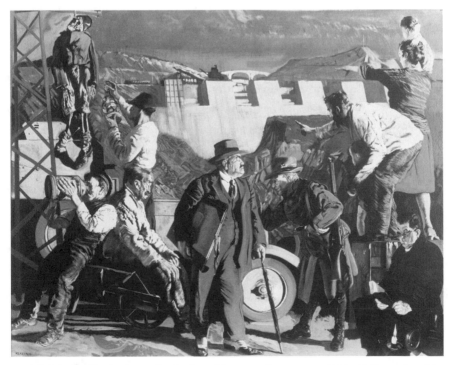

5.1. *Night's Candles Are Burnt Out* by Sean Keating, oil on canvas, 1928–29. Reproduced by kind permission of Oldham Art Gallery and Museum, and the Keating Estate.

of the Shannon Scheme, *Night's Candles Are Burnt Out* (Figure 5.1), painted on site at Ardnacrusha in 1928 and 1929.

The painting shows an uneasy allegory, with the monolith of the power station looming over the figures in the foreground. It represents an attempt to introduce the idea of modernization and electrical power to a largely rural population, and to naturalize the structure by its inclusion in the discourse of national mythology of Keating's paintings. The intention is to symbolize the great national achievements the free Gael is capable of: the vision of Ireland as imagined by Pearse. In this image, the Shannon Scheme engineers inherit the heroic mantle of freedom fighter, and the outdated candle and oil lamp are relegated to the margins, while the young family points forward to the bright future of the country. Using stage-like placing of figures and literal enacting of metaphors, Keating positions the Shannon Scheme center stage in the mind of the new Free State.

However, the representation of electrical technology and the realities of the Shannon Scheme are notable omissions from the painting. These correspond to the unrecognized and uncelebrated aspects of the scheme, those that do not fit into the dominant imagining of Irishness at the time. First, the presence of any German agency is completely absent because it interferes with the image of this heroic national achievement. The pivotal role of Siemens-Schuckert in designing, building, and maintaining the Scheme is completely ignored, despite the continuing importance of ex-Siemens personnel in the early years of the Electricity Supply Board (O'Beirne 2000; O'Beirne and O'Connor 2002, 73–99). There is no indication the image of heroic Ireland pointing forward into the future is supported by anything other than Irish engineers and Irish expertise. The second omission is that of electrical technology itself, which is rather startling, considering the artifact that inspired the image was a hydroelectric power station. To uncover the reasoning behind this blindness, however, a deeper understanding of attitudes toward technology and modernity in Ireland is necessary.

Technology and Modernity in the Free State

Building a hydroelectric power station was an enormous undertaking, particularly for a technologically undeveloped, small nation such as Ireland, which

lacked any sort of widespread industrial base. The very idea of electricity and electrification of the home was modern in outlook, and was in line with contemporary European thinking on progress and industrial development. For example, the A.E.G. in Germany and the Electrical Development Association in the United Kingdom were both involved in electrification programs, in conjunction with education programs designed to educate the people about the cleanliness and safety of this new form of power. Some of the contemporary writing is almost evangelical on the subject, seeing electricity as the key to a clean and modern society (Forty 1986, 190). However, modernizing ideas in Ireland in the late 1920s and early 1930s were not widespread among the general population, and were rarely subscribed to by the government, which was more concerned with redefining an identity for a twenty-six-county Ireland, recently partitioned from the North. The dominant ideological tendencies of the time were a combination of the aforementioned romanticized view of rural peasant life (Gibbons 1984, 1–19; Scott 2005, 14–23), and a well-developed neo-Celtic antiquarianism (Bowe and Cummings 1998; Edelstein et al. 1992; Sheehy 1980). Although these views were by no means universally held, they did represent a major sector of opinion and could not easily accommodate ideas of progress and modernity. This was partly because of a certain conflation of modernization and Anglicization in the public mind of the previous decades. A particular proponent of this idea, Douglas Hyde, had given an influential lecture in 1892 to the National Literary Society called "The necessity for de-anglicising Ireland" (Kinahan 1992, 64–79). This lecture, in addition to underscoring the importance of the Irish language, focused on dress, games, and music as cultural markers, denoting difference between cultures. Hyde assumed his vision of Ireland and Irish culture would not be compatible with a modernized world, and therefore, the country should opt out of any modernization process. This attitude had a strong influence on the shaping of the Ireland of the first half of the century, adjudging as *English* rather than *modern* such developments as popular literature, mass consumption, and government boards. The Irish Labor party and the Trade Union movement, the two most obvious locations for a strong industrial and modern ideology, had moved away from active political involvement during the process of independence in favor of social engagement. In particular, the Cooperative Movement sought a type of alternative modernity based on communal "self-help" ideas, not seeing

traditional ideas as a barrier to progress but as a stimulus (Mathews 2003, 1–6). Many of these grassroots movements sprang from a realization there was an acceptable alternative to focusing on London as a center of culture and that "the time had come for the Irish people to regenerate their own intellectual terms of reference and narratives of cultural meaning" (Mathews 2003, 7).

The Shannon Scheme Photography

To return, therefore, from the nation-building mythology of Sean Keating's paintings to the photographic images of the Shannon Scheme, the two types of images must be considered in parallel because they form alternate representations of the same artifact and undertaking, created during the same period of time. A number of factors influence how the scheme is represented, and these form a specific set of influences on each of them. When compared to the highly structured and staged representation in *Night's Candles Are Burnt Out,* the photography would appear to form a more "naturalistic" and "truthful" representation of the reality of the scheme. Much of this view stems from ideas about the status of photography as "a guaranteed witness of the actuality of the events it represents" (Tagg 2001, 93). However, although it is not as obvious a process as the slow and careful construction of a painting, photographs also contain a number of ideologically significant choices in composition, angle, exposure, and depth, as well as choice of subject. So, the photography of the Shannon Scheme contains as many encoded decisions and ideas about technology and modernity as do Keating's paintings.

The Shannon Scheme photography from this period consists of a number of black and white photographs taken during and after the construction of the power station at Ardnacrusha. There are two series of photographs in the ESB archives, a selection of which have been used to illustrate publishing on the Shannon Scheme over the years (Manning and McDowell 1984, 45–47, 55–57; O'Beirne 2000, 56–57; Bielenberg 2002, 17, 21, 50, 52, 55, 59–60, 70, 72, 79, 98, 109–10; McCarthy 2004, 15, 46, 48, 61, 67, 78, 83, 99, 102, 111, 120, 128, 129, 140, 143, 150). There is a marked difference in the quality of the photography of the two series, although the periods and dates overlap. This discussion focuses on the A-series, because it represents a significant departure from the concerns of photography in Ireland at the time

(Sexton and Kinealy 2002). It includes some 240 photographic prints from an incomplete series of almost 300, mostly mounted in six albums, with some loose prints. They are numbered and dated, and seem to have been taken in batches over the space of a year, from December 1928 to February 1930 (generating began in October 1929). They record subjects from the installation of the turbines into the turbine hall, to interior details, and the exterior work on the penstocks and races. The last fifty or so of the series record the outdoor station at Inchicore built at the same time, as well as the erection of power lines in County Cork. The albums have the name "Mr. Weckler" handwritten inside their front covers, which may refer to Freidrich Weckler, chief accountant on the project, who stayed in Ireland with the newly formed ESB once the project was completed (O'Beirne 2000, 64; O'Donoghue 2001). Whether he took the photographs himself or commissioned them from a member of his staff is as yet unclear.

German *Neue Sachlichkeit* Photography

In contrast to the emerging Irish state, Germany of the time was a society obsessed with technology. By the late 1920s, the intense post–World War I drive toward industrial development and rationalization was beginning to bear fruit. With the reconstruction of the country finally underway, the role played by technology and the study of urban and industrial life were themes explored by artists, photographers, and filmmakers alike. Advances were being made in technical areas of photography and film: the development of advanced camera systems such as Leica, the use of photography as an advertising medium—as well as in the artistic field, with the photographic experiments of the Dessau Bauhaus (Hight 1995) and films such as *Berlin: Die Synfonie der Großstadt (Berlin: Symphony of a Great City)* (Ruttmann 1927) and *Metropolis* (Lang 1928). This sense of technological possibility is presumably what attracted McLaughlin and ultimately, the fledgling Free State government to use the technological expertise of a German company in their own first step at nation building.

In Germany, the Bauhaus designer Lazlo Moholy-Nagy was seen as the leader of the Modernist/Formalist School of photography, with the main concerns being formal issues arising from the composition of the subject matter.

This new objectivity, or *Neue Sachlichkeit,* has a second and consequential role in the broadening of subject matter of photography from portraiture and landscape: the modern industrial world and urban life now become acceptable subjects. Another *Neue Sachlichkeit* photographer, Albert Renger-Patzsch, published a book of photographs entitled *Die Welt ist Schön* or *The World is Beautiful* in 1928, emphasizing the beauty to be found in ordinary objects, especially details of machines and technological objects (Wilde et al. 1997; Heise 1978, 8–14). Renger-Patzsch was interested in industrial buildings and his photography is concerned with the formal qualities of the industrial landscape (Figure 5.2)—in this case, the angled shapes of the intake pipes, arranged symmetrically against the background of the works. There is no human agency in his industrial photography because it is wholly concerned with the formal qualities of concrete and steel, and the shapes and patterns that they create. One of the criticisms of *Neue Sachlichkeit* photography is demonstrated here—that we see no context and no sense of the human agency or intervention that created these forms. This new emphasis on the modern world, seen through the lens of a piece of high technology, was immensely popular in Weimar Germany from the late 1920s. Exhibitions such as *Film und Foto* in Stuttgart in July 1929 brought the work of photographers like Moholy-Nagy and Renger-Patzsch to the attention of the public, and showcased the work of photographers across Europe and America who were concerned with technology, the built environment, and the machine aesthetic (Sichel 1995, 6–8). Therefore, it is not inconceivable one German amateur or semiprofessional photographer could have come from this artistic environment to the shores of the Shannon.

Unlike Keating's panoramic outdoor scenes, many of these images focus on details of the form and construction of the station. The choice of subject matter is also influenced by the concerns of the *Neue Sachlichkeit* as well as the necessities of a documentary project. Many of the photographs are of the turbine hall or the penstocks in various stages of construction, carrying out the task of recording for posterity. But in addition to this, there is a certain fascination with the formal qualities of half-built structures similar to the work of Renger-Patzsch, as the giant turbines are assembled and the forms for pouring concrete are constructed. This may be partly a result of the unique opportunity for a photographer interested in the concerns of the

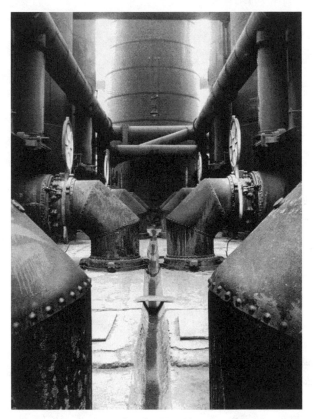

5.2. "Air Intake Pipes for the Hot-Blast Stoves, Herrenwyck Blast Furnace Works, Lübeck" by Albert Renger-Patzsch, 1928. © Albert Renger-Patzsch Archiv—Ann and Jürgen Wilde, Zülpich, 2008.

Neue Sachlichkeit movement to photograph the process of creation of form as well as the finished forms themselves.

Unlike Keating's non-allegorical paintings, which betray a sense of chaos, a landscape disrupted and torn during the same period (Gallagher 1987, 28–32), this photograph gives a sense of an ordered endeavor, both in subject matter and composition, a sense of construction, creation, and great measured feats of engineering. This sense of controlled form also runs through the interior photographs of the station. The photographer's eye has picked out physical details of the construction, some large, some small, and

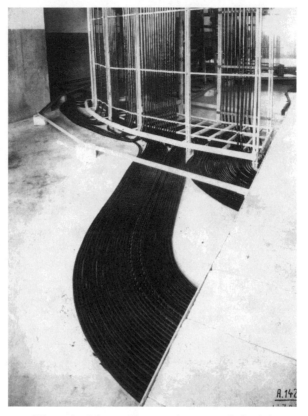

5.3. "Shannon Scheme Photograph No. A142," 7/9/1929.
Courtesy of the ESB Archive.

focused on the physical and formal qualities of the industrial structure. There
are many examples of this within the A-series, and photograph A142 (Fig-
ure 5.3) is an interior shot of cables running down a wall and fanning out
across a concrete floor. The repeated lines created by the black cables on the
pale background are articulated into geometrically precise arcs as they travel
throughout the station. The debt to the *Neue Sachlichkeit* is clear in this
emphasis on the formal qualities of the industrial environment presented for
their abstract form.

Also, in contrast to both the paintings and Renger-Patzsch's work, the
laborers in the photographs are almost always included, either still working
or stopped momentarily to stare at the camera. The sense of agency of these

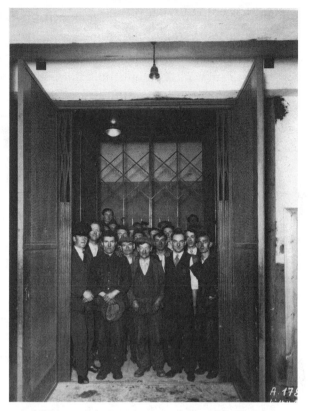

5.4. "Shannon Scheme Photograph No. A178," 4/11/1929.
Courtesy of the ESB Archive.

anonymous workers is strong because they are allowed by the photographer not only to be present alongside their creation, but also to look out at the world through the lens, often quite proprietarily. The resulting images show a sense of inclusion in the work, as well as ownership. The photographs of the testing of the lift are especially interesting in this respect. One of a series of three photographs (A176–78) particularly demonstrates this. The first image is of the empty lift, and the next has a suited gentleman walking across the lift compartment. The third image has thirty-two men squashed into the lift to demonstrate its carrying capacity (Figure 5.4). The men vary from suit-and-tied engineers to a number of manual workers—who have been brought away from other tasks for this demonstration—judging by their overalls,

caps, and goggle marks. A certain stiffness can be detected in the novelty of posing for the camera, along with deathly seriousness, embarrassment, and amusement, but this photograph displays a sense of active involvement with a great collaborative piece of work. Not only does this photograph carry out the function of recording that the physical functioning of the lift has been checked, but also records the participation of the workers in creating this moment. Again, this is where these photographs differ from their German antecedents—the great building project of the Shannon Scheme is recorded as the product of man's labor, rather than springing from the ground fully formed and shining, without human intervention.

The "Currency" of Photographs

In the study of representation in images, there is an added dimension to the discussion that needs to be addressed. First pointed out by theorists such as Susan Sontag and Roland Barthes (Sontag 2001; Barthes 1982) and developed in journals such as *Camerawork* and *Screen Education* (Evans 1997; Alvarado et al. 2001), this provides a method for dealing with the "frozen moment" of the photograph and reinserting it into a contextual discussion "of the production, circulation and consumption of the photograph within particular institutions and under the regulation of technological, economic, legal and discursive relations and problems" (Alvarado 2001, 151). Photographs, along with paintings and other image-based representations, may convey meaning and ideologies in their content, but there is also a parallel encoding of meaning and ideology in their use and manipulation as material objects and artifacts. Despite the lack of any authentic aura of originality as identified by Walter Benjamin (1935), photographs are also produced and traded as commodities, and can also be read from the perspective of their circulation and currency. This is particularly important in the case of the Shannon Scheme photographs because they were created in an environment that privileges the traditional, the original, and the authentic over the modern and the reproduction. Despite having the technical capability to reproduce the A-series photographs, for example in the *Siemens: Progress on the Shannon* newspaper published by Siemens from 1926 to 1929, or in the ESB's newspaper advertisements, these outlets restricted themselves to the use of the unexceptional numbered series, Sean Keating paintings

and hand-drawn illustrations (*Siemens: Progress on the Shannon*, 1927; *Irish Sketch*, 1928). The A-series photographs remained unused within the ESB archive until the 1990s, when a resurgence of interest in the Shannon Scheme prompted their use as book illustrations. This provides a distinct contrast to the reception of Sean Keating's paintings as the favored representation of the Shannon Scheme—exhibited and reproduced throughout the century.[1] It is also ironic, considering many of the audience had only seen *Night's Candles* through the medium of reproduction because photographic reproduction did have a widely used and accepted role in Irish culture from the 1920s. What seems to have mattered, though, was it was a reproduction of an original, traditionally constructed and composed painting, rather than an avant-garde, highly technological photographic image.

The poor currency of these avant-garde photographs throughout the life of the Free State is hardly surprising, considering the dominant attitudes toward technology outlined above. They are clearly the product of modern, progressive thinking, not just in terms of technique, but also in the choice of subject matter and composition, and their apathetic reception echoes the lack of enthusiasm about modernity. This is particularly evident when photographs are considered as displays of technological power. They symbolize "the power of technology to transform the material world into appearances, into representation, thus also a display of command, control and authority" (Lundström 1999, 59), dissecting and controlling the world through the lens. They are mediated by the shutter, the lens and the mirror, the film and its arcane developing processes, rather than the humble (traditional, "natural") artist's paint brush and because of this, do not integrate well with the ideologies of the new Free State.

There is one exception to this lack of recognition of the Shannon Scheme photography during the 1930s. Photograph A69 is of a man standing inside the finished penstocks of the power station (Figure 5.5), and continues the previous themes of man within the industrial environment. The photograph

1. *Night's Candles Are Burnt Out* has been exhibited continually—from 1929 in the Royal Academy in London to the seventy-five-year commemoration of the Shannon Scheme in the Hunt Museum in Limerick in 2004, and is now in the collection of Oldham Art Gallery & Museums in Manchester.

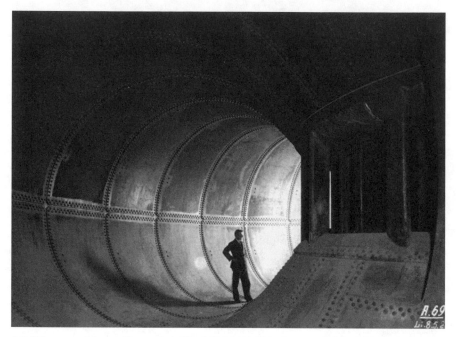

5.5. "Shannon Scheme Photograph No. A69," 8/5/1929. Courtesy of the ESB Archive.

is made particularly striking in its use of high contrast (common to all of the A-series photographs) and by the off-center circles of the penstock tube curving around and into the distance. Although prints remain in the ESB archive, no reproductions of the photograph have been found before 2000 (O'Beirne 2000, 57). However, a version of the image was reproduced in 1932 in the *Saorstát Eireann Irish Free State Handbook,* a government publication celebrating ten years of the Free State. This book had a neo-Celtic interlace cover by Art O'Murnaghan, and covered subjects such as Irish geology, natural history, agriculture, and education. The only exception to this is a separate chapter devoted to "Power Supply in the Irish Free State." An illustrated monogram letter, following the pattern of illuminated manuscripts, followed each chapter heading (*Saorstát Eireann Irish Free State Official Handbook* 1932, 57). It is in this monogram letter that photograph A69 appears, in the form of a woodblock print by noted Irish landscape artist Sean O'Sullivan (Figure 5.6). This is completely in line with the contemporary currency of the Shannon Scheme photographs—they are problematic in

NE
witl
Fre
the
Riv
as c
thei
mac
dist
cou
tion
adn
Elec
to a
Cou

5.6. Monogram letter from chapter on "Power Supply in the Irish Free State" from the 1932 *Saorstát Eireann Irish Free State Official Handbook,* p. 157. Courtesy of The Educational Company of Ireland.

their use of technology and can only be rendered "safe" by representation in a traditional form, mediated by an established and legitimized fine artist. This representation of the image allows the striking circular imagery of the penstock to be reduced to the controlled and bounded position of a capital letter, safely encapsulated within the dominant traditionalist ideology of the state.

The Shannon Scheme photographs form a possible influence on Irish visual culture of the 1930s that never came to fruition. As examples of modern, technologically mediated images, they were too different from the surrounding culture to be readily accepted and circulated, despite the fact they were documenting a large technological undertaking. Irish visual culture of the early 1930s displays a certain reluctance to engage with the ideological questions the use of technology brings, particularly to a small, unindustrialized country. The enabling agents of that technology, the German engineers of Siemens-Schuckert are elided from the visual discourse on the scheme, in favor of a dominant "nation-building" ideology. The poor currency of the Shannon Scheme photographs can be attributed to their creation as overtly technological images within a culture concentrating on imagining the self in terms of nature and romantic tradition, rather than technology and modernity.

6

Moments of Story
Rachel Giese's *The Donegal Pictures*

CHRISTINE CUSICK

> History is everywhere. It seeps into the soil, the subsoil. Like rain, or
> hail, or snow, or blood. A house remembers. An outhouse remembers. A
> people ruminate. The tale differs with the teller. (O'Brien 1995)

Edna O'Brien's words begin a fictional narrative of broken lives and broken
stories; a tale that in every way enacts the movement suggested in the novel's
opening lines. History as movement, as infusion of soil, as the remembrance
of a physical structure, and as the vacillation of human thought: O'Brien
creates the past in relation to the *ways* in which it manifests itself in pres-
ent memory. She extends remembrance not only to human subjects but also
to material sediment and physical structure, suggesting these ways might
involve a system of reflection, or just as easily, a physical condition. The past
is sensory; it is wet and hard, cold and hueless, warm and vibrant. And as
interpreters of these sensations, humans muse and ponder, digest and, like
cattle chewing cud, ponder again. In all of these forms and through all of this
deciphering, stories are created and told, their movement and form telling
more about their teller than that which they recollect.

Photography, as science and as art, demands attention to material cir-
cumstances of proximity, climate, and perspective. As such, the process and
product of the photographer calls for ecocritical study, an academic path
that seeks to uncover the connections between how the natural world is rep-
resented, conceived, and consequently, used by humans in cultural texts.
Through both process and product, landscape photography is an interpretive

engagement with the natural world. The careful photographer waits for the right light, the calm wind, the ready season. Her waiting is in itself selection and mediation. Decisions inscribe the place that is captured, and yet when the photograph is read as an objective, mirrored reflection of its subject, these decisions are often consumed by the stillness of the image.

However, when the photograph is read as a consequence of such decisions, the visual image teaches us a great deal about how nonhuman nature and humans construct each other through processes of representation. Landscape photography has the potential to contain the physical land, offering an illusion of landscape as stable, and dangerously constructing the photograph as a manifestation of memory that is likewise static. Such representations of the natural world, without consideration of their epistemological consequences, have the potential to alienate humans from nonhuman nature and further legitimate disinterested, anthropocentric use of it. Placing the photo-essay within its appropriate cultural context, and viewing it through the lens of a changing tradition of landscape photography in Ireland, this ecocritical study uses Rachel Giese's *The Donegal Pictures* to explore ways of knowing the Irish landscape through the photographic image.[1] Integrating an ecocritical framework and close readings of Giese's photographs, this study navigates how she both engages and reimagines remembrance of place and, in so doing, offers an image of Ireland that honors the interface of cultural and natural histories.

The historical context for visual images of the Irish landscape is largely indicative of insurgent responses to colonialism, the nationalist impulse of the Free State, and the contemporary economic endeavors tied to development and tourism. Spurgeon Thompson's "The Politics of Photography: Travel Writing and the Irish Countryside, 1900–14" explores the sociological implications of English travel writing that simplified and commodified not only the Irish landscape but its inhabitants as well. He links this use of an outsider narrative to the signification process of the photographic image: "[p]hotography . . . enables people to stand as spectators, to aim a device at the landscape and at other people to capture an image, and to move on. It enables a detachment from society" (Thompson 1999, 117–18). Thompson

1. Since the time of *The Donegal Pictures'* publication in 1987, Rachel Giese has published and exhibited her work by the name of Rachel Brown.

supports his reading of this process with an allusion to Fredric Jameson's similar theorization in *Signatures of the Visible* (1992), thereby concluding "the moment of self-reflection or self interrogation, that pause to inquire into how one fits into an encounter is usually eradicated by the activity of photography" (Thompson 1999, 118). Thompson's reading suggests it is the process more than the product of photography that creates an alienated subject. Indeed, the tradition of landscape photography that contextualizes this study attests to such a reading. However, in Giese's photographic representation of Donegal, the images confront photography as an isolating act. The images show an engagement of person and place; but, because of their narrative quality, because the photographs speak to one another, because the images are caught in mid-action, in mid-story, Giese implies the presence of a spectator who is inevitably caught behind the lens, but who has also put down the mechanism long enough to encounter diverse terrains and their inhabitants, and to listen to the stories that mark both land and community.

Giese's engagement with her subjects is both artistic and physical. This embeddedness with both person and place distinguishes her work from the agendas of the early and mid-twentieth-century artistic movements. Thompson points out that just as the Irish literary revival of the early twentieth century sought to debunk colonial characterizations of the Irish "buffoon," there was also a Nationalist response to such travelogues; Thompson locates such idealized pictures of the Irish countryside within the "context of a battle over the representation of Ireland" (Thompson 1999, 124). Thompson's positioning of the photographic image as a part of such tension indicates the visual representation of the Irish landscape and people has inscribed a cultural memory of Ireland's history. When it was to the colonizer's advantage to cast the Irish terrain and its people as savage and primitive, and then to the Nationalist's advantage to use this idyllic rural landscape as a reactionary reinforcement of national unity, this interconnectedness is profound and consequential.[2] Rachel Giese's *The Donegal Pictures* is clearly marked

2. Tricia Cusack observes: "Cottage life was therefore misrepresented first to suit the ideologies of the colonizers, then of the new state. Each had a vested interest in the notion of the 'happy peasant'" (Cusack 2001, 227).

and influenced by this colonial history of landscape photography. Her work both engages with a cultural memory of place and disrupts its foundational assumptions of the Irish landscape as unchanging. Giese offers a visual narrative of the rural community of Donegal, and through her emphasis on the terrain's geological and biological materiality, her disruption of "natural" boundary, and her recognition of human labor and work, Giese crafts a narrative that essentially connects humans to land through story.

Representations of the Irish landscape are dependent upon the stories that rely upon the changing scripts and expectations of cultural memory. D. George Boyce's essay on commemorative practices in Ireland, "'No lack of ghosts': Memory, Commemoration, and the State in Ireland," invokes Raphael Samuel's theorization of memory, which purports memory is "[h]istorically conditioned, changing colour and shape according to the emergence of the moment" (Boyce 2001, 255). Within the context of Ireland's commemorative practices, this theory implies the pieces of Ireland's cultural memory are indeed performative. Therefore, these theories of signification and memory merge at two levels within this ecocritical study of Giese's work. First, the photograph is dangerously susceptible to presenting itself as an authentic reflection of a place. When we read the photograph as a system of signification that connotes ideology, this danger is confronted and the processes of taking a picture and reading a picture are communicated as selective acts. Moreover, the ideology and specificity indicated by a visual image are linked and interpreted through the lens of a changing cultural and individual memory of how the land has been used and what it has come to signify. In Ireland, this memory is necessarily reminiscent of the discourses of colonization, nationalism, and recovery.

During the late twentieth and early twenty-first centuries, this memory and these visual representations of the Irish landscape have also been commodified and manipulated by the tourist industry. Land is framed within the economic agendas of tourist brochures, coffee-table books, and travel videos. Internet sites for the Irish Tourist Board use the visual image of Ireland's landscape to signify the type of experience the traveler should expect in Ireland. In this way, the tourist industry uses word and image to construct a very specific identity not only for the Irish land, but also for the Irish people who

inhabit this land.[3] Such photographic essays chronicle Ireland's landscape in very general terms: the landscape is most often expansive, cast in contrasting shades of light and dark. Giese's achievement in *The Donegal Pictures* is in striking contrast to such narratives: it frustrates expectations of a pristine landscape, defamiliarizes that which the reader has accepted as familiar, and challenges clichéd constructions of an Irish national identity.

Giese's photography demands the reader's attention to geographical specificity. The collection captures the life and landscape of a northwest Gaeltacht community in Donegal. Such an emphasis on locale lies in contrast to the more commercial collections that often position vaguely identified images of rural countryside under the general and nonspecific label of "Ireland." Within this emphasis on regional proximity, Giese's images further specify the geological and topographical diversity of the Donegal terrain. While other photo-essays focus on the grandness and expanse of the Irish landscape, Giese contrasts and redresses oversimplified accounts of the land as distant scene. Her images position the physical magnitude of the landscape against its minute specificity so that, for example, the wide vista of turf is understood against and because of the equally valued fibers of bog cotton. In so doing, Giese's photography does not allow the reader to understand the whole of the landscape without a consideration of its parts.

Giese's invocation of cultural memory might be best understood within the context of what Mieke Bal calls "narrative memory" (Bal et al. 1999, viii). Bal suggests narrative memories are not necessarily wilful remembrance but include "those involuntary memories that surface when the narrator hits upon them by some gesture, some ordinary sense perception that evokes them" (Bal et al. 1999, viii). Within the context of Giese's photography, the reader has a similar experience, in that the images of the landscape call to a cultural memory of how the Irish landscape is a part of the past and present. As readers, we see rough shores and tumbling hills, but they are not the flat surface of an uninhabited context. The scenes are multidimensional and

3. Moya Kneafsey examines the impact of the Céide Fields Heritage project on the inhabitants of its region in County Mayo, arguing the financial and political agendas that drive its establishment neglect the lives and economic realities of the natives who work and reside in the surrounding villages (Kneafsey 1995, 149).

complex. The turf is burning in the cottage fire, for example, but the fireside does not possess the quaint rusticity of primitivism; it is the bright tile of modern convention. Giese's images force the reader to see this turf must first be cut by strenuous human labor.

The photographs thus evoke and rewrite the ways in which the Irish sense of place inscribes Irish cultural identity and engage with the picturesque ideal that so often surfaces in commercialized texts. Yet Giese also reinvents these images within a present moment. In doing so, she forces the reader to reassess what it means to live as part of the terrain, to *use* its resources, to travel upon its rocks, and inevitably to alter its natural processes. For just as material and elemental changes of the natural world teach humans how to adapt and respond to the natural cycles, so too does human inscription and manipulation of the natural world affect its capacity to sustain these cycles. Thus, Giese allows the mediated nature of the visual image to construct a new narrative for Ireland's landscape. Giese's images uncover the magnificence of Donegal's terrain, and yet, they demonstrate this grandness is most astutely seen through physical engagement with the natural world. Giese's photographs position the physical grandness of the Donegal landscape against subtle indications of the ways human presence marks its grandness. Roadways lead the reader's eye *to* the vast hillsides, illustrating that although time and natural processes form the geological complexity of this terrain, so too does human presence.

The first photograph of the collection, "Errigal under Rain," begins the series with the shadows of storm clouds that seem to be slowly moving through the crest of Errigal mountain (Figure 6.1). The light and dark of the clouds reveal pieces of the mountain, its shadows of rock and frost mirrored in the sky. These nuances tell of the visual complexity of natural interactions. The photographer is a significant distance away from Errigal, such that she can capture the faint outline of the hill. However, the lines of the horizon and the expanse of stone and bog are broken by a traveled road that runs into the forefront of the photograph's frame, its beginning not indicated, its end only alluded to as it reaches over the crest of the field's slight hill. Markings within the graveled grooves of the road lead an unseen vehicle into the depth of the landscape. Remnants of a built wall are positioned against a disarray of stones randomly cast onto the ground by thousands of years of natural wear

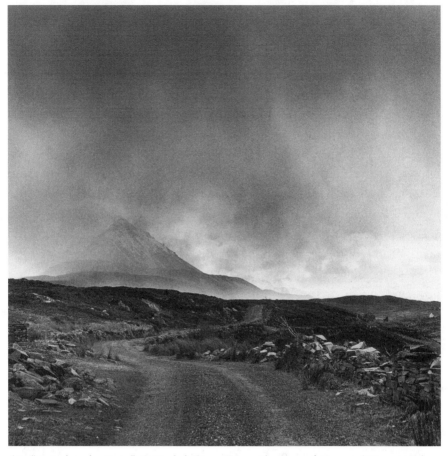

6.1. "Errigal under Rain," © Rachel Giese. From *The Donegal Pictures* (Winston-Salem, N.C.: Wake Forest Univ. Press, 1987). Used with kind permission of the artist.

and geological disruption. And yet the road, its presence not a consequence of geological processes, is just as present within this landscape as the stones and hill. Within this frame, the road forbids the eye to rest for too long on any one image of the landscape, demanding awareness that it is simultaneously a part of human and nonhuman action. The layering in this photograph is not only present in the rows of stone and bog. Giese's caption, "Errigal under Rain," immediately positions the grandness of the mountain beneath the skies; it receives the rain. Therefore, the associations of a mountain's peak as signifier of the highest natural point is disrupted as the reader sees that

climactic changes can softly, though quickly, disrupt even the assumed hierarchies of the natural world. The naming of this hill recognizes geographic borders as well; Mount Errigal exists as a bordering landmark of Donegal, its opposite border touched by the Atlantic sea; the natural boundaries inspired by the cartographic ones, signifying the end of a named place and the natural beginning of a new one.

The eye meets the horizon via a traveled road in a similar way in Giese's "The Mountain Road" (Figure 6.2). The horizon lined by a softer rise of a hill, the perspective shifts slightly from the road's center, as in "Errigal under Rain," to the side of a road that is likewise traveled but marked also by the faint whiteness of snow and water. In a similar manner to the clouds of "Errigal under Rain" these images suggest an active, moving landscape—a wind blowing the tall grass and weak tree to the west. Perhaps closer to the mountain's peak than the road leading to Errigal, the location of this photograph and its resistance to stilled details of the terrain assures the material changeability of this place. The stone and gravel dissemble the changeability of the terrain as a part of the natural scape, when in fact the road is a consequence of human presence. The construction and travel of roads tears away the very sediments natural processes take years to enact. Although the caption of "Errigal under Rain" positions the mountain beneath the cloud's rain, the words "The Mountain Road" call the eye's attention away from the horizon to the textured shifts of the pathway, the point of access that leads the reader's eye to the horizon. The expanse of this photograph is not the line of the horizon but the perpendicular line of a road that captures depth rather than breadth. Such emphasis is in contrast to the expansive picturesque vistas in much landscape photography, which highlights the photographer's position as spectator, and enacts a sort of human voyeurism of the land.

Giese's photographic emphasis on the magnitude and grandness of Donegal's terrain demands attention to its specificity and to its recurring pattern. "Low tide at Magheraroarty" has small stones of the shore in its forefront; some of the stones rise just above the tidewater, some are hidden beneath its shallowness, indicating these as changeable waters. The hills' mirrored image cast upon the water brings them closer to the stones—the subtle contrasts making the hills seem almost unreal. The hills that so often come to signify a fortressed magnitude of Ireland's terrain are made shadows by the

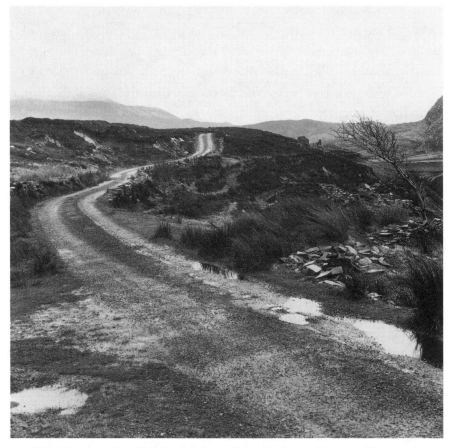

6.2. "The Mountain Road," © Rachel Giese. From *The Donegal Pictures* (Winston-Salem, N.C.: Wake Forest Univ. Press, 1987). Used with kind permission of the artist.

water and stone. At the same time, light allows this image to weave together pieces of the landscape, using shadow of horizon against water to contrast the specificity of water over stone. The source of this light is not clear because the sky is so faint it begins to blend into the blank space that surrounds the frame of the photograph. Yet, the effects of the light are present in the inter-action of land and water, water and stone. Similarly, the name given to this image suggests the presence of an unseen natural force: the moon's pull upon the earth's water is made clear not only through the caption's positioning of action with locale, but also in the way this labeling of event interacts with the manifestation of tidal forces upon water and stone. Again, Giese frames the

vastness of terrain through its specificity and the natural processes that shape this specificity. The interaction of water and stone is not merely a universal, nonspecific material interaction. Within the ecological patterns of Ireland's natural history, human connection to rock has had profound consequences. John Feehan's "Heritage of the rocks" explores this interconnectedness:

> The ways in which the human community has exploited nature in Ireland, and the opportunities for its survival and renewal, have been and continue to be shaped by the heritage of the rocks. The unique patchwork landscape of Ireland has resulted from more than nine thousand years of interaction between man and nature on the island. (Feehan 1997, 21)

Giese's visual construction of the interactions between rock and water, lunar tug and shoreline, does not merely use natural processes for aesthetic effect. Rather, it articulates this place as it is inevitably performed by and through ecological rhythms of time and pattern. In capturing these connections, Giese's work beckons to the natural "heritage" to which Feehan alludes.

In addition to representing natural and cultural cartographic readings of the terrain, Giese's photography highlights the lines that separate the natural world from the buildings that isolate humans. Giese's photographs recognize "house" as an indication of human story as well as a physical structure that frames human perspective of the natural. However, her treatment of "house" expands traditional representations of Irish rural architecture. Not only does Giese capture houses other than the idyllic Irish cottage, but she also dismantles romantic conceptualizations of the rural cottage as a primitive, dark abode removed from the effects of modernization. Giese's thwarting of romantic expectations of the Irish cottage image participates in the political and cultural memory largely responsible for constructing it. Tricia Cusack incisively studies the "cottage landscape" image in relation to Irish nationalism, recognizing the effect of the photographic image's inception on constructions of the cottage as emblematic of Irish rural identity: "The expansion of photographic images in travel books gave documentary weight to popular images such as that of the cottage, and its accessibility as a photographic object (unlike, say, the shamrock) made it a common touristic symbol of Irishness" (Cusack 2001, 225). Locating this image within its

historical context, Cusack recognizes it as a consequence of the British pictur-
esque artistic movement: "The cottage image thus developed out of an eigh-
teenth century picturesque tradition and became popular especially in the
modern period because it was useful government propaganda and because it
met a need for a familiar national image for Irish people at home and abroad"
(Cusack 2001, 227). Giese's photographs reinterpret this national image and
thus, use cultural memory to reassess an Irish sense of place.

Giese's representations of houses as material inhabitants of the land are
similar in that they all seem to bespeak a substratum of past and present
histories, some tied to a rural ideal, others to a complex colonial presence.
"A stately house in Gortahork" calls to the past most explicitly in its title.
"Stately" confers upon the house qualities of dignity and elegance. However,
this description also speaks to its nineteenth-century associations with Ang-
lo-Irish landlords who would manage the land and its tenants from within
the walls of such homes.[4] Therefore, within a collective historical memory,
such a "stately house" would carry connotations of economic inequities as
well as the stigma of the nineteenth-century Land Wars.[5] The location of
this house at the center of the frame suggests the house is deliberately iso-
lated from the surrounding fields, a position in keeping with the estate house
often far removed from the land it managed. Moreover, the physicality of
the house, as well as the surrounding grounds, is one of considerable order.
The symmetry of the house's windows mirrors the two paths of flowers lead-
ing to a larger garden. An aged tree leans from left to center, bending gently
over the structure of the house. The human presence upon this land is evi-
dent not merely in the house but also in the manicured landscape. Although
this land perhaps fulfills one's expectation of "stately," the home itself does

4. This brings us to a complex and intricate historical context involving not only the
political and economic ramifications of the landlord presence as a colonial tool, but also the
ways in which this presence changed with the establishment of the Land League and the conse-
quent Land War, 1879–82. For a thorough and incisive historical analysis of these connections
see R. F. Foster's chapter, "The Politics of Parnellism" in Foster 1988.

5. In Gerald Moran's account of Land War imagery, he notes the land question at this
time "was closely associated with the economic issues of poverty and subsistence crises.
Both of these issues centered around how land was held and managed as resource" (Moran
1999, 39).

not. The desolate position assumed by the house is replicated within its walls as well. Although hung curtains indicate the house is inhabited, its weathered exterior walls suggest the inevitable wear of time, wear that has not been erased by the restoration one might expect of such a "stately" house. Therefore, through these subtleties, Giese's image suggests that, although this house contains stories and may evoke memories of a layered past, in the present material state of this photograph, it, like the stories that have been and will be told about it, has changed. The image of this house participates in a mnemonic conversation with a past the caption gestures toward, but only the reader can complete.

The reader's completion of this story cannot escape the way "A stately house in Gortahork" speaks to the photograph just across from it, "English slate roof." Nestled within a significantly more overgrown terrain, this cottage-like house simultaneously locates and disrupts the genre of traditional rural Irish landscape cottage scenes. The house is reminiscent of the thatch-roofed cottages so common in nineteenth-century romanticized representations of the Irish peasantry, and yet, this house sits not on a crest of a smooth green pasture, but in the thrust of overgrown terrain as high as the cottage's roof. Moreover, the roof of this house is not thatch at all, as Giese's caption carefully points out; the roof is made of "English slate," a material that would begin to replace thatch in the nineteenth century as industrial and transportation advancements in Britain would make slate more accessible.[6] Therefore, the material of this roof is indeed "English" not only in origin but also by association with the industrial revolution that would make it available to a Donegal builder. The initial accessibility of such products in the nineteenth century is indicative of England's colonial presence in Ireland. And, although the introduction of new building materials as well as new farming techniques and equipment slowly brought Ireland toward agricultural modernization, this progress is simultaneously a complex indication of colonial presence. Furthermore, it would have a far-reaching impact on the distribution of work in Ireland, and would hence contribute to the economic decline in Ireland's West. Unlike England, Ireland was not

6. For a more complete assessment of the historical and archaeological contexts of the thatch roof, and of the factors that contributed to its waning presence, see Letts 2001.

benefiting from the large-scale impact of industrial change, and therefore, could not compensate for the disruption of rural labor force. This house seems to have become almost indecipherable from its surrounding terrain, branches growing against the wall and into the moss-covered crevices of the slate roof, suggesting at some level, that natural processes remain unresponsive to such politics. Although the slate may be of a different place, it is soon made a part of the shrub's growth and of a new natural history. However, the memory that underwrites human conceptualization of this image is not so free of ideological implication.

Giese's photography poses a connectedness between humans and the natural world rooted in their experiential relation to one another. Her images locate such relation most specifically in her process-oriented representations of work. Giese's emphasis on the stages of agricultural practice recognizes human use of the natural land as progressive and time-focused. The rural life so often associated with constructions of Irishness implies an economic dependency on the land, a learned understanding of its cycles and changes. Yet, when landscape photography freezes images of this land, particularly when the land is seemingly uninhabited, the realities of a worked, changed landscape are often erased so that vista is made symbol for the rural, although the interaction that sustains human presence within this land is essentially neglected.

However, through both process and product, Giese's photographic gesture maps not only the possibilities of how the natural terrain is physically present, but also the possibilities of how its human readers become its writers. Rather than imply human use and interaction with the landscape, "Putting out the cows in Prochlais" subtly *shows* it through both words and image. Offering a linguistic framework for land work, the title of this photograph calls attention to action within place. A traveled road winds against a stonewall and up a narrow path. Upon this path, an elderly man, named Hugh Sweeney in Giese's references, seems to struggle to traverse the road, two walking sticks or braces supporting a physically tired body, hinting at this as an aged chore. The worn terrain mirrors the characteristics of the task and the man. There is parallelism in the lines of this image as well; the curve of the wall has guided the path of absent vehicles, their mark following the bend of the barrier. But the man's stature also reflects this alignment. The bend of

his left knee follows the worn tire marks of the road, a road that sustains the man's weary gait; this photograph portrays a man's tired ambulation within an equally tired landscape. Still the action persists, as the cows move forward and the man watchfully follows them.

The exhausted landscape of "Putting out the cows in Prochlais" lies in considerable contrast to "Newborn lamb." A faint hillside cradles distant homes and roads in what seems to be a shadowed contrast to the lit field of the photograph's foreground. Sheep and border collies step upon a tended field, the photograph's title forcing the eye to look for the smallest life that stands as tall as its thin legs will allow. The new life of a lamb is held against two adult sheep, and this circle of age is paired against the young and old of the canines who lead them. Yet, this field also holds a human presence; a man stands in the sun's path, his shadow marking the grass as he watches the young lamb. Giese captures young and old of two different animals, the interruption of the sun's rays by a man's frame, as well as the contrast of a muted hillside that seems amazingly still against the brightness of the newborn lamb's surroundings. What is represented as unknowable is not the distant vista of patchwork fields; it is the interweaving of new life, light's shadow, and man's watch that comes to the reader in the foreground of the image. "Newborn lamb" allows for wonder, and yet, this wonderment is not necessarily complicit with the romanticization of rural Irish life. Rather, what Giese suggests through this photograph, understood within a context of many, is recognition of the material use and disruption of the natural terrain does not necessarily erase the moments of awe a man standing in the sun, on a field with lamb and dog, may experience in a day's work.

"Ballyconnell sheep market" and "Penned sheep" offer an economic context for the birth of this lamb, emphasizing he is a part of a larger day's work. Calling attention to this animal as a participant, or perhaps victim, of commerce, "Ballyconnell sheep market" pictures a lone sheep on a center stage, surrounded by its potential owners. The light and gentleness of the field in "Newborn lamb" is replaced with the shadows of an austere showroom, and the reader is reminded the reality of rural life involves more than the image of animal upon land. It also requires work and industry to sustain the animal and to make use of the land. In a roomful of talking and gawking men, the touching shoulders of two men frame the stare of the sheep.

The cramped room of men in this market sits in contrast to the opposite photograph, "Penned sheep," where sheep are packed within the boundaries of a chaotic frame, perhaps awaiting their turn on the stage of the market. The physical space of this market and pen subverts the open fields of the expected rural scene, thus calling attention to the commerce so closely tied to rural life.

Understandings of work are perhaps most complexly personified in the agricultural use of the bog lands. The relationship between the Irish bogland and its inhabitants is fraught with dualistic tension. Although this natural area is an integral part of the romantic imagination to which early twentieth century nationalist ideologies and contemporary tourism appeal, for its natives it is a natural foundation that both gives and takes from them. This tension manifests itself in the work of farmers whose productivity in cultivation depends on their keeping this bog at bay: "For farmers, life is a struggle against the bog which always threatens to encroach upon the small green patches of cultivated land which spread out from the farms and villages and around the feet of the hills" (Kneafsey 1995, 138). Kneafsey appropriately defines the Irish farmer's relationship with the bog through and by a victory-less and time-intensive struggle to demand its arability. Although the bog resists cultivation, it does indeed contain a usable resource in its turf and nutrients in its grass, perhaps examples of the natural world dictating its own use

> Yet although the locals are faced with a day-to-day struggle against the bog, it provides them with turf for their fires and grazing for their cattle. The bog has shaped a whole way of life for generations, and is intrinsically connected with the folklore and mythology of the west. (Kneafsey 1995, 138)

The bog's connection with the folklore and mythology of Ireland's coastal west has in large part dictated its visual and literary constructions. The artist, or even the Nationalist, who seeks either an imaginative or political muse is, of course, drawn to a land that preserves the past through its connection to ancient story and legend. As a result, narrative scripts of the landscape neglect the less romantic connection of working farmer to turf. In many ways, Giese's photography of the Donegal bog rewrites this script, as well as

the work of the turf cutters who labor for access to what the bog land is willing to provide for them.

The Oxford Irish dictionary records the Irish word for sod as *fód* or *fód móna,* indicating a sod of turf or layers of turf; likewise *an fód dúchais* means one's native place. These simple linguistic turns indicate an understanding of the material earth that involves both geological layers and their formation of a human sense of origin. A linguistic mapping of the Irish word for earth is perhaps mirrored in the processes involved in its material excavation, and it is with these processes Giese's photography is concerned. "Drying Turf in Spring" contrasts the soft bog cotton and captures a small stream against the gritty density of an anomalous spring image and "Turf Bank" offers a subtle shift of perspective in its framing of a light-touched turf field (Figures 6.3 and 6.4).

Smooth edges of the broken turf pieces lie in contrast to the rough grass of the bogland, the wall of the bank traveling to the edge of the frame, its pattern of lines revealing years of settling earth. Although these two photographs construct an image of turf as a still collage of angled sod and thicket bog, this visual impression is not left untouched. Giese illustrates an excavational human engagement with this earth, as turf cutters work against the natural processes of the bog to transform it into a usable source of fuel. "Taking out the Turf" captures an arduous moment in this transformation (Figure 6.5). A spade's blade is deep within the turf, its handle pushed by a person whose presence is only made known by the toe of a mud-covered Wellington boot and the slant of a shovel's handle. Another man's action becomes the most clear indication this is a labored land, his fingers deeply entrenched into the moist turf, the veins raised from beneath the skin of his forearm, his knuckles white with strain.[7] The man's physical embrace of the sod is clear in his face as well, eyes focused down, the flex of his face muscles suggesting gritted teeth. He stands within the sod; his feet follow the path the spade crafts, and his strained back brings him closer to the sod he takes.

7. In Ciaran Carson's "Introduction" to the collection, this photograph is included as one example of what Carson calls the "narrative moment." This photograph, according to Carson, realizes details by "direct action" where the spade, "just about to dislodge the sod, is balanced against the straining sinews in the man's wrist, the veins in his arm" (Carson 1987).

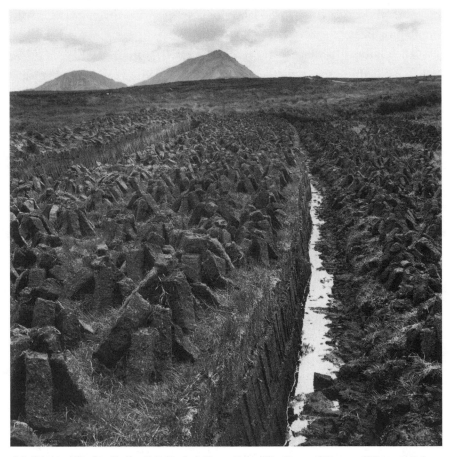

6.3. "Drying Turf in Spring," © Rachel Giese. From *The Donegal Pictures* (Winston-Salem, N.C.: Wake Forest Univ. Press, 1987). Used with kind permission of the artist.

In addition to augmenting the photograph's emphasis on active work, the title given to this photograph positions the action in relation to the material earth. The sod is not just taken, it is taken "out" of something; it is taken away from its larger source. This phrase recognizes the use of a land is not only being taken as resource but is also being left behind.

"Cutting Turf" further suggests the motion and disruption involved in an excavation of the turf (Figure 6.6). Two men unearth the sod, digging it from its depths, and tossing it to the bog's surface for drying. The blurred image of a piece of turf leaving the hands of the worker indicates motion of

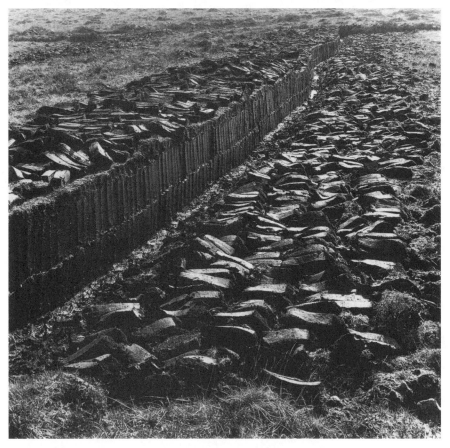

6.4. "Turf Bank," © Rachel Giese. From *The Donegal Pictures* (Winston-Salem, N.C.: Wake Forest Univ. Press, 1987). Used with kind permission of the artist.

earth and time. This dense soil formed naturally over thousands of years is taken from its base in a matter of moments. The darkness of the turf contrasts the lightness of the air and the sky that hangs over the geological enormity of what seems to be the recurrence of Mount Errigal. Although the vastness of mountain and the density of bog declare the fortitude of natural processes, this power is suddenly pale in comparison to how quickly the men's cutting action can wear away the earth. Yet, this is what it means to live in a rural life. Heritage centers may long to celebrate the cultural significance of a terrain that can preserve time, but the simultaneous reality for those who live upon

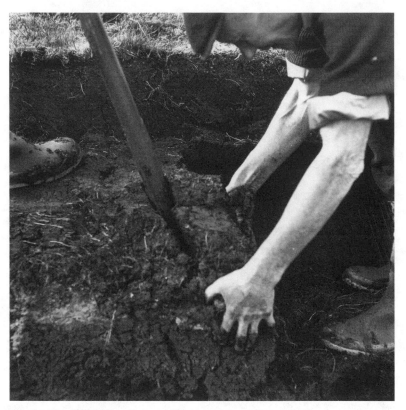

6.5. "Taking out the Turf," © Rachel Giese. From *The Donegal Pictures* (Winston-Salem, N.C.: Wake Forest Univ. Press, 1987). Used with kind permission of the artist.

it is they must adapt and change this terrain as resource and product. The paradox is that if humans are to evaluate their responsibility to this natural terrain, then it is indeed both the cultural and the material interaction they must interrogate, because these interactions do not exist in separate spheres.

Giese's construction of Donegal as an inhabited and worked land is a narrative impulse; it listens to and tells of the landscape as a storied one. Richard Kearney writes: "Every life is in search of a narrative. We all seek . . . to introduce some kind of concord into the everyday discord and dispersal we find about us" (Kearney 2002, 4). Although a desire for "concord" perhaps compels much narrative, its achievement is not necessarily found in unity. What is found through a desire for narrative is a process of integration that

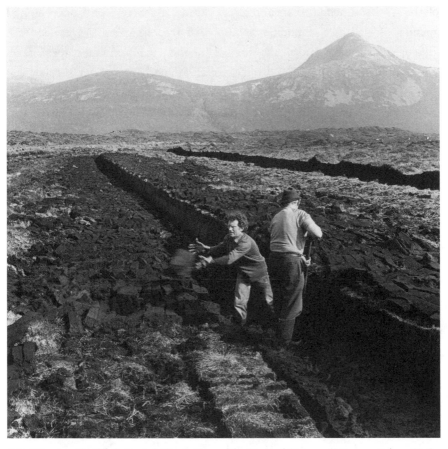

6.6. "Cutting Turf," © Rachel Giese. From *The Donegal Pictures* (Winston-Salem, N.C.: Wake Forest Univ. Press, 1987). Used with kind permission of the artist.

locates change, action, and conversations within their natural place. Giese's photography emphasizes the natural terrain as simultaneously grand and dense, diverse and specific; it pushes spatial and topographical boundaries, and identifies the connectedness of human and natural forces through active work. The material landscape is thus storied. It is a place for and participant in changes and experiences that are always being formed into narratives, are always being told, and heard, and seen, and are always the consequence of memory's movement.

Through this construction of story, Giese's photography invokes the landscape as a mnemonic part of a human experience and past. Because so many

of the stories attached to Ireland's rural landscape were a part of a colonial agenda, as well as a reactionary Nationalist response to this agenda, these ideological impulses inform the story of Ireland's material landscape. Giese's photography reenvisions the diversity of this landscape's materiality as well as the possibility of new stories. This possibility is mapped, in part, through Giese's visual representation of the landscape's human inhabitants. The images of dense and fragile ecosystems are filtered by the simultaneous inclusion of schoolchildren, farm hands, a young woman against blank space, and postal carriers. These photographs serve a different mnemonic purpose. They situate the story of Ireland's landscape within the boundaries of a diverse, local Donegal people rather than in a vast nonspecific national discourse.

Through its narrative, Giese's work forces the reader to have a heightened awareness of not only what rests within its frame, but also the absences implied by it. As a collection filled with dialogic images, within a historical and cultural context that imposes expectation of what a place called Ireland should look like, Giese's work examines the possibilities within the story. In so doing, she examines the negotiations of the image and the possibilities of the past. Through the stories of Giese's photographs, she guides the interpretive processes through which this past is remembered, and she allows her images to inscribe the mnemonic impulse that compels the creation of a place called Ireland. In one of the final photographs of the collection, "Glen funeral on way to church," Giese captures a grand landscape and calls attention to a path of cars moving toward an absent church to honor life and death. The road winds and falls, turns and rises, across the rugged terrain, the line of cars nothing but a faint line upon a material formation that contains a geological history to which human mortality pales in comparison. Still, even with such reminders of natural perspective, humans find a place within this landscape. The photographs of *The Donegal Pictures* allow us to see this process while the written word forces us to imagine it. One such moment of story is not more valuable than another, but all are necessary to an understanding of how memory lingers, how people dwell, and how in the midst of it all humans impress a natural world that persists, like a row of cars through the textured hollow to a church aside which a person will rest in a past-seeped soil.

7

Photography and Nostalgia in Christina Reid's *The Belle of the Belfast City*

RACHEL TRACIE

> I want what I can't have. I want it to be like it was. Like the old days in the photo album. (Reid 1997, 208)

Visual images have long played a part in the cultural and social lives of the people of Northern Ireland. When walking the streets of Belfast and Derry in particular, one is aware of the significance of the visual in the public life of the city. Street murals depicting victory in battle, paramilitary images, and celebrations of culture and sacrifice can be surprising and, at times, shocking for the first-time visitor. Commemorative statues in the city center and British, Irish, and Ulster flags hanging from the lampposts reveal a community deeply embedded in the visual. Behind each image is a history remembered differently, a history often highly contentious and far from stable. Such heavily weighted images reveal a cultural atmosphere reliant on negotiating and transforming what is seen into what is felt and what is lived. What role, if any, do these images have in the private spaces of the people of Belfast? How do the visual markers valued by families and individuals figure into the visual landscape? How are these images represented and given public significance? I would suggest theater, both written and performed, provides an alternative space in which private and public images can interact and be challenged. Theater as a cultural medium relies on the visual, both in the stage pictures it creates, and in the images it encourages its audience to recall

and to remember. The plays of the Belfast playwright Christina Reid engage both of these levels of meaning, and invoke the power of visual images, and in particular, the family photograph album, to frame and initiate action. Her work thereby resists traditional methods of creating meaning by presenting the question: How can photographs function as a vital clue to who we are and where we come from?

In her 1989 play, *The Belle of the Belfast City*, Reid explores the tension between the safety of the private images of a Protestant working-class family in Belfast, in the form of framed photographs and the family photograph album, and the reality of the lives lived beyond the frame. Reid takes the photographs out of the realm of the everyday, out of the domestic space of the home, and places them in the public space of the theater, a place where people come specifically to "see" and pass critical judgment. This is an act of resistance to a one-dimensional reading of photographs as pleasant nostalgia. Reid exploits the power of photography to both reveal and conceal, to both freeze moments and spark unbidden recollections. As Joanna Lowry reflects, artists such as Reid

> have forced us to reflect upon the very strangeness of these forms of rep-
> resentation and of their fundamental elusiveness in the face of our search
> for meaning. They have drawn our attention to the ambiguity and poten-
> tial undecidability of the photographic sign, its resistance to meaning, its
> relationship to time and history, and its indexicality. (Lowry, Green, and
> Campany 2003, 10)

In *The Belle of the Belfast City*, the family photograph album is used both as a physical prop with which the characters interact and as a potent metaphor that uncovers the links between familial representation and personal and community identity. The play becomes, in its structure, an album of memories chosen and put together by Belle to question, challenge, and in some cases, affirm her own identity and her place within the Dunbar family and the larger community of Belfast.

The act of reaching for a photograph album can have a variety of motivations: boredom, amusement, reminiscence, comfort, and/or escape. In recent years, the area of domestic photography has gained in significance. What

was once viewed as a highly amateur practice, and not worthy of academic study, has now become a rich terrain for theories of narrative and identity. What is revealed in these studies is a concern with the ability of images to function on a variety of levels, not the least of which is to conceal as much as, if not more than, they reveal. A photograph, as a record of family life, has particular resonances in much recent scholarship, not only in photographic theory, but also in identity and cultural theory as well. What does a photograph reveal about its object or about its taker? How has the picture been constructed? How do repeated viewings of a photograph affect its meaning? Each of these questions points to the fertile ground of domestic photography to yield answers about personal, family, and even community identity. Primary focus in these studies has been given to the way in which family photographs can reflect a sentimentalized and idealized version of the family as a cohesive community whose memories are created and affirmed by the presence of such photographs. Theorists such as Don Slater, Patricia Holland, Jo Spence, Joan Solomon, Marianne Hirsch, and Annette Kuhn engage with such ideas, and offer useful insights into how photography and identity are interrelated. Don Slater suggests domestic photography is at its core about identity formation, and the metaphor of the family album in particular "represents a process of editing images into icons and narratives through which a family identity is constituted and stabilized" (Slater 1995, 138). The ways in which photographs are "told" and subsequently remembered by various generations of a particular family can reveal the specific way a family chooses to see themselves and represent themselves to others. As Patricia Holland writes, the construction, editing, choice, and ordering of such memories reflects the family "*as they wish to be seen* and as they have chosen to show themselves to one another" (Holland 1997, 107). With this in mind, it is then possible to go back to family photographs and the stories that surround them as a type of memory work, to discover how family identity is constructed. Essential to this task is the relationship between photography and narrative. A photograph, in itself, is static, but when someone looks at the photograph and begins to talk about it or speculate about it, the photograph can take on new meaning, or as Susan Sontag succinctly puts it, "in the real world, something *is* happening and no one knows what is *going* to happen. In the image-world, it *has* happened and it *will* forever happen in that way" (Sontag 1999, 87).

Sontag's assertion hints at the double-edged nature of photography. Although the photograph itself might be static in its one-dimensionality, the process of "reading" that same photograph is active and undertaken in the present. Although the photograph may happen in the same way forever, the narrative sparked from that photograph is unknown and subject to change. In this uncertainty lie what Solomon calls the "mines of memory waiting to be excavated" (Solomon 1995, 54)—spaces that have continued to fascinate artists, writers, and theorists.

It is from this narrative spark the Dunbar family in *The Belle of the Belfast City* begin their own process of memory excavation. To examine this point further, I suggest a productive reading of *The Belle of the Belfast City* can be achieved both through the brief theoretical framework already provided, and more specifically through the work of Marianne Hirsch. Hirsch has written extensively on memory and photography, and her theories reflect and illuminate a concern with identity construction and family. In her book *Family Frames: Photograph, Narrative and Postmemory,* Hirsch offers a comprehensive and enlightening discussion of the way in which photography and the idea of family are intertwined. She discusses the transformative power of photography from static, flat representation to the "telling details connecting lives and stories across continents and generations" (Hirsch 2002, 11). In particular I would like to look at Hirsch's notion of the "familial gaze." She defines the familial gaze in the following way:

> When we look at one another within what we think of as our families, we are also the objects of an external gaze, whether sociological, psychological, historical, or nostalgic and mythical. The dominant ideology of the family, in whatever shapes it takes within a specific social context, superposes itself as an overlay over our more located, mutual, and vulnerable individual looks, looks which always exist in relation to this "familial gaze" the powerful gaze of familiality which imposes and perpetuates certain conventional images of the familial and which "frames" the family in both senses of the term. (Hirsch 2002, 11)

This aspect of Hirsch's work most clearly informs a reading of *The Belle of the Belfast City,* because the Dunbar family struggle to live within the frame of the dominant loyalist ideology of Protestant Belfast, where women

must support and be proud of the men, and keep their own business within the confines of the domestic space. This hiddenness is reflected in the photographs referred to in the play, which become, as Hirsch notes, an instrument that "situates human subjects in the ideology, the mythology, of the family as institution and projects a screen of familial myths between camera and subject. Through this screen the subject both recognizes and can attempt to contest her or his embeddedness in familiality" (Hirsch 2002, 11). Each member of the Dunbar family recognizes and works to maintain the family myths created to sustain a seamless identity. This identity is informed by the loyalist politics espoused by Jack, as well as the stories the women tell each other. Reid creates a visual language that challenges the traditional, and predominantly masculine, view of Northern Ireland. Each of the images in the play creates a "double vision" that opens a space for new ways of thinking about familiar and accepted images. This is a powerful inversion in a community dominated by a highly coded visual language.

Because Protestant Belfast forms the backdrop of the play, its visual language is challenged by the domestic images of the women, and political loyalty is set against familial loyalty. Loyalty to the immediate family is a concept one must work toward, and at the same time constantly negotiate. Each character struggles between contributing to the myths constructed to offer cohesion and comfort, and those that expose the family as they really are. Dolly must negotiate between her role as family matriarch and her past as the child-star, "The Belle of the Belfast City"; Vi must negotiate between her role as caregiver/surrogate mother and her lost childhood, and Janet must negotiate between a sentimentalized past and the hidden trauma that keeps breaking through in the present. Furthermore, Rose must negotiate between her complicity in the creation of a family myth and her desire to tell the "truth" through her photography; and, finally, Belle, as daughter, granddaughter, and friend, must negotiate her way through her position as both outsider and insider to find out where she fits in her own family and the community which, until now, has been held away from her. Each of these negotiations can be explored through photography, in terms of both what it reveals and what it hides, because according to Hirsch, "photographs locate themselves precisely in the space of contradiction between the myth of the ideal family and the lived reality of family life" (Hirsch 2002, 8).

Belle is central to the exposure of this "space of contradiction," as she seeks to enter into the midst of the family and to discover for herself the Belfast she has only heard about. As she does this, she and the other characters in the play engage in what Hirsch calls familial looks, which are not located externally but "are local and contingent; they are mutual and reversible; they are traversed by desire and defined by lack [it is] an engagement in a particular form of relationship, mutually constitutive, mediated by the familial gaze, but exceeding it through its subjective contingency" (Hirsch 2002, 11). Each member of the family must confront their place in the family story and as they do this, they must confront their place in the wider community of Belfast as well. Belle not only narrates the action of the play, but she is also a participant in her own remembrances and observer of the stories created by her family. Although Belle's role as narrator invests her with special status and power, it is not only her story, but the stories of her grandmother, her aunt, and her mother as well. Belle appropriates these stories and uses them to construct her image of family.

At the beginning of the play, Belle describes the two conflicting images she has of Belfast: "A magical one conjured by my grandmother's songs and stories and recitations, and a disturbing one of the marches and banners and bands on the six o'clock news" (Reid 1997, 208). Neither of these images is real to Belle; they are both at a distance, separated from her by sentimentality and geography. The "magical" Belfast Dolly embodies lives on in Belle's story and, in fact, it is the first image the audience/reader is presented with. Dolly sits with a photograph album open on her lap and framed photographs all around her, but the largest and most dominant image is of the young Dolly on a concert poster circa 1925 when she topped the bill in the halls as "The Belle of the Belfast City." Dolly begins to sing and as she does, the other characters "come running to her from the past" and dress up and sing while Belle, in the present, watches "with delight as if seeing an often-heard story re-created" (Reid 1997, 180). In Belle's remembrance, photographs become the connective agent between Belle and her family, "they affirm the past's existence and, in their flat two-dimensionality, they signal its unbridgeable distance" (Hirsch 2002, 31). In this scene, three types of photographs are introduced: framed photographs, the large poster of Dolly, and the family photograph album. Each has a particular function

in the world of the play: the framed photographs are reference points for Dolly to remind her of her husband Joe; the poster is a visual trace of the importance of childhood in the play; and the photograph album is a catalyst for action. Reid establishes a construct that disturbs the traditional way in which photography is viewed. The fictional images Reid calls up in the context of the theater "disrupt a familiar narrative about family life and its representations, breaking the hold of a conventional and monolithic familial gaze" (Hirsch 2002, 8). Belle's first "picture" is of this familiar scene, a family working together to create memory through song and theater. The use of a photograph as the prompt for such a memory sequence is a construct used throughout the play. Everyone in the family willingly enters into these group recreations with the exception of Jack. His aversion to having his picture taken, and in particular to being taken off guard, reveals his desire to keep the familial gaze functioning at all times rather than to lose face, as the following exchange demonstrates:

> BELLE: Oh, I wish I could have seen that. Isn't there a photograph of Jack dressed up?
>
> DOLLY: You must be jokin'. He run out of here like a scalded cat. Wouldn't speak to any of us for days after. (Reid 1997, 219)

Jack's reaction is illuminated by David Gross's idea of mutual construction as a necessary precondition to maintaining the memory of significant moments. Jack's unwillingness to enter into the remembrance reflects his unwillingness to enter fully into the life of the family. As Gross notes, in a close group "there is at least as much reminding as recollecting going on, for every intimate group tends to activate and sustain memories that would otherwise be forgotten by each individual member trying to recall, alone and apart from the collectivity, the things considered significant by the group" (Gross 2000, 112). Belle, on the other hand, is eager to enter into the family's remembrances and it is through her we are able to see the mechanics of the familial gaze. Although a member of the family, her experience is untouched by the daily life of Belfast. She longs to discover her roots, and her starting point is the family photograph album. As Dolly shows her the photographs, Belle entreats her, "Not so fast. I want you to

tell me about every one of them. What age everybody is. Where you were at the time. What you were doing. I want to know all about my family. I want to know all about Ireland" (Reid 1997, 194). Rose, Vi, Dolly, Jack, and Janet are embedded in the mythology of the familial gaze simply because of their upbringing in Belfast. Belle, however, has never been to Belfast, and from her position as outsider she is able to challenge the frame placed around her family, "thus allowing the audience . . . to encounter the problems in Belfast through fresh eyes and to see the abnormality of what has become normalcy for citizens of Northern Ireland" (McDonough 2000, 188). Part of the family's complicity in maintaining the external familial gaze has been to keep Belle at a distance. Belle's very physical presence "in the picture" of Belfast as an African American-Irish-English woman would, and indeed does, cause the family to confront issues they have felt it easier to ignore. Jack's and Davy's reaction to Belle reveals one of the deep-seated yet often overlooked features of hard-line Protestantism: racism. It is significant that Jack, Belle's uncle, is an influential member of the UDA. His reaction to her arrival brings the issue of race directly in line with his political agenda. This perspective is shown through the presence of Jack and Tom Bailey, and more specifically in their connection to the National Front. Reid highlights this connection by conflating the issue of race with that of sectarianism. This is shown most powerfully in the confrontation between Rose, Vi, Jack, and Tom Bailey. Their picture of a perfect Northern Ireland, according to Rose, is "to keep Northern Ireland Protestant, Orange and White" (Reid 1997, 227). Reid blurs the line between public and private, equating the women's decision to keep Belle from Belfast with Jack and Tom's involvement with the National Front, and this conflation of the public and private "images" of Belfast illuminates the power of the external familial gaze to affect personal family relations.

It is not just Jack and Tom Bailey who are challenged by Belle's presence in Belfast. Davy, the Dunbar's family friend, is incredulous and hesitant when he first meets Belle and the interchange that follows illuminates this:

> VI: (*laughs*) He's all of a dither because he's never seen nobody with dark skin before, except on the television.
> BELLE: Is this a joke?

ROSE: There aren't many like you in Belfast, Belle. And those that are, are well to do. Restaurant owners, doctors, university lecturers, overseas students. They don't live round here. (Reid 1997, 191–92)

The reality of the secrecy of racism and Belle's own family's complicity in it is an essential part of her identity construction. Belle, in a sense, is one of the Dunbar family's secrets. She has never been in Belfast, despite the fact she's been all over the world with her mother. Although Vi recognizes this omission when she states, "It's a disgrace, so it is" (Reid 1997, 188) and seems to comfort herself with the fact "Rose keeps us up to date with photos. Great they are, but then they would be, wouldn't they, it's Rose's job" (Reid 1997, 189), she and the rest of the family are complicit in keeping Belle outside. Until now, Rose's photographs have been the only "presence" of Belle in Belfast, but as Belle enters the picture, the secret the family has been hiding must be revealed. Annette Kuhn, in her study on memory, photography, and identity construction, discusses how secrets can exist within the myth of the family where "sometimes family secrets are so deeply buried that they elude the conscious awareness even of those most closely involved. From the involuntary amnesias of repression to the wilful forgetting of matters it might be less than convenient to recall, secrets inhabit the borderlands of memory" (Kuhn 1995, 2). The Dunbars have not openly acknowledged their hesitance at bringing Belle to Belfast. It is not until she begins to question her absence, that they are forced to reveal their true motivations. In the conversation between Belle, Rose, and Vi, Belle begins to make connections for herself and she disrupts the excuses held by the family:

BELLE: The National Front are recent arrivals here. Like me. Why have I never been in Belfast before now?
VI: It was always easier for Dolly and me to visit you than for Rose to bring a baby across the water. Dolly loved them trips.
BELLE: I haven't been a baby for a long time. (Reid 1997, 238)

It is Vi who admits their complicity in keeping Belle away from the "wagging tongues" of those who would be scandalized by the presence of a black child. She admits "[w]e may say we meant it for the best, but it's not to our

credit that we took the easy way out at first, and then over the years just let it go on that way" (Reid 1997, 239). Although Reid does not provide clear-cut distinctions in the play, loyalty to the women of the family always prevails. Rose summarizes the difference between these loyalties in her chastisement of Tom Bailey, "If you're going to join the war here, Thomas Bailey, never forget that loyalty to one's immediate family will always take precedence over loyalty to the Unionist family" (Reid 1997, 229).

Every member of the Dunbar family feels the impact of Jack's brand of politics, particularly his sister Janet. It is her voice that begins this essay, imploring, "I want what I can't have. I want it to be like it was. Like the old days in the photo album" (Reid 1997, 208). By maintaining the myth of the Dunbar family as shown in the photographs in the album, Dolly and the other members of the family have created a safe place for Janet, a place in which she does not have to face the reality of her life. Photographs become a tool of escape for Janet, and they become in the course of the play a hindrance to her personal identity construction. She grasps onto the childhood represented in the photographs and thus creates a false version of reality. As Hirsch explains, this act of constructing oneself through photographs shows how "the illusion of the self's wholeness and plenitude is perpetuated by the photographic medium as well as by the autobiographical act: both forms of misrecognition rest on a profound misprision of the processes of representation" (Hirsch 2002, 83–84). As much as Janet clings to this illusory self, she is unable to control the memories of trauma that lurk behind the frame. It is evident from the start of the play Janet is dealing with the effects of an abusive childhood, a celibate marriage, and a current affair. But unlike the other characters in the play, she is unable to control her memories, and subsequently unable to negotiate her way out of the trauma and guilt that engulfs her. Janet's memories are involuntary and are devoid of the nostalgia and sentimentality of the family album.

In a scene sparked by a photograph, Janet and the others enter into the safety of that picture, but as the scene continues, Janet cannot stop the memory at what is shown in the photograph but continues to reenact what the photo does not show. The reenactment of the photograph involves Rose, Vi, Dolly, and Janet smuggling goods over the border. One of the items Dolly bought for Janet was an icon of the Virgin Mary, and it is this statue that she holds as the scene ends: "The group freezes with the exception of Janet

who lifts the statue and dances into the shop. She sings quietly" (Reid 1997, 204). As Jack enters the scene, the tone changes from celebration to fear as Jack describes Janet's "pretty lady" as "a blasphemous Popish statue. A heathen image of Christ's mother. . . . You have sinned, Janet. You have broken the fourth commandment. You must be punished" (Reid 1997, 204). As Jack breaks the statue, Janet's screams break through to the present and the other characters rush to her aid. The photograph, which was at first a place of safety, has been transformed into a place of fear. When Janet is brought back to the present it is with an awareness of the insufficiency of the photographs to contain or override her trauma.

Jo Spence and Joan Solomon discuss this relationship between memory and photography, suggesting, "once we begin to think of both seeing and memory as primarily defensive and self-protective operations, saturated with fantasy, then the status of photographic imagery is affected rather radically" (Solomon 1995, 58). Photographs can become a type of shield protecting the viewer from truth and presenting them rather with a sentimentalized version of the past. This defense allows the viewer to engage critically with the photographs, discovering how identity might be a starting point for telling stories about ourselves, especially when often "the images we want are missing" (Solomon 1995, 54). Janet chooses to "see" the photographs to protect herself from her fear of Jack and the guilt she feels for cheating on her husband. When they no longer provide the safety they once did, she is forced to confront her situation and develop an identity of her own, outside of the determining familial gaze.

Vi seems to be the character most keen to maintain the family within the familial gaze. Throughout the play, Vi seeks to maintain the status quo by giving donations to the Loyalists, stocking her shelves with their literature, and chastising the other members of the family for their childishness. But her presence is also problematized in the family album. The impact of Belle's arrival and the consequent disruption to the familial gaze has its most profound effect on Vi and it is through her that the reader/audience is able to gauge the effects of the clash between personal and public loyalties. Hirsch notes that memory-work through photography can reveal discontinuities and gaps as well as continuities. She discusses how these are the places in which resistance can occur:

> Getting beneath the surface or around the frame of conventional family photographs can make space for resistances or revisions of social roles and positions in vastly different cultural contexts—of conventions upheld through photographic practice. Locating resistance in adolescence, these texts occasion an adult rereading of girlhood as a foundational moment of (re)definition. (Hirsch 2002, 193)

As Vi revisits her past, she becomes aware of the way in which she has been constructed within the familial gaze. She rereads the images of her past and this "becomes a way of contesting that construction, of rewriting the present by way of revisiting the past" (Hirsch 2002, 193). But when Vi looks to the images of the past, she finds absences, the most significant of which is her childhood. Belle's presence and her desire to know about her family when they were young, prompts Vi to confront her own lost childhood

> vi: Maybe my trouble is, I never was that age. I never remember a time when I was really young, the way children are. As soon as I was tall enough to see over the counter, Dolly kept me off school to work in the shop. I tell you, Davy can read and write better than I can. (Reid 1997, 216)

The memory sequences in the play serve as a reminder of childhood, and not all of the sequences are celebratory, nor are all prompted by a photograph, but often by the absence of one. Solomon reveals the implications of such erasures in the construction of family images as "that collection of life moments where what is positive in family experience has been recorded, while disruptions, dangerous connections and difficult changes have been omitted and rendered invisible" (Solomon 1995, 11). In two of the photographs of childhood, Janet and Rose are shown relishing in getting saved at the mission, going to the movies, and trying to stay home from school, but Vi is conspicuously absent. With Belle's arrival, she recognizes her embeddedness in maintaining the familial gaze by simply resigning herself to the way things are. Vi yearns to remember in a way that allows her to be "not merely witness to, but actively to participate in, rituals through which a recognition of some collective destiny, a social sense of belonging, is sustained" (Kuhn 1995, 62). While Janet and Vi move beyond the frame of the pictures that have held them for so long, Rose is engaged in making her own pictures. Her

position in relation to the familial gaze is an interesting one. She left Belfast when she was seventeen, had a child, and pursued a career in photojournalism. According to Anna McMullan, Rose represents "the experience of the exile, at once rooted in the complex, closely knit and self-enclosed community that has been left behind, yet also possessing a much wider experience and perspective" (McMullan 1993, 120). Significant to her perspective is the way in which it disrupts the familial gaze. Although Rose is involved in the memory sequences, singing, dancing, and acting with the rest of the family, she is also actively involved in contesting the sentimentalized version of the past upheld by Dolly and Vi. Rose directly challenges the supremacy of the family album in determining family cohesion through her practice of photojournalism. The tension between these two practices is explored significantly in Rose's relationship with Vi and with Jack.

Rose's position in the play embodies Don Slater's idea that photography has the "potential to empower, demystify and politicize everyday life." He sees this as being in constant tension with the limitations of photography, ending up in "a contradiction . . . between domestic photography as a force of cultural production and the (familial) relations of production which constrained it" (Slater 1995, 144–45). It is interesting that Rose moves from the sphere of domestic photography into photojournalism, a form of cultural production based on public images. Vi, in particular, struggles between Rose's two functions as photographer. From the beginning of the play, Rose is described as a dreamer, a creative child. Dolly's description of Vi and Rose in the first scene is telling, "She [Vi] always calls me mother when she's bein' prim an' proper. She must of got that from your side of the family, Joe. But you see our Rose? She's like *my* one's, Fulla life an' rarin' to go. She's traveled the world you know, takin' pictures. Imagine that!" (Reid 1997, 181). Rose's imagination is constantly praised by Dolly, and compared with her late husband Joe who "was a dab hand with a camera. That was one of the last photos he ever took, God rest him . . . I give your mammy Joe's oul camera after he died, an' she took to it like a duck to water" (Reid 1997, 194). Vi is resigned to the position, once again, of responsible older sister, who not only has to live with this discrepancy but also helps to support Rose, "then me an' Vi bought her a good camera when she was older an' she's never looked back since" (Reid 1997, 194). Vi and Dolly both support Rose's domestic photography,

particularly the pictures she provides them with to keep them up to date on Belle's progress, but Vi is uncertain about Rose's photojournalism because it reflects a public, but hidden agenda:

> VI: Oh, I see. If you hadn't happened to be free this week, you would have sneaked into a Belfast hotel next week, without even lettin' the family know you were in the city?
>
> ROSE: Yes. I would. Partly because it's business and it's confidential. But mainly, because it would be too risky to work from home . . . I couldn't risk exposing you and Dolly to the possibility of that. (Reid 1997, 228)

Vi constantly questions and challenges Rose's job and her tendency to see "only what suits you" (Reid 1997, 221), and Rose constantly questions and challenges Vi's participation in Jack's "mad religious politics" (Reid 1997, 220). Rose's outsider's perspective does not always sit well with Vi, who has to deal with the issues Rose talks about daily. As Rose lectures Vi about giving money to the UDA to protect her shop, Vi challenges her:

> Don't you lecture me, Rose! It's all very fine and easy livin' in London and makin' noble decisions about what's right and what's wrong about how we live here. I'm the one who has to live here. You've been on your travels since you were seventeen. You don't even talk like us any more. Talk's cheap. And it's easy to be brave when you've somewhere safe to run. (Reid 1997, 199)

Rose has a perspective Vi is unable to acquire because she is too close to the troubles. Dolly and Vi, who live in the middle of the troubles, must create illusions to survive. As David Gross notes, "many memories, even though they may have the feel of authenticity, do get significantly distorted because of the particular needs, interests, or desires that happen to be present in the rememberer at the moment of recall" (Gross 2000, 4). Yet, Rose brings out the doubts that challenge the safe collective memory of Dolly and Vi, and Janet as well, doubts raised "because it has begun to seem that many such memories are little more than myths or fabrications, carefully cultivated illusions that are either too insubstantial or too dangerous to serve as the basis

for communal values" (Gross 2000, 5). Even though Vi and Rose struggle throughout the play to come to terms with their own memories and how they have or have not been a part of creating a collective sentimentalized family history, their loyalty to one another is never in question.

In *The Belle of the Belfast City*, Reid presents a history that at first glance conforms to the accepted image of a happy family, where one can think of "family snapshots as those partial mirrors where the masquerade of *appearing* to be something which you know you are not is viewed as a high achievement" (Spence 1995, 156). On further investigation, however, the play reflects how through photography, we can "experience our resistance to remembering: not all memories are celebratory. In this way we may be able to understand some of the ways in which we have been taught to be self-censoring" (Spence 1995, 190). Reid challenges the silences that have surrounded women's history in Northern Ireland by infusing a domestic object with special significance. In this way, Reid foregrounds the lives of the women of the Dunbar family and highlights their experiences. Reid shows how the use of photography in this way can be, as Kuhn posits

> a practice of unearthing and making public untold stories, stories of "lives lived out on the borderlands, lives for which the central interpretive devices of the culture don't quite work." These are the lives of those whose ways of knowing and ways of seeing the world are rarely acknowledged, let alone celebrated, in the expressions of a hegemonic culture. (Kuhn 1995, 8)

In *The Belle of the Belfast City*, Reid reveals the lives of three generations of women whose struggles and celebrations are often hidden from the more public representations of Belfast life, such as the parades and politics signified by Jack. Belle, as the narrator, selects pictures that both celebrate the life of her grandmother, by recreating her cherished memories of Belfast, but also those that reveal the potential danger of allowing memories to calcify into a myth that hinders the development of a strong personal and family identity. Reid's engagement with photography puts her in league with the artists and writers who, according to Joanna Lowry, are not only informed by photographic practices but also inform those very practices that "may sometimes involve radically rethinking what photography is" (Lowry,

Green, and Campany 2003, 9). *The Belle of the Belfast City* introduces the symbol of the photograph album to dramatically explore the function of photographs in familial construction, and in so doing, Reid "rethinks" the dramatic potential of photography. As the characters enact the pictures, the communal construction of memory is emphasized, along with the ruptures and disagreements that surface behind and around it. The theoretical process of uncovering constructions of memory and identity within the lineaments of photographs is powerfully embodied in Reid's theatrical form, offering a glimpse into the potential of photography in theatrical practice.

Part Three
Popular Culture

8

The Art of Resistance

Visual Iconography
and the Northern "Troubles"

EÓIN FLANNERY

> The "excess" meaning conveyed by representation creates a supplement
> that makes multiple and resistant readings possible. Despite this excess,
> representation produces ruptures and gaps; it fails to reproduce the real
> exactly. Precisely because of representation's supplemental excess and its
> failure to be totalizing, close readings of the logic of representation can pro-
> duce psychic resistance and, possibly, political change. (Phelan 1993, 2)

> POD [Painters of Derry] has consistently refused to hand over its large
> stockpiles of white gloss, claiming justifiably that all persons have the
> right to bear brushes and rollers against British imperialism. (*Republican
> News*, 20 Apr. 1995)

Peggy Phelan's comments on the "excessive" potential of all modes of repre-
sentation intersect with many of the concerns of recent, and ongoing, chal-
lenges to the governing narratives of modernity, Western historiography, and
the nation-state itself. Of immediate relevance to our discussion, however,
are the theoretical, ethical, and historiographical questions raised by postco-
lonial studies. The ensuing chapter extracts its theoretical impetus from the
shared solidarity of transnational, and transhistorical, experiences of *localized*
colonial oppression and occupation. Accordingly, the cultural artifacts under
discussion in this chapter are constituents of the affective, performative poli-
tics of counter-modern solidarity. Therefore, my consideration of political
murals in Northern Ireland is an effort to divine alternative theoretical and

ethical vectors with which to confront imperial modernity in both its historical and contemporary guises. Such an undertaking naturally involves an interrogation of the rememorative procedures of the communities implicated in the striven history of the Northern "Troubles." While, at one level, Ireland possesses a limited visual history, in contrast to a prodigious verbal narrative history, the competing muralistic effusions that have manifested during the contested resolution of Northern Ireland's late colonial experience are significant constituents of a "lived" visual economy.[1]

Cultural historian Joep Leerssen contrasts the Nietzschean notion of "monumental history," or "society remembrancing," with a version of subaltern memory, which he terms "community remembrancing" (Leerssen 2001, 215). The modes of such "community remembrancing" are, Leerssen suggests, "rebel songs, paramilitary murals in Belfast housing estates, and Orange Lodge parades" (Leerssen 2001, 215). Although he does acknowledge that instances of "community remembrancing" can exhibit traces of triumphalism usually associated with "society remembrancing," Leerssen's schematic argument signally fails to differentiate between the origins, structures, and legitimacy of the rival mural traditions in Northern Ireland. While the stealthy spontaneity and the historical thematics of republican murals accord with Leerssen's profile of "community remembrancing," loyalist murals, which assumed a distinctly homogenous visage, were traditionally implicated in the "monumental" historical continuum of the sectarian statelet. In alluding to "rebel songs," Leerssen is clearly building on the ideas presented by postcolonial critics of elite or bourgeois nationalism, anticolonial representation and subaltern, or submerged, nationalist communities. However, even to suggest that both communities could occupy comparable political positions or that they conducted memorial practices in equivalent atmospheres is simply unsustainable.

As we shall discuss, the tradition of republican mural art is very much in line with the guerrilla tactics of a military campaign. In contrast, the celebrations of Orangeism and loyalism were integral to the logic of the defense of the statelet. Leerssen subsequently proposes "community remembrancing" belongs to the tradition of history's "losers," the oppressed and victims of

1. On the history of Irish visual art see, Cullen 1997 and 2005.

historical trauma: "the demotic, and in many cases the subaltern nature of 'community remembrancing' in very many cases evinces a different sense of history, one which sees history from the point of view of the losers, the bereaved, the victims" (Leerssen 2001, 215).[2] How he can reconcile such an otherwise reasonable conclusion with the historically dominant rationale of the Unionist Northern statelet and its competing communities is unclear. One avenue through which the divergent political circumstances, memorial procedures, and ethical imaginations of both communities appear is in their respective traditions of mural art. As we shall see, one of the most remarkable aspects of these forms of *lieux de memoire* is the extent to which the murals reveal the "rooted cosmopolitanism" of republican visual art, which is the primary concern of this chapter, and the relative tenor of defiance characteristic of the loyalist aesthetic.[3]

Visions of the Future Perfect, or the Perfect Future

In his celebrated speech from the dock, Robert Emmet proclaimed, "When my spirit shall have joined those bands of martyred heroes who have shed their blood on the scaffold and in the field in defense of their country, this is my hope, that my memory and name may serve to animate those who survive me" (O'Broin 1958, 160). Emmet's aspirational sentiments should not be read solely as a self-conscious or vain attempt to insert himself into a naturalized pantheon of republican martyrs. Despite the ethereal language of the invocation, Emmet's wishes reveal a complex awareness of the volatility, and vitality, of politicized social memory. His speech prior to execution is a valiant performative act of resistance; both the impassioned speech and the *choice* of epitaphic silence belong to equivalent resistant languages. The unwritten epitaph remains as a testament to an alternative linguistic register, one that refuses the power differentials of the colonial dialogic exchange. But more significantly for my present purposes, the speech disinters itself from the repressive codes of the present tense, entering into what Seamus Deane

2. See also Valensi 2000.

3. On *lieux de memoire* see Nora and Kritzman 1996. On ideas relating to "rooted cosmopolitanism" see Robbins 1998 and Brennan 2001.

calls the future perfect tense of Irish republican separatism (Whelan 2003, 50–54; cited in Whelan 2003a, 50)—what amounts to an imaginative political and cultural linguistic declension.

It is in this light, I believe, that the republican murals in both Derry and Belfast should be received as evidence of the persistence, perhaps a visual conjugation, of the future perfect of Irish republican thinking. Effective political resistance does not necessarily operate within the same linguistic register or discursive codes as the oppression being resisted. Just as verbal oppression can legitimately be combated through the choice, or achievement of silence, rather than through antagonistic verbal reaction, republican political murals enact alternative historical, aesthetic, and ethical registers. Their most immediate efficacy is realized *in situ,* but it is articulated in a shared and comprehensible alternative idiom of resistance. The articulation of revolutionary intent in the future perfect tense, then, does not represent a lapse into a facile or unrealistic utopianism; rather it permits levels of expectation and self-belief. The future perfect is the tense of a measured anticipation, in that it expresses a conviction in the probability of achievement. Ultimately, it subtends the assertion of resistant agency and the conviction in the legitimacy and viability of struggle.

Critics such as Bill Rolston have adequately treated of the enduring and changing symbolic content of political murals, but as Neil Jarman notes, there has been scant consideration of "the nationality of these paintings."[4] He maintains, "[t]o regard the murals essentially, or only, as images is therefore to restrict their power" (Jarman n.d.). Ultimately, to confine a discussion of these political murals to the symbolic content, in terms of historical reference and genealogy, is to remain within a narrow temporal continuum and frame of reference. The murals are prime artifacts of a politico-cultural homology within these sectarian discourses and spaces. To the extent they interact with both physical and social environments, the murals are implicated in the social production of space and the spatial production of society. The significance of political murals is not that they constitute a means of endowing space with political import, but their "role in the construction of sectarian space . . . [and] in symbolizing resistance and opposition to the

4. Neil Jarman n.d. See also Jarman 1992.

state" (Jarman n.d.). We are not dealing with exclusive politicizing images, but with a particularly overt manifestation of virulently divisive politics. The locations of the murals are, therefore, synonymous with residential segregation; the murals come to represent boundaries—the space around is definitively marked by the presence of either Unionist/Loyalist or Nationalist/Republican images or symbols. The murals approach metonymic status as, for example, a mural of King Billy can substitute for an entire Protestant neighborhood. Therefore, the presence of political murals constitutes an inherent facet of the locale's cognitive map; their locations are pivotal to the spatial coordinates of both the local community, and indeed through technologically reproducible media [photography, television], they are displayed to a broader, even global, audience. The murals represent variegated gestures of defiance, affirmation, promise, and solidarity—the employment of the familiar images, colors, and slogans of historical record ensure immediate recognition, and more insidiously ensures the perpetuation of the homologies of differentiation.

Political murals, as Jarman notes, "present a comprehensive display of history, symbols, and icons that underpin the distinctive and opposing identities of the two groups" (Jarman 1997, 3). Jarman's analysis situates the murals within the fabric of the antagonistic social memories of both the Nationalist and Unionist communities. This assessment, however, does not signal the radical subversive capacities of social memory.[5] In this context, social memory is portrayed as "a central facet of the ideological armory of the group, helping to legitimize and rationalize difference by rooting it in the far-distant past and thus placing weight on the primordial or essential nature of the antagonisms or otherness" (Jarman 1997, 6). We can easily accept the memorial trade that underwrites the relationship between the past and the present, but it is more profitable, and my intention below, to consider the implicit futurity of the effective visual syntax of the republican mural tradition. The political murals do operate within the same commemorative continuum as alluded to, and entered, by Emmet, but to confine our perceptions of their complex visual vocabularies to the rigidity of nostalgia or atavism is to miss the radical memory braided within their imagistic enunciations.

5. See Connerton 1989; Halbwachs 1992; and Ricoeur 1999.

"Deprived/Depraved Art"

Clearly, the presence of political murals in such proximate and intimate public spaces has been met with criticism. The most vocalized criticisms concern the excessive militarism of the political murals; hooded gunmen or violent sectarian taunts are rightly perceived as naturalizing the two communities into respective, violently opposed "others." Similarly, although the political murals can perform, and have performed, as effective pedagogical tools, members of the local communities read such pedagogy as simply an extension of the propaganda war that adhered to the Northern dispute. It is contested whether or not the murals actually extend out from communal will or sentiment, or instill such sentiments didactically through a propagandistic visual economy. Moreover, political murals are predominantly evident in working-class districts of Belfast and Derry. Some residents of these areas believe the murals are, in fact, "signs" of an area's working-class credentials. The sheer presence of political murals on a locality's walls or gable ends affirms its position as a "deprived" residential area, and for this reason, some residents resent their presence. In a sense, the murals become indices of class distinction, a distinction that is, occasionally, met with chagrin. However, this is the most flawed of arguments against the painting of political murals; such a point reduces the murals to a commercial value. In accenting this aspect of the spatiality of the mural tradition, the conscious, affiliative ethic of republican mural art is shallowly mutated into a suburban currency of market value. To maintain the commercial conceit, such an argument *devalues* the politically and culturally resistant import of republican murals.

The Art of Defiance

Painted in 1908, the first loyalist mural appeared in Belfast and significantly predates the beginning of the production of republican murals. Initiating an artistic style and a thematic concern, the 1908 mural portrayed a triumphant King William of Orange astride a white stallion at the 1691 Battle of the Boyne.[6] This singular imagistic referent became a constant thematic

6. The image appeared on the Beersbridge Road in East Belfast.

resource, and visual display, of the loyalist political aesthetic over the next half-century. Coupled with the Orange order marches and roadway arches, loyalist murals represented political and cultural acts of defense. Loyalist political murals were, and are, elemental to the celebration and creation of political and cultural unity. Rolston notes "it is likely that loyalist murals are unique in this century, emanating as they do from a political ideology committed to conservatism and the maintenance of the status quo rather than liberation, anti-imperialism and socialism" (Rolston 1995a, 193). In effect, they were symptomatic of a performance of entrenchment whereby the repressive state political apparatus was manifest in the literally concretized visual artifacts of loyalist defiance. Rolston continues, "During the halcyon days when the King Billy murals predominated, the community for loyalists was in effect the state writ small" (Rolston 2003a, 29).[7] The loyalist murals serviced the consolidatory requirements of a sectarian and fundamentally disputed political entity. Although the triumphalist stability of King Billy's equestrian posture predominated, it did in fact belie the internecine tensions of the political statelet itself.

Rolston charts two later phases of loyalist mural painting: the 1970s and the early 1980s saw an increased range of symbolic reference, usually consisting of inanimate objects of loyalist heritage, including flags and heraldic signs (Rolston 2003a, 28–30). Later still, specifically after the 1985 Anglo-Irish agreement, loyalist murals assumed a much more militant and militaristic tenor. Ignited by the perceived political compromises of the agreement, these overtly minatory images retain, and perpetuate, the political and cultural intransigence of loyalism. Despite the alteration of symbolic content, the loyalist political imagination remained emaciated and univocal. Loyalist murals are agents of a broader politico-cultural arsenal, which through ritual performance creates, celebrates, and historically, enforced a sense of state political integrity. However, in having found a unionist state to defend, having produced homologies of political and cultural defense, one is left with a sense of loss or vulnerability at the core of the loyalist political sensibility.

7. Also see Rolston 1992a, 1995a, and 2003b. Other interventions on the Northern murals include Sluka 1995a and 1995b, and Woods 1995.

Although attaching itself to the defense of a political union, of an integral Northern Irish polity, loyalism betrays the sense of loss that is inherent to each new beginning. The limited imaginative vistas of the loyalist aesthetic are consistent with the needs of politically conservative containment. Defensive, anxious and aware of its own historical contingency, the infant statelet behaved as all forms of newly born institutional authority behave: performing its own permanence to inspire its present citizens. In other words, the triumphal tones of King Billy's image, of Protestant identity or of stubborn Orange Order parades, bespeak a self-consciously transient statelet. In Cleary's view, this accumulation of identitarian indices were reflective of a garrisoned community in a partitioned statelet: "the whole rationale of the new state was identified with the protection of Protestantism and it was the most reactionary elements of British state iconography—the symbols of royalism, Protestant supremacy and Empire—that were appropriated by Unionists as the icons that mortared their sense of Britishness" (Cleary 2002, 68).[8]

Once performed, an act can never be completely reperformed; just as revolutionaries perform their own disappearance as revolutionaries, so too each performance is its own annihilation. But rather than reimagine the political and cultural languages of performance, loyalist murals, in their defensive, attenuated idioms, reduce ritual to repetition and habit. The defiant stances of loyalist symbolism, ritual and muralistic performances operate in withering repetition. Deeply implanted within a backward-projected imaginaire, these performances simply repeat the past in the present. Although each cultural performance is its own annihilation, the visual iconography of traditional loyalism merely disinters the annihilated for a repeat performance. The more laterally imaginative republican vocabulary allows the past to inform

8. Rolston notes, "Loyalist muralists, on the contrary, have reflected the feelings of the most cautious in their community, the most unwilling to engage in the peace process, the most reactionary. They have preserved the myth of a golden age when unionism ruled without criticism and republicans and nationalists knew their place. Above all, they have done little by way of political education, often confirming the worst sentiments in their community" (Rolston 2003a, 39).

or problematize both the present and the future, without succumbing to nostalgia or revenant politico-cultural rituals. It is a point supported by Rolston, who, writing on republican murals after the 1994 cease-fire, points out, "To first appearances this might seem to be an obsession with the past. But it must be stressed that it is a case of looking back in order to look forward" (Rolston 1995a, 197). Likewise, it has been argued that the later phases of loyalist mural art, which saw a move toward militarism and a concentration on "Ulster" rather than a lateral embrace of "Britishness," are less historically embedded than earlier trends. Nevertheless, there is no escaping the profoundly insular and defensive posture of this artwork, and the underlying mentality that sustains such a viewpoint.

One of the strands of the loyalist muralist tradition that did evolve, and actually intersected with the traditionally nationalist reservoir of imagistic representation was inspired by the propagandistic mythistory of Ian Adamson, which re-sketched the history of the northern part of the island, *The Cruthin* (1986) delivered a tripartite political message to loyalism. Rolston summarizes this message as follows: "it was a counterclaim to nationalist mythology . . . secondly, heroes and achievements claimed by nationalists were judged to have been 'hijacked' by them. . . . Third, and perhaps most important, the planters who went from Scotland to Ulster in the seventeenth century could be said to have been merely returning home" (Rolston 1991, 35). Numbered among the reclaimed nationalist heroes were Cúchulainn and St. Patrick, both of whom were now seen as defenders of the North from political and confessional antagonists from the South of the island. Although these thematic flourishes represented dynamic mythico-historical gestures, they are in truth, exceptions that prove the rule. This guerrilla-style mythistorical revisionism may have punctuated loyalist iconography, but it did not become widespread. Nevertheless, even in its brevity and within its obvious limitations, these appropriations recall David Lloyd's reading of the subversion of myths of authenticity through the recovery of kitsch. As these naturalized icons of the nationalist imaginaire are displaced and recalibrated to oppositional ends, their meaning becomes increasingly ambiguous. Equally, their ability to adequately and securely represent a community's image of itself becomes more problematic.

The Performance of Kitsch

Although it may seem, indeed probably is, a cliché at this point—the conti-
nuity of Irish historical discontinuity leaves its trace on the thematic iconog-
raphy of republican political murals. In representing or reappropriating what
might be deemed "traditional" Irish visual iconography—examples would
include St. Patrick, Cúchulainn, or Mass rock scenes—we do not witness a
sterile and containing regression into a safe nostalgic visual economy. Such
representations function as evidence of a school of political and cultural resis-
tance within Northern Irish republican discourse. Specifically, the recovery
of kitsch is adjudged as a proactive, resistant gesture by dominated political
constituencies. To this end, "the appeal is not to nostalgia for an unbroken
spirit of Irish identity but to the fragmentary tableau that constitutes the
memory of constant efforts to realize other ways of living in the face of unre-
lenting domination. Nor is it a utopian imagination withdrawn from actual
social relations" (Lloyd 1999, 98).[9] In fact, although the imagistic or icono-
graphic content of republican political murals may not always be a radical
vision of the future, its very formal existence and procedures are suggestive
of the alternative employment and seizure of public space. Confounding the
state's monopoly on representation, republican murals also appropriate local,
yet public, spaces of representation through which there can be an articula-
tion of discontent. In this sense, they retain a radical transformative capac-
ity. On the other hand, early loyalist murals were extensions of state policy;
indeed they served as affirmations of the state's contested legitimacy. They
were, therefore, inherent to the state's political aesthetic. Later republican
murals are by their very nature recalcitrant to such politico-visual assimila-
tion; the stable correspondence between the modern state's political dispen-
sation and its aesthetic legitimation is disturbed, if not confounded, by the
contestation of space by, and the contestatory spaces of, republican murals.

Writing on the value of Irish republican political ephemera, Laura E.
Lyons concludes such artifacts are, in fact, an alternative historiographical
reservoir. The self-representational aspect of these political-cultural objects
contributes to "an alternative form through which marginalized groups make

9. For a recent discussion of Irish kitsch that draws on Lloyd's work, see Rains 2004.

their own histories—that is, attempt to recognize and represent themselves as historical agents" (Lyons 2003, 407–25). The republican mural tradition has a much shorter genealogy than its loyalist counterpart and it not only began as an effort to reclaim representational public space, but also later extended both the formal and thematic contours of mural art. Although traditional loyalist murals and commemorations viewed history as a series of past events and personalities, there was little or nothing "past" about the history confronting republican nationalism in Northern Ireland. Murals are not static historical artifacts, but are moments of lived history; their creators and attached communities are aware of their memorial links to the past. In fact, much of the effectiveness of the murals is generated by a sense of transience, spontaneity, or contingency. The republican murals are not monuments to their own permanence but arise out of the immediate "dailiness of struggle" (Lyons 2003, 410). In a sense, the address of the imagistic enunciations is to their audience, who are thereby called into "historical agency" (Lyons 2003, 414), both in terms of resisting the legitimacy of the political status quo and contesting the mandate of the incumbent state authority. Although the visual images are often local or familiar, there is a keen awareness of historically and internationally resonant experiences. The alternative spaces and times of suppressed cultures inaugurate a revolutionary aesthetic, which is nourished by subversive, often ambiguous, stylization. In other words, "the mural operates not as a means to ironize the inadequacy of atrophied aesthetic modes by juxtaposing them with contemporary commodity forms, for example, but as a way to emphasize the discrete but unhistoricized continuities of cultural resistance" (Lloyd 1999, 97).

Indeed, just as Rolston outlines the lateral thematic mobility of republican murals, such solidarity is equally evident in the very form itself. The genealogy of political murals is traceable to the Renaissance period, during which such artistic creations were generally representations or articulations of incumbent political or religious authority. However, the appropriation of the mural tradition for radical political ends began in Mexico in the 1920s, and is evidenced in the work of Diego Rivera, José Clemente Orozco, and David Alfaro Siqueiros (Hurlburt 1989). These murals were co-coordinated artistic celebrations of Mexico's revolutionary history, monumentalizing such figures as Emiliano Zapata and "Pancho" Villa. In many ways, these

early international, twentieth-century murals intersect with the efflorescence of muralists in revolutionary Cuba and Islamic Iran; with a degree of irony, perhaps hypocrisy, all three cases celebrate the triumph of the presiding revolutionary authority. These disparate contexts intersect with the revolutionary animus of Irish republican murals, yet, as I have mentioned, remain legitimate extensions of the state's revolutionary image of itself. In fact, although they ostensibly oscillate between the republican and loyalist mural traditions, in spirit they remain closer to the republican strain. Simply, they may be state-sanctioned, but they are understood as revolutionary affronts to vanquished oppression.

Lateral Mobility

In exploring the lateral ethical vista of republican murals, we might turn to Edmund Burke. Writing in his *Reflections on the Revolution in France,* Burke concludes:

> To be attached to the subdivision, to love the little platoon we belong to in society, is the first principle (the germ as it were) of public affections. It is the first link in the series by which we proceed towards a love to our country and to mankind. (Burke [1790] 1976, 135)

Burke's philosophy of sympathetic ethics prefigures recent discussions of postcolonial or cross-cultural solidarity; these notions of federated theoretical and ethical exchange subtend current approaches to subaltern resistance and representation. Extending from Burke's "little platoon," such ethical conversations manifest in the visual, thematic sympathy of political murals. This lateral ethical imagination, then, both nourishes and is adequately expressed in the progressive conjugations of the future perfect. Postcolonial theory has undeniably "traveled," usually from a Western-sanctioned center to peripheral contexts. In facilitating the germination of a genuinely egalitarian process of postcolonial ethics, it is necessary to conceive of this undertaking in terms of lateral rather than vertical exchange. Through this cultural exchange, we can potentially foster the seed for a cross-periphery solidarity, in which postcolonial cultures can interact in mutually edifying cultural exchanges. Indeed, the pursuit of

such "unapproved roads" can be extended to include not just artistic exchange, but equally to encompass the formulation of radical theoretical innovation.

As part of this cosmopolitan retrieval of shared local solidarities, aesthetic forms are also appropriated by the demands of material resistance. Therefore, the artistic effusions of political murals arise out of the everyday experience of political and cultural disenfranchizement. And as Lloyd suggests, the creative imagination no longer retains a transcendent posture, but the transcendent iconographic is materialized in the subversive tropes of visual kitsch. In representations of Celtic high crosses or dramatic portraits of Cúchulainn, which are then juxtaposed with images of modern militancy, we can trace this labile idiom of protest. In other words, a recast visual theater of resistance razes the rigid contours of nostalgized iconography. Irish postcolonial critics have adjudged that the Irish experience of imperial modernity was one of acute trauma (Lloyd 2000), and the notion of a constructive transgeographical engagement with memory and tradition as a means of forging "new solidarities in the present" (Gibbons 2002, 105)[10] has been suggested as a theoretical and political trajectory out of which a more egalitarian politics might emerge. Therefore, there is a tangible link, as well as an ethical continuity, between ideas of lateral mobility and such "new solidarities." Ireland's "Third World memory" (Gibbons 1996a, 3) should therefore operate within a polyvocal discourse of egalitarian "historically grounded cosmopolitanism" (Gibbons 2002, 100).[11] Indeed, the arguments of Florencia E. Mallon, historian of Latin American subaltern communities, chime with just such theoretical solidarity. She forwards the idea

10. Also as Mallon usefully notes, "This is not to say that "South-South" dialogue has not occurred before" (Mallon 1994, 1492). She lists the fields of peasant studies, the field of slavery, and African diaspora studies, writing on dependency, world systems, and articulation of modes of production.

11. Clair Wills makes a related point. She contends, "by virtue of its post-colonial status within Europe, Irish culture is in a position to say something unique about the experience of being modern (a position which is similar to, but not identical with, that of post-colonial cultures outside Europe, which are nonetheless linked to the hegemonic project of modernity both economically and politically). Hence my use of the term 'impropriety,' by means of which I distinguish the experience of being inside and outside the project of modernity at the same time" (Wills 1993, 237).

of non-hierarchical cross-regional dialogue, where neither of the two cases
is taken as the paradigm against which the other is pronounced inadequate
. . . [such a dialogue] is not the application of a concept, part and parcel,
without contextualization, to another area. Nor can it be framed in the
assumption that one side of the exchange has little to learn from the other.
(Mallon 1994, 1493)

In calling for such "non-hierarchical cross-regional dialogue," Mallon
suggests a form of horizontal egalitarianism; a discourse that enlightens
and processes experiences of mutually endured marginalization. This criti-
cal framework is emphatically not a matter of prospecting for cross-border
correspondences or facile similarities, but allows the contextual specifics of
previously colonized societies to work upon and through a store of politico-
cultural theorization. It is through stimulating and nourishing such "unap-
proved" conversation and by learning from the differential aggregates of this
dialectic postcolonial theory might evolve into a bona fide political praxis.
Such an enabling animus underwrites Rolston's comments on the use of
politically radical murals:

> Politically articulate murals simultaneously become *expressions of and cre-*
> *ators of community solidarity.* Although it would be far-fetched to argue
> that the propaganda war is won or lost at local level, there can be no deny-
> ing the role the murals play as crucial weapons in that war [my emphasis].
> (Rolston 1991, 124)

Lateral mobility or new solidarities in the present do not constitute facile
circuits of elegiac equivalence; rather, they signal economies of moral indig-
nation. Cross-periphery dialogue is not the "talking cure" of puerile analogy,
wherein a correspondence on past oppression inures postcolonial societies to
the exigencies of the present. The past or communal memories retain con-
temporary and future resonances.

By drawing attention to the validity of "non-hierarchical dialogue," as
Mallon terms it, she not only alerts us to the possibilities of cross-cultural
exchange, but also initiates an ethical drama. Just as we have spoken of the
cultural mutualities of horizontal vectors in postcolonial studies, there is also

a discernible ethical dimension to such horizontal exchanges. Postcolonial critique is founded on an ethical explication of the dynamics of colonialism and of postcolonial societies. However, much of the ethical energy of postcolonial reading is expended on negotiating the moral relativity of what might be termed vertical vectors of center-periphery and colonizer/colonized: simply the ethical responsibilities of the internally differentiated categories of colonizer and colonized. Indeed, such notions of international, cross-peripheral or horizontal critical/ethical solidarity is verbalized, albeit at a more localized level, by Guha in "The Prose of Counter-Insurgency." Distilling Guha's thesis, Chakrabarty notes, "In the domain of subaltern politics, on the other hand, mobilization for political intervention depended on horizontal affiliations such as 'the traditional organization of kinship and territoriality or a class consciousness depending on the level of the consciousness of the people involved'" (Chakrabarty 2000, 16). Inherent to such lateral mobilizations is a deep incredulity at, or suspicion of, vertical or hierarchical political relations. Indeed, one of the most remarkable murals that conveys just such a message of borderless solidarity appeared on the Falls Road in Belfast in 1983. Entitled *Solidarity Between Women in Armed Struggle,* the image displayed three militarized female figures, one representative from each of the IRA, the PLO, and SWAPO.[12] Although it would be disinguous to overplay the feminist concessions and/or implications of the mural, it does evidence again the lateral imaginative vectors of the republican mural tradition. Perhaps with the embrace of colonially oppressed female constituencies, republican murals further document the long historical tradition of republican cultural inclusiveness, which manifested previously in the sociocultural programs of the United Irishmen, and later appears in the gendered egalitarianism of the 1916 proclamation.

12. To view a reproduction of this image, see Rolston 1992b. Lyons includes a reference to a political poster disseminated by the Sinn Fein Foreign Affairs Bureau in the late 1970s and early 1980s which "provides a European context for the armed struggle for national self-determination in Ireland. On a map of Europe flanked by images of masked insurgents, the Irish are equated with the Catalans, Sardinians, Manx, Bretons, Cornish, Corsicans, Basques, Scots, Welsh, and Galicians. The top of the poster reads 'free the small nations,' and the bottom of the poster bears a quotation from James Connolly. . . . 'The internationalization of the future will be based upon the free federation of free peoples'" (Lyons 2003, 410).

Likewise, Cleary evinces such a conscious, affiliative ethical forum; he points out "many loyalists estates in Northern Ireland fly the Israeli flag and republican ones the Palestinian flag. In the segregated working-class districts of Northern Ireland the tendency to map the Northern situation in terms of other late colonial cartographies evidently endures" (Cleary 2004, 287–88). Such cross-cultural affiliation is not only manifest in the flying of flags, but is evidenced in the long heritage of political murals in Northern Ireland. Jarman suggests the murals are "Fixed in space but extended in time" (Jarman 1997, 18), but surely, as we have seen, republican murals exhibit a much more dilated political vision. Their spatiality may be limited in terms of their concrete structure, but the imaginative space of these artistic political canvasses reaches beyond the contours of inner city gable ends. In particular, nationalist murals are acutely conscious of "the spectres of comparison," invoking historical, revolutionary figures such as Che Guevara and Nelson Mandela, together with imagistic allusions to Palestine, South Africa, and Cuba.

Implicit in the resistant nationalist murals, then, is the idea of performative subversion; the murals are elemental within the cognitive maps of the everyday, and likewise are part of the brachiating political and cultural forms of communal and identitarian representation. The invocation of "foreign" oppression and histories heightens the critical voltage of the local context. Behind the surface array of visual symbols, images, metaphors, or allegories of the political murals, and of what Cleary briefly describes, I would suggest, lies the exercise of sympathy. The ethics of oppressed solidarity are evident in these political and cultural productions, because the strain of intimate struggle does not alienate other oppressed communities, but enlivens one's sensitivity to the plight of equivalent struggles beyond the horizons of the immediate.

In construing postcolonial or colonial relations in terms of lateral mobility, it is not a matter of blandly asserting a project of analogy or correspondence; quite the contrary. The impacts of colonialism are contextually differentiated experiences, with an entire raft of complicating factors, including geography, race, gender, and time. But, what is proposed is that it is tenable to extract mutual lessons, sympathies, understandings, and solidarities from the very differentials of colonial experiences. One of the most potent sites for the display of alternative solidarity is in the vocalization

of equivalent histories and memories of colonial oppression. However, although history is often associated with the textual form, memory is affiliated with the image. This is not to privilege one over the other, but merely to accent the ability of the image to bear the ethical and rememorative freight of shared suffering. Likewise, if control, surveillance, and indeed from an historical point of view, empire itself, is embodied within the textual, then perhaps one form of alternative resistant articulation can emerge through the power of the image.

But with every positive move toward a political compromise in the North, the function of the muralist alters; indeed, does it become precarious? In 1994 a series of murals appeared in Belfast urging the expeditious departure of the British army. Emblazoned across the top of one such mural in the Ardoyne was the Irish phrase *Slán Abhaile,* effectively, "goodbye." Although the mural displays several British soldiers marching along a tapering roadway, signposted as England, with their backs turned to foreground, *Slán Abhaile* might well apply to the muralists themselves. Just as each critical political theory of revolution or social change has its own obsolescence as its goal or achievement, the animus of republican murals is to foment a situation wherein they are no longer necessary in their current form. However, the sectarian dispute in the North does not necessarily mark the limits of the mural tradition. It has been suggested, and indeed manifested in certain quarters, that a more localized or socially conscious mural practice might emerge. Following the success of Chicano muralists in Los Angeles, might the muralists of Northern Ireland engage, perhaps mutually, in such nonaligned political and cultural activities? Significantly, such measures might dissolve the resolute imaginative borders of loyalist muralists, but it need not delimit the cross-cultural exchange thus far characteristic of republican murals.

To conclude: from a theoretical perspective, the murals navigate the often contested terrain between filiation and affiliation, between a rooted concern for the local and the immediate ("the little platoon" to return to Burke), and the necessary aspirational detachment of constructive political and cultural critique. As Whelan argues at length, regression into the former can lead to an insular essentialism, while an obsession with the latter can lead to apathy towards the urgency of the local (Whelan 2003b, 92–108). But again, in espousing the ethical legitimacy of navigation between filiation

and affiliation, Whelan is indebted to Burke. The expression of solidarity, in the form of the sympathetic sublime, as I have noted, extends outward from "the little platoon." This does not, however, demand the abandonment of the local or the familiar to the universal or the foreign:

> Instead of being objects of proscription, subaltern cultures are endowed with the rights of prescription, which take on a new critical valency in redressing the injustices of the past. Nor is this account of cultural diversity limited by solipsism of localism or relativism which led certain strands in romanticism to construe authenticity as *isolation,* a withdrawal from the outside world [my emphasis]. (Gibbons 2003, 228)

Likewise, the critico-political consciousness of republican murals refuses "isolation;" alternatively such philosophical hermeticism has been more characteristic of loyalist murals. In sum, the isolation, or containment, of nostalgia, of acquiescence, of resignation, of defeat, and of the present tense is reneged. Equally, in figuratively challenging the aesthetic conventions of visual representation, republican murals question the figurative stability of history itself. Returning to Leerssen: toward the conclusion of his essay, he seems to conflate both Protestant and Catholic histories as equivalent subaltern narratives. He states:

> To begin with, I find it significant that this condition is shared by both parties in the Northern conflict, and that it is precisely in this quality that Protestant and Catholic betray their joint Irishness. For both, history is uncanny, broken by rivers and battles like the Boyne or the Somme, by a sense of betrayal or threat. I think that it has something to do with the subaltern nature of the memories which are at issue. (Leerssen 2001, 220)

As the discussion of, and the distinctions drawn between, the competing visual economies of Northern Irish mural art reveal, telescoping the past to extract sustenance or guidance in the present may be a national pastime. But the imaginative voltages that infuse both politico-artistic traditions are not as easy to reconcile. The republican murals, in particular, are facets of the cultural and intellectual history of the Northern conflict. They represent conscious attempts to reclaim a stake in the representational spaces and times

of the Northern Ireland statelet. Although they do mine the historical and mythical resources of Irish culture, they also serve as reminders, through their lateral political affiliations, of the breadth of modernity's failure to alleviate oppression. We only receive confirmation of modernity's irrevocable capacity for such tyranny in its efforts to sustain itself. However, from a practical perspective, perhaps we should turn to Bertram D. Wolfe's panegyric on the impact of Rivera's murals. Remembering that Wolfe was a close friend of Rivera, it is still worth considering his remarks:

> So there are many aspects of a painting which can be conveyed with words, others not even with printed reproductions. If this is true of the single canvass, how much more is it true of a monumental mural, only fragments of which can be reproduced in the pages of a book, and only at the expense of their monumentality, of the qualities which come from scale, and relation to the architecture of which they are a part. All one can do is give a "catalogue" notion of the work in question, falling back in the end on the inevitable truism that such a painting has to be seen to be felt. (Wolfe 2000, 172)

This is not to elevate *all* murals to the artistic merit or visual-corporeal impact of Rivera's productions, but merely to encourage the *experience* of mural painting as a political, cultural, intellectual, and memorial force.

9

"Colleens and Comely Maidens"

Representing and Performing Irish Femininity in the Nineteenth and Twentieth Centuries

BARBARA O'CONNOR

Idealized women have long played a central role in the Irish cultural imagination. Visual representations of allegorical and mythical female figures such as Queen Maeve, Mother Ireland, the Virgin Mary, and Hibernia have, along with their more anonymous sisters, colleens, and comely maidens, been presented as role models of Irish femininity. There have been numerous critical analyses of political allegorical figures such as Mother Ireland (Loftus 1990; Curtis 1998–99; Steele 2004), but although the lure of the "colleen" has been central in popular Irish iconography since at least the middle of the nineteenth century, she has received much less critical attention than her counterpart figure as emblematic of a gendered ethnicity. "The Colleen Bawn" as dramatized in Dion Boucicault's Victorian melodrama is possibly the most famous colleen in Irish popular culture and has been well represented both on stage and screen, as well as in critical academic literature. But it is her less tragic sisters who have come to symbolize young Irish womanhood in the visual arts since the mid–nineteenth century. Visual representations of colleens and comely maidens have been determined largely by the historical, political, cultural, and artistic contexts in which they emerge, and reflect the deep gender cleavages in the society

I would like to acknowledge the invaluable encouragement and assistance of Dr. Jonathan Bell of the Ulster Folk and Transport Museum.

of origin.[1] To understand the role of the colleen in Irish visual iconography therefore, we must look at the ways in which gender was implicated in the construction of national identity in Ireland during the period under review.

Emerging in post-famine Ireland, the fortunes of the colleen have changed over time. Initially, she was the subject of paintings, illustrations, and folk songs, but developments in print technologies enabled the proliferation of a wider range of visual imagery in the late Victorian era (Curtis 1998–99). Since then, representations of the colleen have been crucial markers of Irish femininity in a diverse range of "high" and popular media alike, from paintings to postcards, photographs, advertising posters, book illustrations, fashion, television advertisements, and Web pages. This chapter examines the trajectory of colleen images from the 1860s to the present. In doing so, it addresses the ways in which particular political ideologies such as colonialism and nationalism have determined that imagery, and how it has maintained a symbolic value into the era of global capitalism. Although the images to which I refer are selective, I think they can be instructive in demonstrating how visual representations of Irish femininity reflect the dominant ideologies regarding women in any particular era, while at the same time acknowledging representations are sometimes contested, and the preferred meanings and pleasures they elicit are constantly in the process of negotiation and flux.[2]

In setting out to explore the figure of the colleen, three basic questions need to be addressed: What are the distinguishing iconographic features of the colleen? When and why did the colleen emerge as a popular iconographic figure? Finally, what are the points of similarity and difference between the colleen and Mother Ireland figures? The term colleen is a direct translation from the Irish language word for young girl: cailín, with the suffix "ín" denoting the diminutive, and connoting both affection and junior status, not just in age terms, but more crucially, I would suggest, in social standing.[3] The

1. See for example Loftus 1990; Coombes 1994; Curtis 1998–99.

2. Although acknowledging each of the above genres will have its own specificity and effectiveness in terms of the form and interpretation of images, this essay will, for the most part, highlight commonalities rather than genre specific differences.

3. The significance of naming is illustrated by Coombes's 1994 account of African women performing dances during the 1908 Franco-British Exhibition in White City,

colleen figure developed initially as a country/peasant girl, and was associated with a rural landscape and way of life. Links with particular places were common and regional versions of the colleen were lauded in both popular song and in painting.[4] In appearance, she was portrayed as either beautiful or pretty with long dark or red hair, dressed in native attire, the essentials of which are the cloak or shawl draped around the body and generally covering the head. In nineteenth and early twentieth century representations she was usually barefoot. Imputed personal characteristics or personality traits could vary depending on the function of the representation. She could variously be lively, charming, fiery or timid/shy, roguish, fun-loving, natural, unaffected, hardworking, and invariably pretty/beautiful and chaste. She also differed from her counterparts of Mother Ireland and Maid of Erin in terms of the aesthetic and political context of production. The latter figures were produced as personifications of Ireland and functioned within a political context as clearly allegorical figures. They appeared as emblems on banners and badges, as well as in newspapers and political journals. Perhaps we could say, then, the primary semiotic role of the Maid of Erin is allegorical and this is a secondary role for the colleen. The former is *of* and personifies the country but the latter is embedded *in* it. Representations of the colleen are also naturalistic. In general, the Maid of Erin is associated with symbols of Ireland such as the round tower (historical monuments), harp (musical instrument), and hound (associated with the mythical hero, Cúchulainn), whereas the primary association of the colleen is with rurality and chastity. Ultimately the national feminine ideal is negotiated through these discourses.

Although the two figures are dissimilar in certain ways, they are alike in several others. They are both popularly perceived to be civilizing influences on the nation. One cannot but be struck by the stark difference between these representations of Irish womanhood and the extremely negative visual iconography of Irish manhood in the nineteenth century (Curtis 1984, 1997; Loftus 1990). Like Mother Ireland, the colleen too can be regarded as a

London. In an effort to de-eroticize the naked dancing bodies, they were referred to as "girls" rather than "women."

4. See for example George Petrie's collection [1855] 1967 of songs and Thomas Alfred Jones series on the Irish Colleen in the National Gallery of Ireland.

boundary figure, and therein lies her representational significance and seductiveness. I suggest it is the colleen who bridges the conflicting or discrepant ideologies and sensibilities; it is she who manages the tensions between the rural and urban, between nature and culture, between sexual repression and desire, and between the domesticated and the wild.

The Colonial Colleen

It is difficult to pinpoint precisely the first mention of the colleen in visual representation because the term girl, lass, or maid was often used interchangeably.[5] However, the identification of women as specifically Irish has been noted in paintings and illustrations since at least the 1830s, and the firm establishment of the colleen figure in visual iconography can broadly be seen as a post-famine phenomenon developing within the pictorial romanticism of the Victorian era, at which time the overlapping discourses of gender and national identity were becoming increasingly important within an overarching colonial political framework. The issue of Irish femininity and how it should be best represented in relation both to Britain and other British colonies was firmly on the aesthetic agenda by the mid–nineteenth century. Therefore, the role of colonialism in determining the shape of gender imagery cannot be overestimated. Loftus (1990) notes the general colonial view of the Irish as other but that the "otherness" of men and women was configured in significantly different ways. Women, in contrast to men, were represented as beautiful, charming, quaint, and as representing a civilizing influence. She illustrates her argument by tracing the allegorical figure of Hibernia through the political press of the nineteenth century. With reference to nineteenth-century Irish painting, she claims that although it may be regarded in some respects as akin to other European art of the period, it is distinct in crucial ways. However, similarities cannot be overlooked, and I think it is important to refer to possible points of similarity. Nochlin (1988), for instance, illustrates how representations of peasant women were typically associated with nature and the soil in European painting of the time (e.g.,

5. This was also the case for other forms of popular culture at the time. See for example Petrie's collection of folk songs.

Millet's *The Angelus*), and goes on to suggest this motif functioned to trans-form rural poverty. It is likely these kinds of images would have functioned in a similar fashion in Ireland against the backdrop of extreme rural poverty, famine, and mass emigration.

The role of the Romantic movement in culture and art must also be acknowledged as crucial in valorizing representations of rural life generally, and peasant women in particular. The mid–nineteenth century witnessed the growth of nostalgia for a rural way of life that was fast disappearing, particularly in Britain, and that was evidenced in the choice of subject mat-ter in painting, where scenes of an idealized rural landscape and characters abounded. Cullen (1997) attests to the fact that painters of the nineteenth century sought out the peasant as a source of artistic inspiration because national character was believed to be exhibited most strongly and visibly in the rural poor. This belief in the "authenticity" of rural life parallels, and sometimes overlaps, with anthropological discourses concerned with "savage ethnography" and the "exotic other" because both sought to capture for pos-terity what was perceived to be a rapidly disappearing originary culture.

The representational positioning of the colleen as rural, therefore, is not accidental but plays an important role in colonial and Romantic discourses and the intersections between them. It serves a number of purposes. Images of the colleen battling against the elements serve to construct her as hard working and industrious which, again, is in stark contrast to representations of men as lazy and feckless. Following Gibbons (1988) and Nash (1993a, 105) these images might be termed hard pastoral. This version of the colleen may be contrasted with softer pastoral images referred to below and with later and more consumerist imagery discussed in the next section. Indeed, it would be useful to place these representations on a continuum from hard pastoral on one end to total domestication on the other. Hard pastoral imagery places the colleen on the side of nature—as untamed and wild. The most typical back-ground image of rock, bog, with mountain and water/sea included, embeds her firmly in a rural landscape—in nature. A further anchoring is achieved by her frequent portrayal with animals. This anchoring is further consolidated in verbal descriptions where the colleen takes on attributes of the animals themselves—"graceful as a young fawn" (Hall and Hall 1841–43) or "like a doe fleeing from a pursuer" (Henry 1951, 54). The following description by

the Halls is worthy of note because it is one of the earliest travel accounts in which they comment on the unconscious movements and unaffected manner of a young country girl, signifying both her embeddedness in "wild" nature and her natural beauty:

> As we were leaving the glen, we encountered . . . one of the prettiest little girls we had seen in Ireland was crossing a small brook—an offset as it were from the rushing river; but as rapid, and brawling as angrily, as the parent torrent, which it resembled in all save its width. . . . Her attitude as she stepped cautiously over the mountain cascade, was so striking, that we strove to pencil it down. (Hall and Hall 1841, 2:252)

The description above may be regarded as an example of what Nash (1993a, 93), in relation to the discourse of primitivism, sees as her simultaneous portrayal as product of her environment and an exotic outside her community. In her configuration as "wild" nature she is wholly romanticized as "other."

A more cultivated or tamed series of representations of the colleen are encapsulated in her portrayal as cultivator/gatherer; saving hay, digging potatoes, bringing turf from the bog, or herding sheep. Such a representation is evident in the celebrated opening scene of the film *The Quiet Man*, in which the character of Mary Kate Danaher is described as being like a "Dresden maiden, she appears herding a flock of sheep, hair flowing, framed by an idyllic rural background" (Barton 1999, 40). Although deeply embedded in the rural, the colleen does have a connection with the town, and in standard iconographic composition, toward the end of the nineteenth century, she is seen transporting farm produce to the town market—a reflection of the growth of the market economy in rural Ireland. The negotiation between the contradictory spaces of the town and country is achieved symbolically through the use of footwear. The colleen's lack of urban sophistication is signified by her bare feet and is a feature of most colleen images of this era. Her movement to the town is signified by the temporary donning of shoes as illustrated by a postcard, the caption of which reads: "On a market morning this colleen puts on her shoes before entering the town" (Figure 9.1). In this manner, the tensions between urban and rural are negotiated and resolved through the figure of the colleen.

9.1. *Young girl* depicted in *Halls' Ireland,* 1841.

Although the figure of Hibernia is crucial to the political salvation of Ireland within colonial discourse, the colleen's industriousness and capacity for hard work mark her out as the economic and cultural salvation of the Irish nation. Nowhere is this more clearly demonstrated than in the Franco-British exhibition held in White City, London in 1908 analyzed by Coombes (1994), who claims the exhibition provides "one of the clearest examples of how inextricably interrelated were the discourses on national identity, gender and imperialism" (Coombes 1994, 207). The Irish section of the exhibition was set up as the village of Ballymaclinton, the most remarkable feature of which was that it was populated by 150 Irish colleens who were employed on site. The village was selected for extensive national and local press coverage, displaying photographs of the colleens, laughing, smiling, and working. Indeed, Coombes claims few representations of the village exist without these women being prominently displayed. The iconographic significance of the colleen is contextualized in terms of the construction of Irishness in other contemporaneous colonial writings. She quotes from one such commentator on the provenance of their striking beauty: "[t]he same

flag covers what we believe to be the handsomest people in the world today—
English and Irish—who seem to have acquired by some mysterious process
of transmission or of independent development, the physical beauty of the
old Greeks" (Coombes 1994, 207). She notes further the representation of
the colleens must be understood in terms of colonists' distinctions between
colonies and, in particular, between the portrayal of the Irish and African
cultures in the exhibition. Unlike the representations of African women, the
colleens served to counter the stereotypes of the "dirty Irish by portraying
them as hygienic in their food production and cooking practices" (Coombes
1994, 209). Similarly, their portrayal as industrious and hardworking women
functions to counteract their characterization as a lazy and feckless com-
munity. In addition to solidifying ethnic distinctions, Coombes claims the
colleens performed other important ideological functions. One of these was
to diffuse the more militant aspects of the Gaelic Revival. She also suggests
they carried an important message for British middle-class women by chal-
lenging feminist activism of the period. It was increasingly common for this
class of women to be involved in some form of voluntary public service. Phi-
lanthropy, as opposed to the equality and women's rights agenda of the Suf-
fragette Movement, was seen to be the most appropriate form of good work
for them because it was the philanthropic approach that appeared to be so
effective in the improvement of Irish women and Irish society generally.

Colonial discourse was also effective in terms of negotiating the sexual
status of the colleen, and here again it is instructive to place her in relation to
the contemporary representations of English and African women's sexuality.
Power (1996) suggests English women in the nineteenth century were com-
pared to statues, and were represented as being cold [chaste] as marble while,
alternatively, African women were represented, in a leap from color to sexual-
ity, as being polluted by color and therefore, sexually promiscuous. I suggest
Irish women are represented nearer to the English side of the pole, sufficiently
similar in terms of skin color to be chaste but sufficiently different to be more
exotic, "softer," and "warmer."[6] Indeed, the chastity of young Irish women

6. L. P. Curtis raises the intriguing question of whether allegorical figures such as
Hibernia had a sexual meaning for the viewer. She suggests this was the case and quotes from
H. G. Wells' autobiography to support her view. Although impossible to verify, I surmise

was vigorously promoted through colonial writings. Thomas Joyce opined in *Women of All Nations,* published in 1908, that although Ireland was "stagnating below the line of reason and even sanity," at least the women knew their place, because "no country in Christendom reveals a higher standard of chastity" (Coombes 1994, 208). The strict codes of sexual morality developed in the post-famine era and the increasing importance of the symbolism of chastity as represented by the Virgin/Mother figure is attested to by MacCurtain (1993) in her analysis of the colleen figure of Molly Macree.[7] Despite, or perhaps because of, the trope of chastity, the figure of the colleen is simultaneously and decidedly sexualized. This is partially because peasant women in European art have generally been represented as both religious and sexualized. Nochlin draws attention to this duality of representation, arguing "[a]t the same time as the peasant woman is represented as naturally nurturing and pious, her very naturalness, her proximity to instinct and animality, could make the image of the female peasant serve as the very embodiment of untrammelled, unartificed sexuality" (Nochlin 1988, 19). Nochlin also contends that the peasant woman's role as signifier of "earthy sensuality" in nineteenth-century art is as important as her nurturant or religious role, and this role is influenced by the representation of the young peasant girl as invariably striking in form and posture (Nochlin 1988, 20).[8]

As in European art, the sexualization of the colleen is achieved through drawing attention to bodily form and posture. We can see this clearly in the Halls' descriptions of a young woman's cloak, in which the emphasis on the cloak serves to draw attention to the female form: "[p]erfect in form as a Grecian statue, and graceful as a young fawn. The hood of her cloak shrouded each side of her face; and the folds draped her slender figure as if the nicest art had been exerted in aid of nature" (Hall and Hall 1841–43, 8). The reference

the more naturalistic depictions of the colleen allow for a greater sexualization of the image because they are perceived as more "flesh and blood" figures.

7. Strict codes of sexual propriety were enforced in post-famine Ireland because of the need to keep population growth under control to consolidate land holdings. This led to higher rates of celibacy and late marriage.

8. Berger (1972) too has identified a similar sexualization of women in art with the rise of the nude in European painting from the sixteenth century onward.

to the cloak as sheltering but not concealing the face has connotations of modesty and shyness at the same time as it affords the viewer the power of observation. The Halls later note, "[s]he was completely enveloped in one of the huge cloaks of the country; it had been *flung* on, carelessly and hastily, but it flowed round her form in a manner peculiarly graceful" (Hall and Hall 1841–43, 252). They also frequently refer to young Irish women's physical beauty and good deportment, as in the following: "good nursing gives the women good shapes; there are seldom any "angles" about them; the custom of carrying burthens upon their heads makes them remarkably erect" (Hall and Hall 1841–43, 470).[9] One particular young woman they encountered on their travels is described thus: "her nose was well formed and straight—quite straight—and her brow was finely arched; the chin, a feature so seldom seen in perfection, was exquisitely modeled; and as she only knew a few words of English, her gestures, expressive of her wants and wishes, were full of eloquence" (Hall and Hall 1841–43, 471).

Obviously influenced by the Romantic Movement in art and classical allusions to Grecian perfection and simple lines, the Halls saw Irish women as embodying this simple grace in form. In addition to their aesthetic function, the comments on health, strength, and beauty above implicitly connote fertility and childbearing capacity. The colleen's childbearing capacity is signaled rather than explicitly stated in the following comment by the Halls on her strength and sturdiness: "[t]ake a portrait of one of them—a fine hale and healthy mountain maid; as buoyant as the breeze and as hardy as the heath that blossoms on its summit" (Hall and Hall 1841–43, 248). In reproductive terms, then, the colleen can be clearly distinguished from Mother Ireland, who is dependent on the next generation for survival. The colleen not only symbolizes the future generation but, as MacCurtain claims, also "embodied the reproductive capacity of giving birth to that generation" (MacCurtain 1993, 14). "Mother Ireland" is asexual; the colleen is sexualized in the sense that she is the object of romantic longing and desire, the differences between them emphasizing the dichotomy between the maternal and the sexual in

9. It is worth noting the contrast with simian discourses of male Irish masculinity beginning to develop and were to become such a common feature of colonial representations from the 1860s.

Irish culture. One important point to note in relation to the colonial, as indeed other discourses discussed above, is the variability in ideological and aesthetic role of the visual images depending on the production and consumption context.

The Nationalist Colleen

If the colonial discourse on Irish femininity determined visual representations of the colleen from the 1860s, one might ask if, and how, they were altered with the growing strength of cultural nationalism toward the end of the nineteenth century and the subsequent establishment of the Free State in 1922. Critics on the issue (Meaney 1993; Nash 1993b; Loftus 1990; Curtis 1998–99) seem to agree that cultural nationalists, far from making radical iconographic changes, were very much influenced by gendered ideas of nation, which were in vogue during the colonial period, and they generally adopted, and in some cases inverted, the images of Irish womanhood established under colonial rule. According to Loftus (1990), dominant colonial representations were taken up and reproduced by native and nationalist artists. Nash also argues convincingly that, despite the transition from Celtic to Gaelic within cultural nationalism, which "asserted masculinity as the essential characteristic of the Gael" (Nash 1993a, 99), women's bodies remained as important signifiers and nationalism was inscribed onto women's bodies in specific ways. She argues that, in painting and travel photography, young women were increasingly absent and that this was partially because cultural nationalists denied women "an autonomous sexuality in their idealization of asexual motherhood" (Nash 1993b, 47). This gave rise to a situation in which the "visual representation of the idealized country woman rested uneasily with the history of eroticized images of women in Western art" (Nash 1993b, 47). Consequently, she claims the image of the young woman was replaced by images of the old peasant woman who could be represented more easily in line with contemporary state ideals of women as mothers and as bearers of language and folk traditions.

Although Nash's argument is convincing in relation to painting, I tend toward the view that images of young womanhood retained their importance in visualizations of the national imaginary but were diversified into other aspects of popular visual culture. One banal, but important example of this

might be the colleen figure on the paper currency of the new state based on Sir John Lavery's painting of Lady Lavery as Kathleen Ni Houlihan (1928). References to young women were also common in the rhetoric of political leaders in postindependence Ireland and were key signifiers, I suggest, in the construction of a political and cultural national "imagined community" (Anderson, 1983). De Valera's famous radio broadcast on St. Patrick's Day 1943 refers to the "laughter of comely maidens" as an essential element in his vision of a rural idyll. In an earlier but telling passage, Michael Collins uses similar utopian imagery in which young women play a central symbolic role:

> One may see processions of young women riding down on Island ponies to collect sand from the sea-shore or gathering turf, dressed in their shawls and in their brilliantly coloured skirts made of material spun, woven and dyed by themselves Their simple cottages are also little changed. They remain simple and picturesque. It is only in such places that one gets a glimpse of what Ireland may become again. (McLoone 1984, 55)

Here we note the symbolic importance of red home spun and home-dyed yarns of the colleen's costume and its connotations of indigenous authenticity and sexuality.[10] Women are simultaneously linked to the landscape, to local crafts, peasant self-sufficiency—threads that link the past with a utopian vision of the future. I concur with McLoone's reading of this passage as "the displacement of women into symbols of Ireland itself—in Collins' version, young Irish girls, asexual in their beauty and chaste in their deportment" (McLoone 1984 55). He goes on to suggest that in offering myths of Mother Ireland, or Cathleen Ni Houlihan, this dual concept of chastity and rural utopia is posited against all that England symbolized.

10. The red color of women's clothing was a signifier of vitality as far back as the 1830s. Referring to the woman depicted in Wilkie's painting "The Brigand Asleep," Cullen remarks: "Wilkie makes the woman's indigenous red skirt the most striking visual component of the painting and that his choice was underlined by a remark in a letter from Limerick that: 'in Connaught and Cunnemara [sic], the clothes particularly of the women are the work of their own hands and the colour they are most fond of is a red they dye with madder, which as petticoat, jacket or mantle, brightens up the cabin or landscape, like a Titian or Giorgione'" (Cullen 1997, 124).

However appealing the colleen image may have been to male political leaders of the day, it did not go unchallenged by some nationalist and feminist women. An editorial in Cumann na mBan's publication *Bean na hÉireann* denounced references in another publication, *The Irish Homestead,* as "pernicious nonsense" for "romanticising over the barefoot Irish cailín in her red petticoat and hooded cloak when the reality was that poverty determined what Irish girls wore and not the desire to look picturesque" (Ward 1983, 74). Despite these objections, colleen imagery continued to be consolidated as part of the popular visual imagination and in line with the marginalization of republican and feminist women's voices in Irish public life. Paul Henry's work might be seen as typical of the dominant national pictorial representation of the time. Henry's claim to be witnessing "[the] slow fading out of an era" (Henry 1951, 108) can be seen as exemplary of the romantic nostalgia and desire to capture a way of life perceived to be in rapid decline. In his autobiography, he comments on the unearthly beauty of the women of Achill, of their clothes of home spun and dyed red petticoats, and of their immersion in the natural landscape. He recounts "witnessing with sorrow the gradual discarding of the scarlet petticoat by the womenfolk" (Henry 1951, 108). The association Henry makes between women and their colorful clothes is echoed in other stories of his time on the island. At one point he is taken to see "a most beautiful girl on the island in the hope that she will assent to sit for the artist. However, on entering the cabin where the girl lives she flees to the next room." (Henry 1951, 53) In his words, "she was unearthly in her beauty, barelegged and dressed in a faded and tattered frock of dyed red homespun. That one startled look from those beautiful eyes I shall never forget. She was like a doe fleeing from a pursuer" (Henry 1951, 54). There appears to be a thinly disguised eroticism in Henry's description, also evident in other accounts of his artistic relationship with the young women of the island. The resistance to being an artist's model displayed in the incident just recounted was typical of the other young girls of the village and Henry, by his own admission, was forced to resort to drawing from memory or surreptitiously. In these passages, one gets a strong sense of the unattainability and the ephemeral quality of native beauty, of the difficulty of "capturing" the essence of this beauty in his work. The relationship Henry had with the women of Achill is a good example of what Nochlin identifies as "the notion of the artist as sexually dominant creator: man—the

artist—fashioning from inert matter an ideal erotic object for himself, a woman cut to the very pattern of his desires" (Nochlin 1988, 143)—much the same, then, as the relationship between the colonizer and the colonized.

No account of popular representation/performance of the colleen in the twentieth century would be complete without reference to the idealized version of Irish womanhood as represented in Irish step dance. Although unable to detail it fully here, I would like to note in passing a number of pertinent observations about the changing symbolic role of dance. During the early years of the twentieth century, the public performance of step dance changed from being a predominantly male to a female practice (Cullinane 1994), and has arguably become one of the most influential visual markers of Irish feminine identity.[11] In this context, we might also note that the colleen figure was no longer embedded in landscape but rather performed in a theatrical space. We might also observe that, despite the antipathy expressed by cultural nationalists toward urbanization, Irish dance became very popular in towns and cities—both changes distancing the colleen from the rural. However, dance performance through the establishment of An Coimisiún le Rincí Gaelacha (The Irish Dancing Commission), and the development of formal rules of movement and presentation, including dress, in dance competitions, continued to encourage young women to perform a distinctly gendered identity. Irish step dance was regarded as graceful and pure because it was given shape in opposition to other "foreign" types of dance, particularly jazz. The visual style of the young dancing girl that emerged in the 1930s continued to play an important role as a signifier of idealized ethnicity (O'Connor 2005) at a national level for the next sixty years.

The Commercial Colleen

As advertising became well established, and as representations of women were increasingly used to sell products and services, the colleen became a popular icon for marketing Irish goods and the country itself through tourism promotion.

11. It is interesting to note how Irish step-dance, as described by Cullinane, changed from being a predominantly male to a predominantly female practice in the early years of the twentieth century, a phenomenon that warrants more investigation in relation to dynamic of gender and national identity construction at this time.

9.2. *Young Woman Going to the Market,* postcard, undated.

Queen Victoria herself, who was "an enthusiastic patron" of the play *The Colleen Bawn,* paid a visit to Killarney in 1861, where she visited Colleen Bawn Rock, the place where, allegedly, the heroine attempted to drown herself. It subsequently became a fashionable spot on the tourist trail (Condon 2003).[12] The expansion of transport networks helped to develop internal tourism, and

12. A postcard from the era entitled "Bewilderin' the Tourist" contains reference to the tourist being pestered by locals to buy pictures of the "colleen ban" or the "colleen das" as souvenirs.

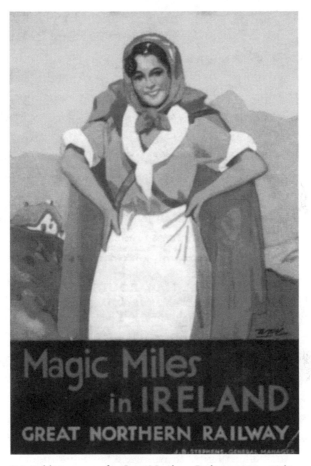

9.3. Publicity poster for Great Northern Railway, 1930s–1940s.
Courtesy of Ulster Folk and Transport Museum.

again we see the clear association between women and the Irish landscape in the invitation to travel.[13] Tourist representations have continued to utilize images of colleens to attract visitors to Ireland because there is a continuing need for ethnic demarcation in tourist discourse (Negra 2001).

Ethnic imagery continued to be utilized to sell products across communication platforms. A television advertisement for Harp lager in the 1980s

13. It is also interesting to note the similarity between the style of this poster and Paul Henry's paintings.

introduced the figure of Sally O'Brien—a classic example of the association between male desire and Irish femininity. The advertisement in question revolves around the fantasy of an Irish oil worker in a desert environment, far from home comforts. On his return, there is the attractive prospect of a pint of cold Harp to slake his almighty thirst, and the additional voiceover promise of Sally O'Brien and "the way she might look at you." Although the use of colleen imagery is in decline in Irish television advertising (Stevens et al. 2000) or is used in an ironic way (Graham 2001), the current television advertising campaign for Kerrygold butter points to the continuing sexual appeal of the ethnic other. In this advertisement, the main protagonists are an Irish woman and French man, although the campaign has reversed the gendering in previous advertisements. The action revolves around a classroom where an attractive teacher with long dark hair, Miss Kennedy, is taking a domestic science class. She is in the process of extolling the health benefits of Kerrygold butter to the class of young women when the entrance of an equally attractive man, who appears to be a new teacher, interrupts the class. In a seductive French accent, he asks Miss Kennedy, very politely and formally, if he might have some Kerrygold. She assents, proffers him the plate of butter, smiles, and lowers her eyes in a coy manner, connoting a sexual tension between them. A stern and disapproving middle-aged headmistress wearing glasses and a bun—her mien signifying sexual primness and repression, witnesses this scene through the open classroom door. At one level, we may interpret the colleen figure in this scene as being more sexually aware than her earlier counterpart, but one might also interpret the lowering of the gaze as a continuation of a certain sexual coyness.

If the colleen was such a central figure in visual representations of the colonial and nationalist eras from the 1860s onward, the question arises as to the need for such representations in the contemporary era of a global economy, and cultural and ethnic hybridity. Furthermore, if the colleen has historically been represented in terms of rurality and chastity, what is her fate in a world where these concerns and attributes have been superseded and/or devalued? Is there still a need for other idealized versions of Irish ethnic femininity, and how would they function in the global economy of representation?

To answer these questions adequately would require much more investigation of specific visual domains. Preliminary evidence suggests that

contemporary versions of the colleen are extremely popular in certain cultural contexts but not in others. The Barbie doll Web site currently displays two versions of the Irish Barbie, so in its most kitschy commodified form, one could say Irish femininity is alive and well. However, in other domains, the colleen is in definite decline. Rains, for instance, points to the relative absence of Irish female stars in contemporary Hollywood cinema (2003). She contends that the kind of sexuality associated with such stars as Maureen O'Hara in the film *The Quiet Man* no longer has any cultural purchase because of changing ideas about what constitutes physical/sexual attractiveness for female stars:

> the rapidly changing ideals of female physicality that have radiated out to all of the Western world from Hollywood from the late 1980s onwards could also be analysed in tandem with the rising popularity of this "southern femininity" in particular, the uniform equation of bronzed skin and voluptuous body-shape (naturally or otherwise in both cases) with female sexual attractiveness. (Rains 2003, 194)

The new generation of film actresses are associated with a now positively represented physical exuberance, eroticism, and emotional openness. These qualities are very different from more traditional representations of Irish femininity:

> It is this association between Irish female sexuality and traditional ideas of chastity which is perhaps the key to its lack of appeal in contemporary representations of ethnic femininity, and also the nexus around which these cultural associations are combined with more literal, physical markers of women as objects of desire. (Rains 2003, 195)

The representations cited above fall clearly within the global economy of representations with few links to the local. However, there are other representations such as *Riverdance*[14] and *The Rose of Tralee*, which are hugely popular

14. "The Countess Cathleen" scene accompanied by the following text: "Sensual, nurturing, independent and fierce, the power of women as they celebrate themselves, as they

but indicate changing relations between the global and local, and consequently, tensions around the meaning of a quintessential Irish femininity. Although no longer barefoot or becloaked, the representations of the female dancers in *Riverdance* both embody and draw on many of the markers of ethnic femininity habitually associated with the colleen (Carby, 2001). *Riverdance* has been an international success for over ten years, and I have argued elsewhere it sought to emphasize stereotypical aspects of Irish femininity by way of clothing, hair, and choreography. Carby, too, claims the show valorizes traditional gender roles but that there is a reversal of the moral color coding in the other successful dance show *Lord of the Dance*. In the latter, "bad women are sexual temptresses, have black hair and dress in red: the perfect female partner for our hero, the Lord of the Dance, is a blonde, Irish Colleen who signals her virgin state by dressing in white" (Carby 2001, 341). She argues these two recent dance shows have constructed a racialized and gendered Irishness presented in its extreme in *Lord of the Dance*. In the latter, the racial and sexual purity of the Irish colleen is "equally racialized as authentically Celtic" (Carby 2001, 341). The lesson from this is that within an increasingly globalized culture, images of gendered ethnicity may be appropriated in such ways that "particular histories are erased or denied, replaced instead by particular national, or racialized, or ethnic imaginings" (Carby 2001, 326). This indicates that in the global, as in the colonial era, representations can function in a racially problematic way. However, there are also contradictions within representations of feminine sexuality in *Riverdance,* or at least contrary interpretations of the meaning of the show. Numerous commentators have emphasized the way in which *Riverdance* transformed Irish step dancing from a rigid and sexually repressed practice to one that was joyful and "sexy" (O'Toole 1998).

The annual Rose of Tralee competition is perhaps one of the most enduring representations of youthful Irish femininity.[15] The festival is particularly

challenge men in a dance of empowerment." www.riverdance.com provides a contemporary proto-feminist/Celticist take on the Irish feminine.

15. With reference to the performance of ethnicity in the form of beauty pageants Wilk (1993) claims contradictions are not only tolerated in the person of the beauty queen but are indeed demanded. I am suggesting this has also been the case for the colleen.

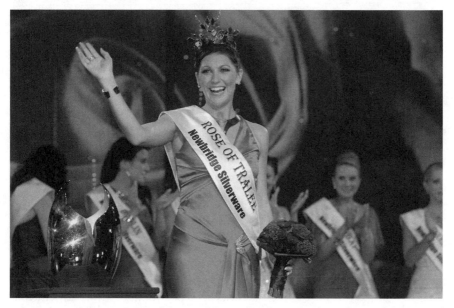

9.4. Kathryn Feeney, winner of the 2006 Rose of Tralee Festival. Courtesy of the Rose of Tralee International Festival.

interesting in terms of its mix of migration and tourist discourses, as well as its attempt to define an idealized ethnic hybridity in the face of global and diasporic cultural conditions. It taps into issues of national identity as well as tourist interests. Established in 1959 as a state effort to boost the tourist sector by inviting Irish emigrants back to visit Ireland, and initially targeted at emigrants mainly from Britain and the United States,[16] the pageant now has competitors from many other countries including the Middle East and Asia. The festival became very successful in terms of the tourist economy, but more germane to the discussion here, in terms of the televising of the main competition and its hosting for many years by Ireland's premier television personality, Gay Byrne. It may also be regarded as the only public space where diasporic ethnic identity is continually constructed and negotiated in

16. Moloney (2002) comments on the establishment of the colleen figure in popular culture in the United States by the turn of the twentieth century. He attributes her role as cultural icon to the upward mobility of second generation Irish women who were by now regarded as pretty and hardworking, thereby making ideal marriage partners.

the interchanges between the presenter and competitors in front of both a live and a television audience. The visual highlight of the week's festival is the competition to select the "best" Rose. Although it is not billed as a beauty pageant,[17] the competitors are invariably "good-looking." The discourses of the show were influenced not just by the judges, but also crucially by the presenter Gay Byrne. Avuncular in style, he steered the conversation with competitors between "traditional" images and contemporary realities of ethnic hybridity. Great care was taken to establish their Irish credentials in terms of ancestry. The problems of contradictory discourses and the hyphenated status of the competitors were smoothed over by the presenter.[18] The 2004 show was presented by Ryan Tubridy, one of the younger generation of broadcasters, in a more ironic/tongue-in-cheek style. The show has also been dogged by organizational and funding problems in recent years, and perhaps is an indication of the increasing difficulties of constructing and committing to a single idealized ethnic identity in a postmodern and multicultural environment.

The Colleen Looks Back

What I have attempted to do here is explore the image of the colleen in visual representations in/of Ireland over a century and a half. I have argued she has been constructed in accordance with the dominant interests of political and cultural elites over that time. In this sense, one can say the representations of the colleen substantiate the claims generally made in relation to dominant representations of Irish womanhood. However, the submissiveness noted by Loftus in terms of allegorical figures and the passivity and wistfulness noted by Cullen in painting are not upheld across time and genres. As we have seen from the discussion above, the colleen can in some contexts be regarded as

17. This is in keeping with the words of the popular song the Rose of Tralee, based on the real life Mary O'Connor whose suitor proclaims "it was not her beauty alone that won me. Ah, no 'twas the truth in her eye ever dawning that make me love Mary the Rose of Tralee."

18. But even young women with no Irish ancestry could be ethnically converted by marriage to an Irishman as in the case of "My Yiddisha Colleen," a popular song in Irish America in the 1920s!

passive and submissive; in others, she can be seen as feisty and fun loving. We have also seen how traits associated with the colleen such as chastity are no longer valorized in certain performance contexts such as Hollywood cinema but are in others. Visual representations raise the thorny issue of interpretation in specific historical contexts, and periods, by different viewers, a question also raised by Curtis in relation to feminine images of Ireland. In the contemporary context, for instance, while some commentators see the female dancers in *Riverdance* as sexual in a positive way, for others, their sexual representation is implicated in racist ideology. Through colonial representations, to nationalist, to transnational/global, the image of the colleen has functioned variably to signify sexual and national purity, future prosperity, the exotic, the "wild," modernity, to sell places and products, and to affirm the expectations of emigrants and tourists alike. Whatever the fate of the colleen in the future—and this will depend on her usefulness in a global circuit of imagery—her endurance over the last century and a half has demonstrated the importance of idealized femininity in constructing and negotiating an Irish ethnic imaginary.

10

Tá Siad ag Teacht
Guinness as a Signifier
of Irish Cultural Transformation

EUGENE O'BRIEN

That Guinness is a synecdoche of Ireland is almost, at this stage, a cultural given. This commodity has taken on a fetishistic association with Ireland, an association enunciated by the desire of tourists to have a pint of Guinness as a testament to having arrived in Ireland. In all tourist shops, practically every item of consumption can be found with a Guinness brand on it, from drinking glasses and alcohol-related products to all forms of clothing, including underwear. Indeed, Guinness has operated as a synecdoche in a further dimension; in most pubs in Ireland if one asks the barperson for "a pint," the default beverage will be a Guinness.

However, this chapter will look at a more macrocosmic index of Guinness. By tracing a number of advertisements, I hope to demonstrate that Guinness as a commodity has followed, paralleled, and at times anticipated, sociocultural trends in contemporary Irish society. This may seem a large claim to make for what is, after all, a brand of beer. But a brief discussion of how cultural codes develop and change will provide the theoretical framework for an exploration of Guinness advertisements as published by the company itself, specifically, in a special celebration of seventy-five years of advertising, published in 2004 (*Guinness Calendar*). This adequation between the product and a sense of Irishness is not accidental, as an example from the calendar will demonstrate. The March 2004 image is of a close-up of the logo on a pint glass of Guinness. This logo is a golden harp, an image also associated

with Ireland, and Irish nationalism in particular, so the adequation is clear at an iconic level. This is further foregrounded by the text of the advertisement: "Natural Anthem" (*Guinness Calendar* 2004, March). Here the visual and verbal texts conflate to fuse in the mind of the consumer a "natural" adequation between the product and the nation, and it is all done at a level of clever abstraction, especially given the sea changes that have occurred in both the product and the nation in the last seventy-five years.

Guinness was founded in 1759, and the stout was initially a local beer because of distribution problems. Now the company is owned by Diageo, and is a world brand with a huge distribution network. Ireland has changed phenomenally over the past ten years, in the wake of economic boom and the Celtic Tiger. From being a country with a predominantly agricultural base, we have now developed into a service and consumer economy, which has leaped from the premodern to the postmodern without that long period of embourgeoisement typical of most Western European democracies. Gone are the days when Irish laborers emigrated to London to help rebuild that city; now Irish property companies like Sherry-Fitzgerald are buying large tracts of London property. Irish investors including Aidan Brooks, Derek Quinlan, and Alanis Limited have spent around 250 million euro on property on Bond Street since 2000. Gone are the days when Irish soccer fans saved their wages for the annual pilgrimage to Old Trafford or Parkhead; now Irish businessmen like J. P. McManus and Dermot Desmond have bought, and sold, shares in Manchester United and Glasgow Celtic. Gone are the days when Eamon De Valera's vision was of comely maidens dancing at the crossroads; now the comely maidens dance on the stages of world capitals in shows like *Riverdance* or *Feet of Flames*.

In short, Ireland has changed rapidly, and we have become a western consumer culture with all the cultural baggage that is entailed therein. The subjectivity of the contemporary Irish person probably has far more in common with our contemporaries in Western Europe and America than it has with past generations of Irish people: the influence of mass media, television, radio, film, the Internet, and mobile and miniaturized personal communication technology is pervasive across the developed world, and this can be demonstrated in the marketing processes of Guinness. This seemingly "Irish" product is in fact globally based and marketed, and the image it

portrays has a parallax effect in terms of contemporary Irish subjectivity. In terms of contemporary culture, advertising is one of the most carefully researched ways of appealing to an individual's subjective desires, and in this chapter, the different advertisements for Guinness over seventy-five years will be examined precisely in terms of how this is achieved. Given that consumption has become a defining characteristic of who we now are, advertising has become a crucial signifier in the whole area of subjectivity, and the work of Louis Althusser can be deployed to aid our understanding of this.

For Althusser, society achieves its desired aims of perpetuating the subjective identities of populations through ideology. He defines ideology as the ways in which society constructs subjectivity, and this is done through what he termed Repressive State Apparatuses (RSAs), such as the police, the army, and censorship; and Ideological State Apparatuses (ISAs), such as education and the media. In contemporary culture, large corporations also achieve the same aim by constructing subjects motivated to consume their products. For Althusser, ideological success was achieved when individuals voluntarily set out to become what society wishes them to be. The process of interpellation begins with "hailing," a calling to participate in a form of ideology (Althusser 1998, 302).

Hailing is ubiquitous, almost entirely irresistible, and is at the center of any ideological system. It attempts to make another individual recognize and accept a form of ideology. Through hailing, ideology "acts or functions in such a way that it recruits subjects among individuals" (Althusser 1998, 301). Individuals are born into ideology, but hailing recruits subjects of particular ideologies. Subjects do not realize their subjection, and are only free in that subjection is freely accepted. Althusser states that an institution or individual hails another individual much as the "common everyday police (or other) hailing: Hey, you there!" (Althusser 1998, 301). A successful hailing occurs if the individual "recognizes that the hail was really addressed to him, and that it was really him who was hailed" (Althusser 1969, 41). This recognition, for example, may be the acceptance of a particular social practice or label, such as an advocate of Christian religious ideology terming himself a Christian. If a hailing is successful, an individual becomes a "subject" of a particular ideology, and hence, is "interpellated;" interpellation being a successful hailing (Althusser 1998, 303). Althusser succinctly

states this process in his central thesis: "Ideology interpellates individuals as subjects" (Althusser 1998, 299). Thus, the individual sees him or herself as successful through the eyes of society.

If we transpose this into contemporary culture, multinational corporations also attempt to interpellate subjects, but in this case, the dictum could be restated as "corporate ideology interpellates individuals as consuming subjects," and the mode of hailing used to this end is advertising. By hailing a subject, and by getting the subject to recognize that his or her sense of self is in some way enhanced by the consumption of this product, advertising becomes the ultimate ISA of capitalist society. In this context, the first point to make is that advertisements are cultural signifiers specifically ideologically charged. In terms of their efficacy, they operate within the context of what Roland Barthes termed a cultural code:

> it is the code of knowledge, or rather of human knowledges, of public opinions, of culture as it is transmitted by the book, by education, and in a more general and diffuse form, by the whole of sociality. (Barthes 1981, 155)

These signifiers, be they oral, visual, or verbal, must operate within a given social code, otherwise they will be unintelligible to the consumer. Thus, to be successful, advertisements must both participate fully in and at the same time anticipate the development of cultural codes if they are to market their chosen product to best effect. Of course, it is something of a moot point when such cuspal shifts take place, and these are definitely contextually based. For example, the notion of the mobile phone, so very much taken for granted now, would not have become so popular without the Walkman, which preceded it, and the same is true of many products, such as the MP3 player and the iPod.

In fact, in a Lacanian context, all subjectivity is defined in terms of what is called the symbolic order, and this order is the structural matrix through which our grasp of the word is shaped and enunciated. For Lacan, the symbolic order is what actually constitutes our subjectivity: "man speaks, then, but it is because the symbol has made him man" (Lacan 1977a, 72). It is the matrix of culture and the locus through which individual desire is expressed: "the moment in which the desire becomes human is also that in which the

child is born into language" (Lacan 1977b, 103). The social world of linguistic communication, intersubjective relations, knowledge of ideological conventions, and the acceptance of the law are all connected with the acquisition of language. Once a child enters into language and accepts the rules and dictates of society, it is able to deal with others. The symbolic, then, is made up of those laws and restrictions that control both desire and the rules of communication, which are perpetuated through societal and cultural hegemonic modes. The symbolic, through language, is "the pact which links subjects together in one action. The human action *par excellence* is originally founded on the existence of the world of the symbol, namely on laws and contracts" (Lacan 1991, 230).

Currently, our culture and subjectivity are very much consumer-driven, and commodities have become a huge part of contemporary subjectivity. It can be said capitalist society and consumer culture are the ideal expressions of the desire Freud and Lacan see as central to the human subject. The rush to embrace capitalism by former Communist countries in Eastern Europe, and to a more gradual extent in China, would seem to bear this out. To buy a product, one must be persuaded it will be of value, and once one has gone beyond the basic categories of Maslow's hierarchy of needs, the requirement to purchase something beyond food and safety becomes problematic (Maslow 1943, 370–96). It is here that advertising as genre becomes significant because its role is to persuade the consumer that a particular product will not just satisfy a basic human need, but instead will make the consumer happy and fulfilled. It is at this point we enter the mode of commodity fetishism, and, at a more basic level, we encounter the notion of desire.

Within capitalist societies, people find their material life organized through the consumption of commodities. They trade their labor-power for a special commodity—money—and use that commodity to claim various other commodities produced by other people, and have no direct human contact or conscious agreements to provide for one another. Their productions, and by extension their relationships, take on a property form, meet and exchange in a marketplace, and return in property form. However, this is a very reductive definition of this term because these commodities, in turn, become invested with a lot of the qualities of social relationships—for example, people adverting to their cars by name, and imbuing inanimate

objects with projected personalities. The work of social relations seems to be conducted by commodities amongst themselves, out in the marketplace. "The Market" appears to decide who should do what for whom. Social relationships are confused with their medium, the commodity. The commodity seems to be imbued with human powers, becoming a condensation of those powers. Social relations between people are experienced mainly in the form of the commodities they see extracted from them as producers, and those returned to them as consumers. Both are private experiences, of person to commodity and of material self-interest, and both are initiated by desire.

As a consequence of commodity fetishism, the basic political issues involved in social relationships are obscured. Commodity fetishism ensures neither side is fully conscious of the political positions they occupy. Although the term is originally Marxist, within psychoanalysis the word fetish is used with a different resonance, which led to new interpretations of commodity fetishism, as types of sexually charged relationships between a person and a manufactured object. This is especially true of the world of advertising where sex is used as the marketing tool to encourage the purchase of commodities.

Georg Lukács based *History and Class Consciousness* on Marx's notion of commodity. Lukács' work was a significant influence on later philosophers such as Debord, who in turn developed a concept of the spectacle that ran directly parallel to Marx's notion; for Debord the spectacle made relations among people seem like relations among images (and vice versa) (Debord 1995). Jean Baudrillard is especially interested in the cultural mystique added to objects, which encourages consumers to purchase them as aids to the construction of their personal worth. In *For a Critique of the Political Economy of the Sign,* Baudrillard develops a quadripartite notion of the sign that, like Debord's notion of spectacle, runs alongside Marx's view of commodity.

For Baudrillard, the functional value of an object is its instrumental purpose, so a pint of Guinness satisfies thirst as well as satisfying a desire for a form of stimulant. This is very close to the Marxian notion of use-value. The next stage for him is the exchange-value of the commodity, which is its economic value. A pint of Guinness is, at present, worth 4 euro. The next phase is the symbolic exchange-value of an object, which is its arbitrarily assigned value in terms of an agreed value in relation to another subject. So in this schema

a pint of Guinness represents leisure activity or a form of reward in leisure time; it is also a symbol of a particularly Irish form of leisure and pleasure activity. By asking someone to go for a pint, one engages in a form of social exchange, and of valuing another subject in terms of wanting to spend leisure time with him or her. The final aspect of Baudrillard's topology of the commodity is the sign exchange-value, which represents the value of an object in a system of objects. Here the sense of care in pouring the pint of Guinness, as adverted to in a number of Guinness advertisements, represents the pint as almost a social artifact (Baudrillard 1981, 123). Thus a pint of Guinness has sign exchange-value in terms of other pints of beer, which do not require a waiting time to be ready to drink. The pouring ritual of Guinness is itself interesting in terms of fetishizing the commodity. Two thirds of the glass is filled with the stout, which surges until it "settles" into the classic black body and white head. When this is done, the remainder of the glass is filled and then there is a further wait until the pint is fully settled. This bestows on the consumer the value of being someone who appreciates the almost fetishistic quality of a special product, and this is clear from the advertisements.

In 1994, the "Anticipation" campaign featured Joe McKinney who, while waiting for the pint to "settle," engages in a series of contortions to music, with the caption "there's no time like Guinness time" (*Guinness Calendar* 2004, June). Here, the stress is on the intrinsic value of the product that is worth waiting for. A similar focus on the length of time it takes for the product to achieve readiness for consumption is to be found in the 2004 campaign. In this advertisement the image is of a pint glass, viewed from below, as the pint surges; the focus again is on waiting for it to settle, and the caption cleverly inverts a cliché: "the storm before the calm." The lettering is colored in a manner to match the brown froth of the surging liquid. The sub-caption, in white, reads: "pure magic" (*Guinness Calendar* 2004, February).

What is most interesting in this instance is the increasing scale of value of an object in terms of relational as opposed to useful qualities. Hence, the value of a commodity derives less from what it does or is, as opposed to how it makes the consumer feel about him or her self. By being the kind of consumer who is willing to wait for his chosen object of consumption to achieve a state of perfection, the advertisement is hailing the consumer as a subject who has taste and judgement. The distinction between use-value and

exchange-value is less stable than Marxists would allow, and accordingly, the work of Jacques Derrida is of interest.

Derrida argues use-value and exchange-value are not clearly separated but "haunted," by culture and by each other. Derrida takes this as a classic example, which has very general applications, and reasserts his plea for "hauntology" rather than the usually carefully separated and compartmentalized ontology. Exchange-value haunts use-value, for example, by expressing repetition, exchangeability, and the loss of singularity (Derrida 1994, 161). Use-value haunts exchange-value, because exchange is only possible if the commodity might be useful for others. In *Specters of Marx,* Derrida discusses what he terms *hauntology,* in answer to his question: "*What* is a ghost?" (Derrida 1994, 10). In this book, he discusses the spectrality of many areas of meaning, seeing ghostly hauntings as traces of possible meanings. One might compare his *hauntology* to the paradigmatic chains that hover over [haunt] the linearity of the syntagmatic chain. But Derrida makes one important distinction, in that he sees spectrality and time as closely connected. He makes the point, speaking both of the ghost in *Hamlet,* and the ghost that haunts Marx's *Communist Manifesto* (where the first noun is "specter"), that: "At bottom, the specter is the future, it is always to come, it presents itself only as that which could come or come back" (Derrida 1994, 39). In this sense, use-value and exchange-value are temporally connected: we buy a product to fill a future need, as I purchase a pint of Guinness it is with a view to drinking it after its being bought. As such, we purchase products with a view to satisfying a future desire, a desire as both Baudrillard and Derrida suggest, that is predicated on a better, more sated us in the future. It is also with a view to being the subject who is valued because of his or her choice of product. The product, through the advertisement, hails the subject and causes him or her to want to purchase Guinness.

Thus, the first advertisement in 1929 seems to focus on its use-value, or functional value. The quality of the ingredients is foregrounded "going right back to the Barley seed that will enable the farmers to grow the Barley that makes the most suitable malt to make the best Stout" (*Guinness Calendar* 2004, 1929). The capitalization of the key words "barley" and "stout" suggests the importance of the ingredient to the constitution of the product. The foregrounding of the connection through capitalization is an example of

linguistic over-determination that stresses the poetic function of language. Similarly, one can read the sub headings of the advertisement, which are also capitalized, in similar terms, as these, in turn, foreground the quality function of the product:

ITS GREAT PURITY

ITS HEALTH-GIVING VALUE

ITS NOURISHING PROPERTIES (*Guinness Calendar* 2004, 1929)

The stress is on the naturalness of the product: "naturally matured;" "no artificial colour is added;" "it enriches the blood;" it is "one of the most nourishing beverages, richer in carbo-hydrates than a glass of milk." The ultimate form of authority, that of medical doctors, is invoked to substantiate these claims: "doctors affirm that Guinness is a valuable restorative after Influenza and other weakening illnesses. Guinness is a valuable natural aid in cases of insomnia" (*Guinness Calendar* 2004, 1929).

The function of the product as an enhancement of one's physical well-being is stressed in this case. Its use-value is that of a quasi-medicine, and the presumption is that the consumer is ill before he or she drinks Guinness and that the product will make him or her feel better. Already however, there is an appeal beyond the simple use-value or functional value. At a core level, this is an alcoholic drink, which is consumed for the purpose of relaxation and enjoyment of the effects of alcohol. Its use-value, in crude terms, is a form of narcotic escape, but this is never stressed. Instead, what it does is make the consumer feel better about him or her self: it hails the subject as a healthier subject because of the consumption of Guinness.

Six years later, a development in approach is clear. In this advertisement, a uniformed zookeeper is chasing a sea lion, which is balancing a pint of Guinness on its nose, and the only words used in the advertisement are found in the four-word caption; "My Goodness, MY GUINNESS" [*capitalization original*] (*Guinness Calendar* 2004, June). The product has achieved a magical transformation; the sea lion has moved away from its normal diet to enjoy a pint of Guinness and is being chased by a harassed looking zookeeper. The transformative power of the product is clear; the ad invokes the notion of Guinness as an object of desire, because it is ambiguous as to whether the

zookeeper is chasing the sea lion or the pint of Guinness. There is a cartoon-ish air to the image, as if Guinness has a magical effect on all with whom it comes into contact; it is seen as transformative. It is almost as if the product is attempting to create a Benjaminian aura.

According to Benjamin, even a perfect reproduction of a work of art is lacking in time and space—its "unique existence at the place where it happens to be" (Benjamin 1992, 229). This sense of history or duration that builds the character of a work of art cannot be transmitted to the mechanical reproduction. This, by definition, means it cannot apply to a proliferation of like-things because they are not each unique in time and space, but duplicates of each other. He goes on to argue, "that which withers in the age of mechanical reproduction is the aura of the work of art" (Benjamin 1992, 221). Therefore, Benjamin's aura is a presence or atmosphere attached to a thing that is one of a kind (unique in time and space), and cannot be reproduced mechanically. This is possibly why Guinness is always defined in the singular as opposed to the plural, with the stress being on the perfect quality of each individual pint, and the focus on the amount of time each pint takes to achieve readiness for consumption.

Here, use-value fuses with symbolic exchange-value because the product becomes an object of desire. The sense of the chase after the object is an index of desire and, according to psychoanalytic theory, desire is one of the most potent and constitutive aspects of our humanity. This quality is diagnosed as a structuring agent of humanity, and a brief exploration of the history of desire will contextualize our discussion of how Guinness has become such an iconic signifier of different types of Irishness. Jacques Lacan, developing the work of Freud, undercut the notion of rationality as the dominant factor in our humanity, and instead began to examine language as an index of the unconscious processes of the mind. He also coined the phrase "the unconscious is structured like a language" (Lacan 1977b, 20), which brought the study of structures to the fore in continental thought. For Lacan, the unconscious and language could no longer be seen as givens, or as natural; instead, they were structures that required investigation. In this model, language, no matter what the mode of enunciation, was shot through with metaphors, metonymies, and complex codifications that often masked, as opposed to revealed, the real self. Lacan stressed the lack of correlation between the

signifier and the signified, adding that meaning is always fraught with slippage, lack of clarity, and play. His recasting of the Cartesian *"cogito ergo sum"* ("I think therefore I am") into *"desidero ergo sum"* ("I desire therefore I am") has led to a revision of the primacy of reason in the human sciences. A more recent version reinforces this consumer-driven subjectivity of which we have been speaking in its wry reinscription of the *Cogito*; "Tesco ergo sum." He also suggested selfhood was a complex construct in which the self took on reflections and refractions from the societal context in which it was placed.

His notion of the mirror stage stressed the imaginary and fictive nature of the ideal self, which he saw as predicated on a desire for an unattainable ideal that could never be actualized. In the mirror stage, what Lacan terms the ideal ego is formed, which he sees as premised on the desire for a future synthesis. As the subject anticipates the imagined and imaginary future wholeness, which will never arrive, and which is announced in the future perfect tense: "the subject becomes at each stage what he was before and announces himself 'he will have been' only in the future perfect tense" (Lacan 1977a, 306).

Given that desire is that of the other, and it is always the desire for something else, then as soon as one desired signifier is reached, it is no longer the object of desire and the metonymic movement along the chain is repeated. Thus, for Lacan "desire *is* a metonymy" [*emphasis original*] (Lacan 1977a, 175). The impossibility of fulfilling desire is captured mimetically by the fact the sea lion can never drink the pint of Guinness because it is balanced on its nose and it is running, nor can the zookeeper either catch the sea lion or drink the Guinness. At a structural level, the impossibility of fulfilling desire is further explored in the advertisement which won the Grand Prix Ad of the Century in 1999, called "The Island" (*Guinness Calendar* 2004, April). This advertisement appeared on Irish television in 1977, and portrayed three men from one of the islands that dot the west coast of Ireland rowing a currach (a small rowing boat) with a keg of Guinness perched in the stern of the boat. Meanwhile, on the island itself, the customers in the pub are awaiting their arrival. The advertisement is a series of cuts from the active rowing to the passive waiting, and all is done in silence. Finally, one of the islanders sees the currach on the horizon and calls in Irish *"Tá Siad ag teacht"* (they are coming). When the Guinness arrives on the island, there is huge excitement,

and when the keg is finished, the rowers set off again, thereby enacting the impossibility of any real fulfilment of desire.

Again we have moved from the actuality of consumption of a product, which will enhance the physical well-being of the body, to an object of desire. What is set up is a process of desire, as the Guinness is brought, consumed, and through its consumption the chain of desire is set up again, and the process continues. Of course, advertising, like desire, is predicated on the future—the consumption of one pint of Guinness leads to the other. In symbolic terms, Guinness is the object that leads to a relationship between the island and the mainland, and given that in Irish iconography, the west of Ireland is always seen as the more authentically Irish part of the country, then Guinness is being associated with traditional, male, patriarchal, and rural consumer culture. As Irish culture changed, this pattern would also change, and a more cosmopolitan aspect of Guinness would be set out.

Desire, says Lacan, is located in language and in objects outside of ourselves. Speaking of the moment at which the mirror stage comes to an end, Lacan says, "It is this moment that decisively tips the whole of human knowledge into mediatization through the desire of the other" (Lacan 1977a, 6). This enables Lacan to propose "[t]he symbol manifests itself first of all as the murder of the thing, and this death constitutes in the subject the eternalisation of desire" (Lacan 1977a, 114). What is crucial here is that the capture, or consumption, of the "thing" in no way sates or stops desire, and the progression of Guinness advertisements underlines this fact. The first toucan poster appeared in 1955; in this advert, two military pilots, looking stereotypically British with handlebar moustaches, are looking up at five toucans, flying in military formation, each with two pints of Guinness balanced on their beaks (*Guinness Calendar* 2004, October). The toucans have stolen the pints of Guinness and the airmen are horrified. Once again, noone is actually drinking the Guinness, the toucans are carrying off the drink, in a manner paralleling the sea lion, and the airmen are chasing but in vain. Here the object of desire is once again metonymically in motion without any sense of closure.

Clearly, in terms of the advertising of Guinness, as an index of consumer culture, the line between use- and exchange-values is blurred. People's relation to consumption has hierarchical status value in a system of *symbolic*

exchange, which is a "social institution that determines behavior before even being considered in the consciousness of the social actor" (Baudrillard 1981, 31). In terms of the mechanisms of desire, Lacan states the subject's ego is that "which is reflected of his form in his objects" (Lacan 1977a, 194), and it is this identification of the subject with the product as an index of his or her ego that is the key to the development of these advertisements in consumer culture. In this system, consumption determines one's social status, as Baudrillard notes "through objects, each individual and group searches out his-her place in an order, all the while trying to jostle this order according to a personal trajectory" (Baudrillard 1981, 38). In this sense there is no point in positing the existence of an "empirical object" (Baudrillard 1981, 63), because the object only has meaning as a signifying relation, and in this context, Derrida has some interesting points to make.

In terms of the difference between use-value and exchange-value, Derrida, citing Marx, describes how Marx spoke about a piece of wood being made into a table: "the wood remains wooden when it is made into a table: it is then an ordinary, sensuous thing [*ein ordindäres, sinnliches Ding*]" (Derrida 1994, 150). Here the table remains wood even after the wood has been transformed. However, once the table enters the marketplace and becomes a commodity, things change radically:

> It is quite different when it becomes a commodity, when the curtain goes up on the market and the table plays actor and character at the same time, when the commodity-table, says Marx, comes on stage (*auftritt*), begins to walk around and to put itself forward as a market value. *Coup de theatre:* the ordinary, sensuous thing is transfigured (*verwandelt sich*), it becomes someone, it assumes a figure. This woody and headstrong denseness is metamorphosed into a supernatural thing, a *sensuous non-sensuous* thing, sensuous but non-sensuous, sensuously supersensible (*verwandelt er sich in ein sinnlich übersinnliches Ding*). The ghostly schema now appears indispensable. (Derrida 1994, 150)

His view is that use-value is haunted by exchange-value as the aura of the commodity hails the subject because it serves as an identificatory agent through which the subject recognizes him or herself in terms of these consumable products. The notion of the commodity as a figure is close to what

we have been describing in terms of the Guinness advertisements hailing the consumer. It is as if the product is looking at the consumer.

Likewise it is as if the commodity is like an actor:

> Marx must have recourse to theatrical language and must describe the apparition of the commodity as a stage entrance (*auftritt*). And he must describe the table become commodity as a table that turns, to be sure, during a spiritualist séance, but also as a ghostly silhouette, the figuration of an actor or a dancer. Theo-anthropological figure of indeterminate sex (*Tisch*, table, is a masculine noun), the table has feet, the table has a head, its body comes alive, it erects its whole self like an institution, it stands up and addresses itself to others, first of all to other commodities, its fellow beings in phantomality, it faces them or opposes them, For the spectre is social. (Derrida 1994, 151)

It is as if the commodity is looking at the consumer, and here we enter another area of significance in terms of desire, namely the power of the gaze, or as Lacan termed it, the scopic drive. For Lacan, the notion of looking is inseparable from that of being looked at, and indeed, his seminal construction of the dawning of the ego in the mirror stage is a process shot through with the scopic drive.

For Lacan, the child, as it reaches the stage of "situational apperception," begins to experience, through play, the "relation between the movements assumed in the [mirror] image and the reflected environment" (Lacan 1977a, 1). This captation by the image has profound effects on the development of the ego. For Lacan

> This jubilant assumption of his specular image situates the agency of the ego, before its social determination, in a fictional direction, which will always remain irreducible for the individual alone, or rather, which will only rejoin the "coming-into-being" (*le devenir*) of the subject asymptotically, whatever the success of the dialectical synthesis by which he must resolve as *I* his discordance with his own reality. (Lacan 1977a, 2)

In other words, as the I looks in the mirror, it is being looked at in turn by its image, and for Lacan this is a process that remains with us all our

lives and one that, if we combine the theoretical apperceptions of Althusser, Baudrillard, Derrida, and Lacan, allows us to create a theory of consumer advertising wherein the products are designed, in commodity form, to look back at us and reflect value into ourselves through our consumption of these objects. It is a circular structure that has been, as we have noted, captured in the ongoing return journeys by the currach from the mainland to the island, carrying kegs of Guinness to a pub where desire can never be sated, and no sooner is the keg empty then the journey begins again. Interestingly, the caption is in the future tense, the tense of desire, because the keg "is coming," and it always will be. The value of the rowers is reflected in their ability to enact the signifying chain of desire over and over again.

The part of culture that provides this reflected value is called "the other" by Lacan: "the Other is, therefore, the locus in which is constituted the I who speaks to him who hears" (Lacan 1977a, 141). As an increasingly visual culture, the power of the image in terms of the subject is ever on the increase. This is reflected in some of the more contemporary Guinness advertisements.

The contemporary symbolic order in Ireland is very different from that of seventy-five years ago. In gender terms, Guinness was seen as primarily a drink aimed at male consumers. Today, however, Guinness is consumed by an increasing number of women, and the single advertisement in the calendar featuring a woman is an interesting example of how the female subject is hailed by advertising. This picture, aimed at women's magazines in 1974, is of a slim, deeply tanned, attractive young woman, wearing a white bikini and standing in silhouette in front of a sea and sky background. Her face is not visible but her long dark hair is, and in her right hand, she is holding a half-pint glass of Guinness, which is about one-third full. The caption for the advertisement, which runs across the page at a point in the picture that is level with the glass, is: "WHO SAID: 'men seldom make passes at girls with glasses?'"(*Guinness Calendar* 2004, August). Here the traditional symbolic order position of woman would seem to be undercut. This woman is free and unrestricted, there is no man at hand in a sexual or paternalistic role, the vast expanse of beach, sea and sky are hers to enjoy as if by right, and she is enjoying the solitude of the scene, with her glass of Guinness. It would seem this image is embracing the ideological position of the Woman's Movement, and also stressing that Guinness, traditionally seen as a "man's drink," and

indeed, for a time as an older man's drink, is now also the preserve of women. She is part of a changed symbolic order where women can be hailed by a product that is traditionally male. It also seems to say a woman with a glass of Guinness will be attractive to a male gaze.

However the advertisement is also aimed at the other 50 percent of consumers, as the old saying that is mirrored, in an altered fashion, by the caption, is actually: "men seldom make passes at girls who wear glasses." Generally, glasses were seen as being not very sexy, and it was common practice for women not to wear them. They connote an intellectual quality, and the symbolic order of the past deemed woman's place was in the home, and she should not be over intelligent because this could be threatening to men. In the caption, the pun is on the glass the woman has because it is a Guinness glass, and she herself, iconically, mirrors the color scheme of Guinness in a metonymic way. She embodies the dark and white color scheme and the running image of the sea in all of these advertisements (it figures in six of the twelve pictures, as well as one of the other two television advertisements) connects her with the drink. So, as well as suggesting woman who drink Guinness are sophisticated and self-actualizing, she is also attractive to a male gaze and, at a connotative level, is almost an embodiment of the sensual appeal Guinness is given in many of the advertisements.

The contrast with the previous month is telling. This image is the surfer advertisement from 1999 (*Guinness Calendar* 2004, July). This also features the sea, but it is a sea transformed. In the previous image, the woman is on the edge of a becalmed sea; in this image three men are in extremely active poses as they surf huge waves. They appear in a triangle, and behind them both emerging out of the waves and constructed by the waves, are four beautiful white horses following the surfers. The contrast could not be more emblematic. The male figures are mastering the sea, both actual and mythological—the Celtic god of the sea was Manannán mac Lir, and he rode the horses of the sea. The metaphor of waiting for the perfect wave and waiting for the pouring of the pint is also to be found—the frothing of the Guinness is compared, in metaphor, to the frothing of the waves of the sea.

Aesthetically, the image of the combined waves, horses of the sea and the surfers is stunning, both real and surreal, taking the imagery of animals that ran through the Guinness advertisements in the 1950s and 1960s, the

toucan, the sea lion, and the kangaroo, to new visual levels. To be hailed by this image is to be hailed by very strong images of strength, power, and mobility, as well as fantasy, and there is a cosmopolitan touch to these two advertisements that hail subjects that are not traditionally Irish. Both the woman and the surfers are no longer traditionally Irish, or at least, are not pictures in Irish settings. They may well signify the Irish as new Europeans, enjoying different cultures. Here the image that is scopically captating the consumer is one of sophistication and power; it is an aesthetically pleasing image, and the connection with the product is metaphoric as opposed to metonymic. The surging of the waves and the horses, which appear out of the waves, suggest the surging of the pint, but the connection is left implicit as opposed to explicit. Instead, metaphorical images of power, naturalness, beauty, and relaxation are metaphorically connected with Guinness as a product, and by extension, with the subjects who are intelligent enough to consume them. In an increasingly technologically driven economy, where intelligence as opposed to strength is the new currency, more recent Guinness advertisements have appealed to this tenet of subjectivity, because they hail an intelligent consumer whose intelligence is underscored by his or her choice of a superior product, whose appeal is to just such a discerning consumer.

The final advertisements to be discussed are the television advertisements featuring Mic Christopher's song "Heyday," in which the protagonist moves from a very realistic image pattern in Ireland to the Cliffs of Moher where, as the realism turns magic, he swims to New York; upon arrival, he enters an Irish bar and, dripping wet, confronts another man and says: "sorry." There is an intense few seconds of silence and, then, with Guinness as the peace offering, calm and friendship return. It is a clever advertisement because it reprises the island image of the earlier campaign, but now instead of that almost premodern journey across a small channel to bring Guinness to the inhabitants of that island, we see a magically real journey from Ireland to America to cement an intersubjective relationship. The product, the subjectivity that is interpellated, is a postmodern one, a subjectivity that imaginatively connects Ireland with America and one in which Guinness is no longer domain-specific, but very much a part of the worldwide consumer community. This interpellated subject is a person who has no fear of travel or of other cultures and one who is at ease at home or

abroad, it might well be the "*figurante*" that Derrida speaks of as the commodity. Guinness itself could be seen in this light: originating in Ireland but now a citizen of the world.

In a follow-on advertisement, redolent of postmodern irony, there is a parody of this advertisement in 2005 when a young man, bringing cans of draught Guinness to a party, walks through puddles of water, trails mud across the carpet and, on being looked at quizzically by the calm owner of the house, he says, without any of the intensity of the previous advertisement, "sorry" and everyone laughs. The interpellation is at a cerebral and intellectual level. The assumption of the advertisement is that the audience has seen the previous advertisement, so there is an intertextual presumption the postmodern humor of parody and pastiche will be a shared moment of enjoyment, and Guinness is now seen as the provider of that intertextual sense of knowledge and cultural *nous*. We have come a long way from the island and, yet, perhaps not, because the notion of desire is still prevalent, and the appeal to core aspects of subjectivity is still as strong as ever.

So we have come full circle here because Guinness is now hailing postmodern, intelligent, cosmopolitan subjects through the aura its product creates. As a synecdoche of Irishness, that image of the harp in "Natural Anthem" has turned out to be a polysemic one. The commodity is protean, suggesting it has parallelled all the changes of the Irish economy and psyche over the past seventy-five years. To quote Derrida again, this is part of the spectral power of the commodity, "it changes places, one no longer knows exactly where it is, it turns, it invades the stage with its moves, there is a step there [*il y a là un pas*] and its allure belongs only to this mutant" (Derrida 1994, 151). Just as Ireland has changed out of all recognition over the past seventy-five years, so too has Guinness advertising; they have each kept pace with each other, and in terms of subjectivity, the postmodern Irish man or woman, drinking a pint of Guinness in a pub in Ireland, Europe, or America, is precisely the subject of consumer culture being interpellated by Guinness: the harp on the glass and the harp of the nation are transformed.

Works Cited | Index

Works Cited

Adamson, I. 1986. *The Cruthin.* Belfast: Pretani Press.

Althusser, L. 1969. *Lenin and Philosophy.* New York: Monthly Review.

———. 1998. "Ideology and Ideological State Apparatuses." In *Literary Theory: An Anthology,* edited by J. Rivkin and M. Ryan, 294–304. Malden: Blackwell.

Alvarado, M. 2001. "Photographs and Narrativity." In *Representation and Photography: A Screen Education Reader,* edited by M. Alvarado, E. Buscombe, and R. Collins, 148–63. New York: Palgrave.

Alvarado, M., E. Buscombe, and R. Collins, eds. 2001. *Representation and Photography: A Screen Education Reader.* New York: Palgrave.

Anderson, B. 1983. *Imagined Communities: Reflections on the Origin and Spread of Nationalism.* London: Verso.

Bal, M., J. Crew, and L. Spitzer, eds. 1999. *Acts of Memory: Cultural Recall in the Present Hanover.* New Hampshire: Univ. Press of New England.

Barry, T. 1949. *Guerrilla Days in Ireland.* Dublin: Irish Press.

Barthes, R. 1981. "Textual Analysis of Poe's *Valdemar.*" In *Untying the Text: A Post-Structuralist Reader,* edited by R. Young, 133–63. London: Routledge.

———. 1982. *Camera Lucida: Reflections on Photography.* New York: Hill and Wang.

Barton, R. 1997. "From History to Heritage: Some Recent Developments in Irish Cinema." *The Irish Review* 21: 41–56.

———. 1999. "Feisty Colleens and Faithful Sons: Gender in Irish Cinema." *Cineaste: Contemporary Irish Cinema Supplement* 24, nos. 2–3: 40–45.

———. 2001. "Kitsch as Authenticity: Irish Cinema and the Challenge of Romanticism." *Irish Studies Review* 9, no. 2: 193–202.

———. 2004. *Irish National Cinema.* London and New York: Routledge.

Barton, R., and H. O'Brien, eds. 2004. *Keeping It Real: Irish Film and Television.* London: Wallflower Press.

Baudrillard, J. 1981. *For a Critique of the Political Economy of the Sign.* St. Louis: Telos.

Beale, J. 1986. *Women in Ireland: Voices of Change.* London: Macmillan Education.

Beere, J. T. 1935–36. "Cinema Statistics in Saorstat Eireann." *Journal of the Statistical and Social Society of Ireland* 15: 83–110.

Benjamin, W. 1992. *Illuminations.* London: Fontana.

Beresford, D. 1987. *Ten Men Dead: The Story of the Irish Hunger Strike.* London: Grafton Books.

Berger, J. 1972. *Ways of Seeing.* London: BBC and Penguin Books.

Bielenberg, A. 2002. "Seán Keating, the Shannon-Scheme and the Art of Nation-Building." In *The Shannon Scheme and the Electrification of the Irish Free State: An Inspirational Milestone,* edited by A. Bielenberg, 114–37. Dublin: Lilliput Press.

Bowe, N. G., and E. Cummings. 1998. *The Arts and Crafts Movement in Dublin and Edinburgh.* Dublin: Irish Academic Press.

Boyce, D. G. 2001. "'No Lack of Ghosts': Memory, Commemoration, and the State in Ireland." In *History and Memory in Modern Ireland,* edited by I. McBride, 254–71. Cambridge: Cambridge Univ. Press.

Breathnach-Lynch, S. 1998. "Framing Ireland's History: Art, Politics and Representation, 1914–29." In *When Time Began to Rant and Rage: Figurative Painting from Twentieth Century Ireland,* edited by J. C. Steward, 40–51. London: Merrell Holberton Publishers.

———. 2000. "Landscape, Space and Gender: Their Role in the Construction of Female Identity in Newly Independent Ireland." In *Gendering Landscape Art,* edited by S. Adams and A. Gruetzner-Robins, 76–86. Manchester: Manchester Univ. Press.

Brennan, T. 2001. "Cosmopolitanism and Internationalism." *New Left Review* 7 (Jan.–Feb.): 75–84.

Burke, E. 1976. *Reflections on the Revolution in France.* Harmondsworth: Penguin.

Butler Cullingford, E. 1997a. "The Reception of *Michael Collins.*" *Irish Literary Supplement* 16 (Spring): 17–18.

———. 1997b. "Gender, Sexuality and Englishness in Modern Irish Drama and Film." In *Gender and Sexuality in Modern Ireland,* edited by A. Bradley and A. G. Valiulis, 159–86. Amherst: Univ. of Massachusetts Press.

———. 2001. *Ireland's Others: Gender and Ethnicity in Irish Literature and Popular Culture.* Cork: Cork Univ. Press.

Cantacuzino, M. 2004. "The Forgotten Protesters." *The Guardian,* (9 Feb.).

Carby, H. V. 2001. "What Is This "Black" in Irish Popular Culture." *Cultural Studies* 4, no. 3: 325–49.

Carson, C. 1987. "Introduction." In *The Donegal Pictures*. Winston-Salem, N.C.: Wake Forest Univ. Press.

Chakrabarty, D. 2000. "Subaltern Studies and Postcolonial Historiography." *Nepantla: Views from the South* 1, no. 1: 9–32.

Cleary, J. 2002. *Literature, Partition and the Nation State: Culture and Conflict in Ireland, Israel and Palestine*. Cambridge: Cambridge Univ. Press.

———. 2004. "Postcolonial Ireland." In *Ireland and The British Empire,* edited by K. Kenny, 251–88. Oxford: Oxford Univ. Press.

Condon, D. 2003. "Touristic Work and Pleasure: The Kalem Company in Killarney." *Film and Culture* 2: 7–16.

Connerton, P. 1989. *How Societies Remember*. Cambridge: Cambridge Univ. Press.

Coombes, A. E. 1994. *Reinventing Africa: Museums, Material Culture and Popular Imagination in Victorian and Edwardian England*. London: Yale Univ. Press.

Cullen, F. 1997. *Visual Politics: The Representation of Ireland, 1750–1930*. Cork: Cork Univ. Press.

———. 2005. "The Visual Arts in Ireland." In *The Cambridge Companion to Modern Irish Culture,* edited by J. Cleary and C. Connolly, 304–21. Cambridge: Cambridge Univ. Press.

Cullinane, J. 1994. "Irish Dance World Wide." In *Irish World Wide: History, Heritage and Identity,* edited by P. O'Sullivan. Vol. 3. Leicester: Leicester Univ. Press.

Curtis, L. P. 1984. *Nothing but the Same Old Story: The Roots of Anti-Irish Racism*. London: Information on Ireland.

———. 1997. *Apes and Angels: The Irishman in Victorian Caricature*. Washington: Smithsonian Institution Press.

———. 1998–99. "The Four Erins: Feminine Images of Ireland, 1780–1900." *Eire-Ireland* nos. 33–34: 72–102.

Cusack, T. 2001. "A 'Countryside Bright with Cosy Homesteads': Irish Nationalism and the Cottage Landscape." *National Identities* 3, no. 2: 221–38.

Dalsimer, A. M., ed. 1993. *Visualizing Ireland: National Identity and the Pictorial Tradition*. Winchester, Mass.: Faber and Faber.

Debord, G. 1995. *The Society of the Spectacle*. London: Zone Books.

Derrida, J. 1994. *Specters of Marx: The State of the Debt, the Work of Mourning and the New International*. London: Routledge.

Edelstein, T. J., R. Born, and S. Taylor, eds. 1992. *Imagining an Irish Past: The Celtic Revival, 1840–1940*. Chicago: The David and Alfred Smart Museum of Art, Univ. of Chicago.

Elsaesser, T. 1987. "Chronicle of a Death Retold." *Monthly Film Bulletin* 54, no. 641: 164–67.

ESB Touring Exhibitions Service. 1987. *Sean Keating and the ESB*. Dublin: RHA Gallagher Gallery.

Evans, J., ed. 1997. *The Camerawork Essays: Context and Meaning in Photography*. London: Rivers Oram Press.

Feehan, J. 1997. "The Heritage of the Rocks." In *Nature in Ireland: A Scientific and Cultural History*, edited by J. W. Foster and H. C. G. Chesney, 3–22. Dublin: Lilliput Press.

Fitzpatrick, D. 1998. *Politics and Irish Life, 1913–22: Provincial Experience of War and Revolution*. Cork: Cork Univ. Press.

Forty, A. 1986. *Objects of Desire: Design and Society since 1750*. London: Thames and Hudson.

Foster, R. F. 1988. *Modern Ireland: 1600–1972*. London: Penguin Books.

Gael-Linn Web site. www.gael-linn.ie.

Gallagher, P. 1987. "From Pomerania to Parteen." In *Sean Keating and the ESB*, ESB Touring Exhibitions Service, 28–32. Dublin: RHA Gallagher Gallery.

Gibbons, L. 1984. "Synge, Country and Western: The Myth of the West in Irish and American Culture." In *Culture and Ideology in Ireland*, edited by C. Curtin, M. Kelly, and L. O'Dowd, 1–19. Galway: Galway Univ. Press.

———. 1988. "Romanticism, Realism and Irish Cinema." In *Cinema and Ireland*, edited by K. Rockett, L. Gibbons, and J. Hill. London: Croom Helm.

———. 1996a. *Transformations in Irish Culture*. Cork: Cork Univ. Press.

———. 1996b. "Topographies of Terror: Killarney and the Politics of the Sublime." *South Atlantic Quarterly* 95, no. 1: 23–44.

———. 1997. "Demisting the Screen: Neil Jordan's *Michael Collins*." *Irish Literary Supplement* 16 (Spring): 16.

———. 2002. "The Global Cure? History, Therapy and the Celtic Tiger." In *Reinventing Ireland: Culture, Society and the Global Economy*, edited by P. Kirby, M. Cronin, and L. Gibbons, 89–106. London: Pluto Press.

———. 2003. *Edmond Burke and Ireland: Aesthetics, Politics and the Colonial Sublime*. Cambridge: Cambridge Univ. Press.

Giese, R. 1987. *The Donegal Pictures*. Winston Salem, N.C.: Wake Forest Univ. Press.

Gillespie, M. P. 2002. "The Myth of Hidden Ireland: The Corrosive Effect of *The Quiet Man*." *New Hibernia Review* 6 (Summer): 18–32.

Girvin, B. 1989. *Between Two Worlds: Politics and Economy in Independent Ireland*. Maryland: Barnes and Noble Books.

Goggin, C. 2002. "The Boats: The New Ross Galley." *Newsletter of the Inland Waterways Association of Ireland* 29, no. 1: 1–4.

Gonne-MacBride, M. 1936. *An Phoblacht* 11, no. 13: 1.

Graham, C. 2001. "Blame It on Maureen O'Hara: Ireland and the Trope of Authenticity." *Cultural Studies* 15, no. 1: 58–75.

Gross, D. 2000. *Lost Time: On Remembering and Forgetting in Late Modern Culture.* Amherst: Univ. of Massachusetts Press.

Guinness Calendar 2004: Guinness Celebrates 75 Years of Advertising. Dublin: Guinness.

Halbwachs, M. 1992. *On Collective Memory.* Chicago: Chicago Univ. Press.

Hall, S. C., and A. M. Hall 1841–43. *Ireland: Its Scenery, Character, & C.* London: Virtue.

Heaney, S. 1992. "Preface." In *Sweeney's Flight, Based on the Revised Text of "Sweeney Astray"; Photographs by Rachel Giese,* vii–viii. London: Faber and Faber.

Heise, C. G. 1978. "Preface to Albert Renger-Patzsch, *Die Welt ist schön.*" In *Germany—The New Photography, 1927–33,* edited by D. Mellor, 8–14. London: Arts Council of Britain.

Henry, P. 1951. *An Irish Portrait.* London: B. Batsford

Heverin, A. 2000. *The Irish Countrywomen's Association: A History, 1910–2000.* Dublin: ICA and Wolfhound Press.

Hight, E. M. 1995. *Picturing Modernism: Moholy-Nagy and Photography in Weimar Germany.* Cambridge, Mass.: MIT Press.

Hill, J. 1988. "Images of Violence." In *Cinema and Ireland,* edited by K. Rockett, L. Gibbons, and J. Hill. London: Croom Helm.

———. 2000. "'Purely Sinn Fein Propaganda': The Banning of *Ourselves Alone* (1936)." *Historical Journal of Film, Radio and Television* 20, no. 3: 317–33.

Hirsch, M. 2002 *Family Frames: Photography, Narrative, and Postmemory.* Cambridge: Harvard Univ. Press.

Holland, P. 1997. "'Sweet It Is to Scan . . .' Personal Photographs and Popular Photography." In *Photography: A Critical Introduction,* edited by L. Wells, 117–64. London: Routledge.

Hurlburt, L. 1989. *Mexican Muralists in the United States.* Albuquerque: Univ. of New Mexico Press.

Jackson, N. 2001. "Kirk Jones." In *Contemporary British and Irish Film Directors.* London and New York: Wallflower.

Jarman, N. 1992. "Troubled Images: The Iconography of Loyalism." *Critique of Anthropology* 12, no. 2: 133–65.

———. 1997. *Material Conflicts: Parades and Visual Displays in Northern Ireland.* Oxford and New York: Berg Press.

———. n.d. "Painting Landscapes: The Place of Murals in the Symbolic Construction of Urban Space." Extract available on the CAIN Web site: http://cain.ulst .ac.uk/bibdbs/murals/jarman.htm.

Kearney, R. 1988. *Transitions: Narratives in Modern Irish Culture.* Dublin: Wolfhound Press.

———. 2002. *On Stories.* London and New York: Routledge.

Kearns, K. C. 1976. "Ireland's Mining Boom: Development and Impact." *American Journal of Economics and Sociology* 35, no. 3: 251–70.

———. 1978. "Development of the Irish Peat Fuel Industry." *American Journal of Economics and Sociology* 37, no. 2: 179–83.

Kennedy, S. B. 1991. *Irish Art and Modernism, 1880–1950.* Belfast: The Institute of Irish Studies, Queen's Univ. of Belfast.

Kinahan, F. 1992. "Douglas Hyde and the King of the Chimps: Some Notes on the De-Anglicizing of Ireland." In *Imagining an Irish Past: The Celtic Revival, 1840–1940,* edited by T. J. Edelstein, R. Born, and S. Taylor, 64–79. Chicago: The David and Alfred Smart Museum of Art, Univ. of Chicago.

Kirby, A., and J. MacKillop. 1999. "Selected Filmography of Irish and Irish-Related Feature Films." In *Contemporary Irish Cinema: from "The Quiet Man" to "Dancing at Lughnasa,"* edited by J. MacKillop, 182–234. Syracuse: Syracuse Univ. Press.

Kneafsey, M. 1995. "A Landscape of Memories: Heritage and Tourism in Mayo." In *Landscape, Heritage and Identity: Case Studies in Irish Ethnography,* edited by U. Kockel, 135–53. Liverpool: Liverpool Univ. Press.

Kuhn, A. 1995. *Family Secrets: Acts of Memory and Imagination.* London: Verso.

Lacan, J. 1977a. *Écrits.* Harmondsworth: Penguin.

———. 1977b. *The Four Fundamental Concepts of Psycho-Analysis.* Harmondsworth: Penguin.

———. 1991. *Freud's Papers on Technique 1953–54: The Seminar of Jacques Lacan, Book 1.* New York: Norton.

Lang, F. 1928. *Metropolis.* Berlin: Universum Films.

Lee, J. J. 1973. *The Modernization of Irish Society.* Dublin: Gill and Macmillan.

———. 1989. *Ireland, 1912–85: Politics and Society.* Cambridge: Cambridge Univ. Press.

Leerssen, J. 2001. "Monument and Trauma: Varieties of Remembrance." In *History and Memory in Modern Ireland,* edited by I. McBride, 204–22. Cambridge: Cambridge Univ. Press.

Letts, J. 2001. "Living under a Medieval Field." *British Archaeology Magazine* 58 (April). Http://www.britarch.ac.uk/ba/ba58/feat1.shtml.

Linehan, H. 1999. "Myth, Mammon and Mediocrity: The Trouble with Recent Irish Cinema." *Cineaste* 24, nos. 2–3: 46–49.

Lloyd, D. 1999. *Ireland after History.* Cork: Cork Univ. Press.

———. 2000. "Colonial Trauma/Postcolonial Recovery." *Interventions: International Journal of Postcolonial Studies* 2, no. 2: 212–28.

———. 2005. "Republics of Difference." *Field Day Review* 1: 43–70.

Loftus, B. 1990. *Mirrors: William III and Mother Ireland.* Dundrum, Co. Down: Picture Press.

Longford, L. 1937. Quoted by Sean O'Meadhra. *Ireland Today* (March): 70–71.

Lowry, J., D. Green, and D. Campany. 2003. "Foreword." In *Where Is the Photograph?* edited by D. Green, 9–11. Brighton: Photoforum and Photoworks.

Lukács, G. 1972. *History and Class Consciousness.* Cambridge: MIT Press.

Lundström, J. 1999. "Realism, Photography and Visual Culture." In *Symbolic Imprints: Essays on Photography and Visual Culture,* edited by L. K. Bertelsen, R. Gade, and M. Sandbye, 51–64. Aarhus: Aarhus Univ. Press.

Lyons, L. 2003. "Hand-to-Hand History: Ephemera and Irish Republicanism." *Interventions: International Journal of Postcolonial Studies* 5, no. 3: 407–25.

MacCurtain, M. 1993. "The Real Molly Macree." In *Visualizing Ireland: National Identity and the Pictorial Tradition,* edited by A. M. Dalsimer, 9–21. London: Faber and Faber.

MacGóráin, R. n.d. "Scannáin, Amhrin agus Dramaí," Unknown collection; copy obtained from Gael-Linn archives, 67–76.

Mallon, F. 1994. "The Promise and Dilemma of Subaltern Studies: Perspectives from Latin American History." *American Historical Review* 99, no. 5: 1491–515.

Manning, M., and M. McDowell. 1984. *Electricity Supply in Ireland: The History of the ESB.* Dublin: Gill and McMillan.

Maslow, A. 1943. "A Theory of Human Motivation." *Psychological Review* 50: 370–96.

Mathews, P. J. 2003. *Revival: The Abbey Theatre, Sinn Fein, the Gaelic League and the Co-operative Movement.* Cork: Cork Univ. Press.

McCarthy, M. 2004. *High Tension: Life on the Shannon Scheme.* Dublin: Lilliput Press.

McDonough, C. J. 2000. "'I've Never Been Just Me': Rethinking Women's Positions in the Plays of Christina Reid." In *A Century of Irish Drama: Widening the Stage,* edited by S. Watt, E. Morgan, and S. Mustafa, 179–92. Bloomington: Indiana Univ. Press.

McIlroy, B. 1988. *Irish Cinema: An Illustrated History.* Dublin: Anna Livia Press.

McLaughlin, C. 2004. "Filmic Representations of the British-Irish Conflict since the Cease-Fires of 1994." In *Relocating Britishness,* edited by S. Caunce, E. Mazierska, S. Sydney-Smith, and J. Walton. Manchester: Manchester Univ. Press.

McLoone, M. 1984. "Strumpet City: The Urban Working Class on Television." In *Television and Irish Society: Twenty-One Years of Irish Television,* edtied by M. McLoone and J. MacMahon, 53–88. Dublin: RTÉ-IFI.

———. 1999. "Reimagining the Nation: Themes and Issues in Irish Cinema." *Cineaste* 24, nos. 2–3: 28–34.

———. 2000. *Irish Film: The Emergence of a Contemporary Cinema.* London: British Film Institute.

McMullan, A. 1993. "Irish Women Playwrights since 1958." In *British and Irish Women Dramatists since 1958: A Critical Handbook,* edited by T. R. Griffiths and M. Llewellyn-Jones, 110–23. Buckingham: Open Univ. Press.

Meaney, G. 1993. "Sex and Nation: Women in Irish Culture and Politics." In *Irish Women's Studies Reader,* edited by A. Smyth, 230–44. Dublin: Attic Press.

Mohr, J. 1999. *At the Edge of the World.* London: Reaktion

Moloney, M. 2002. *Far from the Shamrock Shore: The Story of Irish-American Emigration Through Song.* New York: Crown Publishing.

Moran, G. 1999. "The Imagery of the Irish Land War, 1880–90." In *Images, Icons and the Irish Nationalist Imagination,* edited by L. McBride, 37–52. Dublin: Four Courts Press.

Nash, C. 1993a. "Embodying the Nation: The West of Ireland Landscape and Irish Identity." In *Tourism in Ireland: A Critical Analysis,* edited by B. O'Connor and M. Cronin. Cork: Cork Univ. Press.

———. 1993b. "Remapping and Renaming: New Cartographies of Identity, Gender and Landscape in Ireland." *Feminist Review* 44: 39–57.

Negra, D. 2001. "Consuming Ireland: Lucky Charms Cereal, Irish Spring Soda and 1-800-Shamrock." *Cultural Studies* 15, no. 1: 76–97.

Newey, G. 1996. "Review of 'Michael Collins.'" *Times Literary Supplement,* 15 Nov., 20.

———. 2000. *Irish Film: The Emergence of a Contemporary Cinema.* London: British Film Institute.

Nochlin, L. 1988. *Women, Art and Power and Other Essays.* New York: Harper and Row.

Nora, P., and L. D. Kritzman, eds. 1996. *Realms of Memory.* New York: Columbia Univ. Press.

O'Beirne, G. 2000. *Siemens in Ireland, 1925–2000: Seventy-Five Years of Innovation.* Dublin: A&A Farmar.

O'Beirne, G., and M. O'Connor. 2002. "Siemens-Schuckert and the Electrification of the Irish Free State." In *The Shannon Scheme and the Electrification of the Irish Free State: An Inspirational Milestone,* edited by A. Bielenberg, 73–99. Dublin: Lilliput Press.

O'Brien, E. 1995. *House of Splendid Isolation.* New York: Penguin.

O'Brien, H. 2004. *The Real Ireland: The Evolution of Ireland in Documentary Film.* Manchester: Manchester Univ. Press.

———. 2006. Http://indigo.ie/~obrienh/wn.htm. Accessed 25 Apr.

O'Broin, L. 1958. *The Unfortunate Mr. Robert Emmet.* Dublin: Clonmore and Reynolds.

O'Connor, B. 2005. "Sexing the Nation: Discourses of the Dancing Body in Ireland in the 1930s." *Journal of Gender Studies* 14, no. 2: 89–105.

O'Donoghue, D. 2001. "Heil Hibernia." *Sunday Business Post* (May): 6.

O'Grady, J. P. 1996. "Stopover at Shannon." *Air Power History* 43, no. 2: 34–47.

Ó Laoghaire, C. 1957. "Gael-Linn: Vest Pocket Documentaries." *Irish Film Quarterly* 1, no. 1: 9–11.

Ó'Laoghaire, N. 2003. Author's interview, Dublin, 19 Nov.

O'Sullivan, N. 2005. "Mass in a Connemara Cabin: Religion and the Politics of Painting." *Eire-Ireland: An Interdisciplinary Journal of Irish Studies* 40: 126–39.

O'Toole, F. 1998. *The Ex-Isle of Erin: Images of a Global Ireland.* Dublin: New Island Books.

Pearse, P. H. 1922. *Political Speeches and Writings.* Dublin: Talbot Press.

Petrie, G. [1855] 1967. *The Petrie Collection of the Ancient Music of Ireland.* Westmead: Gregg International Publishers.

Pettitt, L. 2000. *Screening Ireland: Film and Television Representation.* Manchester and New York: Manchester Univ. Press.

Phelan, P. 1993. *Unmarked: The Politics of Performance.* London and New York: Routledge.

Power, R. 1996. "Healthy Motion: Images of "Natural" and "Cultured" Movement in Early Twentieth-Century Britain." *Women's Studies International Forum* 1, no. 5: 551–65.

Pratschke, M. 2005. "A Look at Irish-Ireland: Gael Linn's *Amharc Éireann* Films, 1956–64." *New Hibernia Review* 9, no. 3: 17–38.

Rains, S. 2003. "Diasporic Ethnicity: Irish-American Performativity of Irishness in Popular Culture, 1945–2000." Ph.D. diss., Dublin City Univ.

———. 2004. "Celtic Kitsch: Irish-America and Irish Material Culture." *Circa* 107 (Spring): 52–57.

Reid, C. 1997. *Plays: 1 Tea in a China Cup; Did You Hear the One about the Irishman; Joyriders; The Belle of the Belfast City; My Name, Shall I Tell You My Name?; Clowns.* London: Methuen Drama.

Ricoeur, Paul. 1999. "Memory and Forgetting." In *Questioning Ethics: Contemporary Debates in Philosophy,* edited by Richard Kearney and Mark Dooley, 5–11. London: Routledge.

Robbins, B. 1998. *Feeling Global: Internationalism in Distress.* New York: New York Univ. Press.

Rockett, K. 1988. "1930s fictions." In *Cinema and Ireland,* edited by K. Rockett, L. Gibbons, and J. Hill. London and Sydney: Croom Helm.

———. 1991. "Aspects of the Los Angelesisation of Ireland." *Irish Communication Review* 1: 18–23.

———. 1996. *The Irish Filmography: Irish Films, 1896–1996.* Dublin: Red Mountain Media.

Rockett, K., L. Gibbons, and J. Hill. 1987. *Cinema and Ireland.* London and Sydney: Croom Helm.

Rolston, B. 1991. *Politics and Painting: Murals and Conflict in Northern Ireland.* Cranbury, London, and Mississauga: Associated Univ. Presses.

———. 1992a. *Drawing Support: Murals in the North of Ireland.* Belfast: Beyond the Pale Publications.

———. 1992b. "'When You're Fighting a War, You've Gotta Take Setbacks': Murals and Propaganda in the North of Ireland." *Polygraph* 5: 113–35.

———. 1995a. *Drawing Support 2: Murals of War and Peace.* Belfast: Beyond the Pale Publications.

———. 1995b. "Culture, Conflict and Murals: The Irish Case." In *Distant Relations,* edited by T. Ziff, 191–99. New York: Smart Art Press.

———. 2003a. "Signs of the Times: Murals and Political Transformation in Northern Ireland." In *The Representations of Ireland/s: Images from Outside and from Within,* edited by R. Gonzalez, 27–43. Barcelona: PPU, S.A.

———. 2003b. "Changing the Political Landscape: Murals and Transition in Northern Ireland." *Irish Studies Review* 11, no. 1: 3–16.

Ruttmann, W. 1927. *Berlin: Symphonie der Großstadt.* Berlin: Deutsche Vereins-Film.

Ryder, C. 2000. *Inside the Maze: The Untold Story of the Northern Ireland Prison Service.* London: Methuen.

Saorstát Eireann Irish Free State Official Handbook. 1932. Dublin: The Talbot Press.

Scott, Y. 2005. "The West as Metaphor." Royal Hibernian Academy, *The West as Metaphor.* Ely Place, Dublin, 11 Mar.–24 Apr.

Sexton, S., and C. Kinealy. 2002. *The Irish: A Photohistory: 1840–1940.* London: Thames and Hudson.

Sheehy, J. 1980. *The Celtic Revival: The Rediscovery of Ireland's Past, 1830–1930.* London: Thames and Hudson.

Shiel, M. 1984. *The Quiet Revolution: The Electrification of Rural Ireland.* Dublin: The O'Brien Press.

Sichel, K. 1995. *From Icon to Irony: German and American Industrial Photography.* Boston: Boston Univ. Art Gallery.

Siemens: Progress on the Shannon. 1927. March.

Slater, D. 1995. "Domestic Photography and Digital Culture." In *The Photographic Image in Digital Culture,* edited by M. Lister, 129–46. London: Routledge.

Sluka, J. A. 1995a. "Domination, Resistance and Political Culture in Northern Ireland's Catholic-Nationalist Ghettos." *Critique of Anthropology* 15, no. 1: 71–102.

———. 1995b. "The Politics of Painting: Political Murals in Northern Ireland." In *The Paths to Domination, Resistance and Terror,* edited by C. Nordstrom and J. Martin, 190–218. Berkeley: Univ. of California Press.

Solomon, J. 1995. *What Can a Woman Do with a Camera?* edited by S. Spence and J. Solomon, 85–96. London: Scarlet Press.

Sontag, S. 1999. "The Image-World." In *Visual Culture: The Reader,* edited by J. Evans and S. Hall, 80–94. London: Sage Publications.

———. 2001. *On Photography.* New York: Picador.

Spence, J. 1995. *Cultural Sniping: The Art of Transgression.* London: Routledge.

Steele, J. 2004. "'And Behind Him a Wicked Stag Did Stalk': From Maiden to Mother, Ireland as Woman Through the Male Psyche." In *Irish Women and Nationalism: Soldiers, New Women and Wicked Hags,* edited by L. Ryan and M. Ward. Dublin: Irish Academic Press.

Stevens, L., S. Brown, and P. MacLaran. 2000. "Gender, Nationality and Cultural Representation of Ireland." *European Journal of Women's Studies* 7: 405–21.

Tagg, J. 2001. "The Currency of the Photograph." In *Representation and Photography: A Screen Education Reader,* edited by M. Alvarado, E. Buscombe, and R. Collins, 87–118. Hampshire and New York: Palgrave.

Thompson, S. 1999. "The Politics of Photography: Travel Writing and the Irish Countryside, 1900–14." In *Images, Icons and the Irish Nationalist Imagination,* edited by L. McBride, 113–29. Dublin: Four Courts Press.

Valensi, L. 2000. "Traumatic Events and Historical Consciousness." In *Historians and Social Values,* edited by J. Leerssen and A. Rigney, 185–95. Amsterdam: Amsterdam Univ. Press.

Ward, M. 1983. *Unmanageable Revolutionaries: Women and Irish Nationalism.* Dingle, Co. Kerry: Brandon.

Whelan, K. 2003a. "Robert Emmet: Between History and Memory." *History Ireland Special Issue: Robert Emmet Bicentenary* 11, no. 3: 50–54.

————. 2003b. "Between Filiation and Affiliation: The Politics of Postcolonial Memory." In *Ireland and Postcolonial Theory,* edited by C. Carroll and P. King, 92–108. Cork: Cork Univ. Press.

Wilde, A., J. Wilde, and T. Weski. 1997. *Albert Renger-Patzsch: Photographer of Objectivity.* London: Thames and Hudson.

Wilk, R. 1993. "Miss World Belize: Globalism Localism and the Political Economy of Beauty." Http://www.indiana.edu/wanthro/beaaauty.htm 05/12/01.

Wills, C. 1993. *Improprieties: Politics and Sexuality in Northern Irish Poetry.* Oxford: Clarendon Press.

Wolfe, B. 2000. *The Fabulous Life of Diego Rivera.* New York: Cooper Square Press.

Woods, O. 1995. *Seeing Is Believing: Murals in Derry.* Derry: Guildhall Press.

Index

Italic page numbers indicate illustrations.